CAMBRIDGE STUDIES IN THE HISTORY OF ART

EL GRECO
AND HIS PATRONS

CAMBRIDGE STUDIES IN THE HISTORY OF ART

Edited by FRANCIS HASKELL

Professor in the History of Art, University of Oxford

and NICHOLAS PENNY

Keeper of Western Art, Ashmolean Museum, Oxford

Cambridge Studies in the History of Art will develop as a series of carefully selected original monographs and more general publications, aimed primarily at professional art historians, their students, and scholars in related subjects. The series is likely to embrace a broad range of topics from all branches of art history, and to demonstrate a wide variety of approaches and methods.

Titles in the Series:

El Greco and his Patrons: Three Major Projects
RICHARD G. MANN

A Bibliography of Salon Criticism in Second Empire Paris
Compiled by CHRISTOPHER PARSONS and MARTHA WARD

Giotto and the Language of Gesture
MOSHE BARASCH

The Oriental Obsession: Islamic Inspiration in British and American Art and Architecture 1500–1920
JOHN SWEETMAN

Power and Display in the Seventeenth Century: the Arts and their Patrons in Modena and Ferrara
JANET SOUTHORN

Marcantonio Franceschini and the Liechtensteins: Prince Johann Adam Andreas and the Decoration of the Liechtenstein Garden Palace at Rossan – Vienna
DWIGHT C. MILLER

Pavel Kuznetsov: His Life and Art
PETER STUPPLES

EL GRECO
AND HIS PATRONS

THREE MAJOR PROJECTS

RICHARD G. MANN

ASSISTANT PROFESSOR OF ART HISTORY
STATE UNIVERSITY OF NEW YORK COLLEGE AT PURCHASE

The right of the
University of Cambridge
to print and sell
all manner of books
was granted by
Henry VIII in 1534.
The University has printed
and published continuously
since 1584.

CAMBRIDGE UNIVERSITY PRESS

CAMBRIDGE
NEW YORK PORT CHESTER
MELBOURNE SYDNEY

Published by the Press Syndicate of the University of Cambridge
The Pitt Building, Trumpington Street, Cambridge CB2 IRP
40 West 20th Street, New York, NY 10011, USA
10 Stamford Road, Oakleigh, Melbourne 3166, Australia

First published 1986
Reprinted 1988
First paperback edition 1989

Printed in Great Britain at the University Press,
Cambridge

British Library cataloguing in publication data

Mann, Richard G.
El Greco and his patrons: three major projects.
– (Cambridge studies in the history of art)
1. El Greco
I. Title
759.6 ND813.T4

Library of Congress cataloguing in publication data

Mann, Richard G.
El Greco and his patrons.
Revision of thesis (doctoral) – New York University, 1982.
Bibliography: p.
Includes index.
1. Greco, 1541?–1614 – Criticism and interpretation.
2. Christian art and symbolism – Modern period,
1500– – Spain. 3. Altarpieces, Renaissance – Spain.
4. Art patrons – Spain. I. Title.
ND813. G735M35 1985 759.6 85-7913

ISBN 0 521 30392 3 hard covers
ISBN 0 521 38943 7 paperback

UP

CONTENTS

v

FIGURES

Between pages 144 and 145

vii

ACKNOWLEDGMENTS

Many scholars have shared my enthusiasm for El Greco and his patrons, and I have benefited immensely from their advice and encouragement. I began my research on El Greco's major commissions as a doctoral dissertation at the Institute of Fine Arts, New York University (1982). Jonathan Brown, my dissertation advisor, has generously continued to assist my investigations and has made many invaluable comments and criticisms.

Fernando Marías dropped broad hints which facilitated my research on the Seminary of the Incarnation and provided a useful critique of an earlier version of my analysis of the altarpieces for the Hospital of Saint John the Baptist Outside the Walls. I discussed various aspects of El Greco's career with Gregorio Andrés, who kindly shared with me some of his important discoveries on the Castilla family. I conducted an informative correspondence on El Greco's patrons with Richard L. Kagan. I very much enjoyed several cordial and instructive conversations with John Elliot on various matters relating to my investigations. I also had the pleasure of discussing El Greco studies with David Davies. Colin Eisler, always friendly and helpful, provided needed criticisms of the organization and style of earlier versions of two of the chapters of this book. Donald Posner helped me to focus and organize my research.

The kind assistance and cooperation of many librarians greatly aided my investigations. I particularly want to thank the directors and staff of the following institutions: Archivo Histórico Nacional, Madrid; Archivo Histórico de Protocolos, Madrid; Biblioteca Apostolica Vaticana, Rome; Biblioteca Hertziana, Rome; Biblioteca Nacional, Madrid; British Library, London; Frick Art Reference Library, New York; Hispanic Society of America, New York; Index of Christian Art, Princeton; Institute of Fine Arts Library, New York; Instituto Diego Velázquez, Madrid; and the Research Division of the New York Public Libraries.

Several generous financial grants enabled me to undertake research in Europe.

I am especially grateful to the donors of the Diego Suarez Fellowship and the Walter S. Cook Fellowship.

I am very grateful to William Davies of Cambridge University Press; his encouragement and assistance helped to make the publication of this book a reality. I am also indebted to Francis Haskell and Nicholas Penny, whose helpful advice and criticisms greatly facilitated my final revision of this book. Margaret Freel provided useful suggestions on matters of style.

My wife Jill has assisted my research in innumerable ways. Robert and Sandra Sheppard and Rita Havivi have provided constant encouragement and laughter. I wish also to express my thanks to my parents, George and Alberta Mann.

New York and Memphis, 1985

PREFACE

I have long been curious about the individuals who commissioned El Greco's paintings and in other ways fostered his development. When I began studying art as an undergraduate on foreign study in Madrid, I was immediately captivated by El Greco's dramatic and astonishing images. His paintings displayed at the Prado seemed very different from those of the Venetian, Flemish, and Spanish artists in the surrounding galleries. To my untrained eye, Titian, Rubens, and Velázquez all seemed to have been concerned with glorifying the sensuous beauty of things of this world. In contrast, El Greco seemed to have negated and transcended the earthly realm and sought to elevate his viewers to a higher level of spiritual existence. As I looked at El Greco's paintings, I wondered if they reflected his own spiritual experiences, and I tried to imagine what sort of people had been bold enough to purchase his work. Although undertaken many years later, this study resulted directly from my initial encounters with El Greco's art.

I think that my first impression of El Greco's work was probably much like that of many other modern viewers. The stunning visual qualities of El Greco's religious paintings encourage direct emotional involvement. El Greco endowed many of his altarpieces with an almost hallucinatory force through such devices as stylized but intense facial expressions and gestures, striking and unusual poses, 'electric' colors, and rapid, nervous brushstrokes. He conceived basic Christian themes very differently than had other Renaissance artists. For instance, instead of showing John baptizing Christ in the midst of a beautiful landscape, he presented the two figures before a crowd of awestruck angels who hold up a brilliantly shining curtain that closes off the view into the distance (see fig. 19). It is not surprising that many nineteenth- and twentieth-century writers have proposed that El Greco was a mystic who recorded his visions on canvas much as Saint Teresa transcribed hers in her memorable poems.

The theory that El Greco was a mystic intrigued me and stimulated my original

interest in his work. However, the evidence which I have uncovered does not support the assumption that his paintings represent his own spiritual experiences. It has become apparent to me that El Greco conscientiously tried to express the ideas, beliefs and concerns of his patrons. Thus, the connection of El Greco's work to mysticism cannot be denied, although it needs to be redefined. One of his most important pictorial programs illustrates the visions and meditations of an influential Spanish mystic whose impact on the artist has been overlooked.

My investigations were intended to complement the contributions of the many scholars who have examined various aspects of El Greco's art. Near the beginning of this century, Cossío and San Román initiated the modern study of the artist and published many useful documents, including contracts, records of legal disputes, and the inventories of his estate. Wethey and Soehner assembled comprehensive catalogues of El Greco's paintings and established criteria for distinguishing autograph works from workshop pieces, copies, and forgeries. More recently, Davies, Brown, and Kagan examined the Toledan milieu of the artist and its impact on his work in general terms; Marías and Bustamante reviewed the aesthetic philosophy which El Greco expressed in his annotations to a copy of Barbaro's edition of Vitruvius.

In the present study, I have tried to clarify El Greco's interaction with his patrons, who must have appreciated and fostered his unique talents. Specifically, I have reconstructed the personalities and careers of some of El Greco's major supporters and have attempted to determine how the artist collaborated with them to produce altarpieces that elucidated their beliefs and that reflected their emotional and spiritual moods.

In order to analyze the factors which affected El Greco's work, I have focused my research upon three major programs. This limited approach has enabled me to reach a more thorough acquaintance with the respective patrons and a greater comprehension of their intentions in commissioning works from El Greco than could have been achieved through a more general survey because until now relatively little was known about these individuals and about the purposes of the important pictorial ensembles which the artist created for them.

Large-scale pictorial programs involving several altarpieces were especially appropriate for the sort of analysis which I proposed to undertake. Contracts and other documents provide at least a minimal amount of concrete information about the patrons, dates, and other historical circumstances of these commissions. Many of El Greco's single paintings are undocumented and, therefore, could not have been related to their original context. With one exception, El Greco's major programs involved a substantial investment of time, money, and creative energy. Therefore,

they must have been carefully conceived by the artist and his patrons. These important undertakings reveal what the artist and his patrons could achieve at their highest levels of intellectual and financial commitment.

El Greco designed six major pictorial programs. Of these projects, only the retable for the parish church of Talavera la Vieja did not include paintings of outstanding quality. This retable seems to have been executed entirely by the workshop – probably because of its relatively low price. Earlier studies exist on El Greco's altarpieces for the Chapel of Saint Joseph and for the Hospital of Charity in Illescas, although further work needs to be done on them.

I have examined the programs which El Greco created for three important institutions: Santo Domingo el Antiguo, Toledo, the church of an ancient and venerated convent of Cistercian nuns; the Seminary of the Incarnation, Madrid, a prestigious Augustinian college for training preachers; and finally, the Hospital of Saint John the Baptist Outside the Walls, Toledo, a general hospital dedicated to providing care for persons of all classes. Although El Greco created some of his most stunning and beautiful paintings for these projects, the commissions had not previously been examined in detail.

These three projects marked important turning points in El Greco's career. The commission for Santo Domingo el Antiguo provided El Greco with his first chance to execute works on a monumental scale and to create an ensemble of several paintings. The opportunity to undertake this project inspired the artist to go to Toledo and established his reputation there.

El Greco may well have regarded his altarpieces for the Seminary of the Incarnation in Madrid as his most important undertaking. Because many members of the royal court frequented the church, these paintings would indeed have had a very prestigious audience. El Greco executed the altarpieces during the period in which he fully evolved his mature expressionistic style, and it seems possible that the requirements of this commission may have influenced this development. The patrons demonstrated their appreciation of the artist's efforts on their behalf by awarding him the highest fee of his career.

The retables for the Hospital of Saint John the Baptist Outside the Walls constituted the artist's final large-scale project. The study of this commission enables us to assess El Greco's method of conceiving pictorial ensembles at the conclusion of his career. The paintings for the hospital included the *Apocalyptic Vision* (fig. 37), one of the most overwhelming and awesome of all his works.

Through the analysis of many published and unpublished sources, I have been able to reconstruct the personalities of El Greco's patrons and other persons who influenced these projects. My eagerness to learn about these individuals has only

grown as I have come to know them better. I particularly hope that I have succeeded in conveying the fascination which these people still hold for me and the affection that I feel for them.

In order to interpret El Greco's altarpieces with the eyes of his contemporaries, it has also been necessary to review Catholic doctrines and beliefs which concerned his patrons. El Greco's religious paintings often seem strange and puzzling today because he visualized religious concepts which are no longer widely understood. The analysis of relevant theological and devotional literature has perhaps been the most difficult part of this study. Sixteenth-century Spanish Catholic theologians and devotional writers generally defended their beliefs by weaving an entangled web of arguments. However, these authors were not trying to mislead or confuse. On the contrary, they intended their careful exploration of every possible thread and hair of each belief to reveal the truth of the Catholic faith and to demonstrate the solid fabric of their Church. Although their lengthy explanations are likely to seem dull and irrelevant today, well-educated Spanish Catholics of the sixteenth century would have read their discussions with absorbed interest. During El Greco's lifetime, even very minor points of doctrine were capable of arousing the deepest emotions of the faithful.

El Greco's ability to visualize his patrons' concerns in dramatic and astonishingly original ways is a true indication of his genius. We can no longer imagine El Greco as a solitary mystic, but we can better appreciate the actual context of his extraordinary endeavors.

CHAPTER 1

SANTO DOMINGO
EL ANTIGUO IN
TOLEDO

El Greco's commission for the altarpieces for the church of the convent of Santo Domingo el Antiguo in Toledo was the first major project of his career. He seized the opportunity to prove his ability to create dramatic paintings on a monumental scale and to unite them into a closely interrelated program. For this commission, El Greco produced four of the masterpieces of his early Toledan period: *The Adoration of the Shepherds* (fig. 4), *The Resurrection of Christ* (fig. 5), *The Trinity* (fig. 6), and *The Assumption of the Virgin* (fig. 9). All of these canvases are distinguished by his mastery of Italian forms and techniques. In conceiving these paintings, El Greco largely depended upon earlier images, but he introduced into all of them original details which greatly enrich their meaning. El Greco also provided designs for the architectural frames of the altarpieces and for statues. This project established the artist's reputation and brought him to the attention of a group of well-educated ecclesiastics whose patronage encouraged him to remain permanently in Toledo.

Don Diego de Castilla (1510/15–1584; fig. 1), Dean of Toledo Cathedral, commissioned the altarpieces as part of his reconstruction of the church of Santo Domingo, which he intended to use as the burial chapel of himself, his son, and Doña María de Silva, a noble lady whose will he executed. Because this commission brought El Greco to Toledo and provided him with the first important opportunity of his career, Don Diego deserves to be considered as one of the major patrons of the Spanish Renaissance. However, he has been overlooked by modern art historians, and García Rey's review of documents associated with Don Diego has thus far been the only lengthy study of the Dean's life and achievements.

Through the analysis of various published and unpublished texts, it is possible to reconstruct Don Diego's career and to comprehend his major concerns and achievements. The study of his life provides the basis for a new interpretation of the program executed by El Greco.

I

The Patron: Don Diego de Castilla

Don Diego de Castilla typified the well-educated and successful ecclesiastics who proved to be El Greco's most important patrons. For thirty-three years, Don Diego held the office of Dean of Toledo Cathedral, second in rank only to the Archbishop. Don Diego thrived on political disputes and throughout his career brought his extensive learning to the defense of the causes to which he was passionately dedicated.

Born between 1510 and 1515, Don Diego was the son of Don Felipe de Castilla, who preceded him as Dean of Toledo.[1] Don Felipe openly acknowledged Don Diego as his child and even obtained from Pope Paul III a special dispensation which legitimized him.[2] Don Felipe's admitted failure to keep his vow of chastity did not prevent him from enjoying a reputation as a pious, diligent servant of the Church. Don Diego paid tribute to his father by building a funerary chapel for him in the church of Santa Clara in Valladolid and establishing a chaplaincy to pray for his soul.[3]

Don Diego's mother has not been identified, but it seems most probable that she was Doña María de Niño de Portugal, for whom he also built a funerary chapel.[4] Doña María de Niño, whom Don Diego usually described as his aunt,[5] had been married to Baptista de Monroy, to whom she bore no children. After her husband's death, she retired to a monastery of Hieronymite monks near Zamora, where she wore the habit of a nun of the Order and demonstrated exemplary piety. (Motherhood does not seem to have tarnished the virtuous reputations of wealthy Spanish widows who retired to cloisters in the sixteenth century.) According to Don Diego, Doña María cared for him in the monastery from the time of his birth. She later supported him during his studies at the University of Salamanca and left him a large bequest in her will.

Her assumption of responsibility for raising him would suggest that Doña María was Don Diego's mother, but more secure evidence for this theory is provided by a document connected with the chapel which he built for her tomb. When the Hieronymite community with whom Doña María had lived moved to the city of

[1] Verardo García-Rey, *El Deán de la Santa Iglesia de Toledo, don Diego de Castilla, y la reconstrucción e historia del Monasterio de Santo Domingo el Antiguo*, Toledo, 1927, 7. This important study was first published as an article of two parts in *Boletín de la Real Academia de Bellas Artes y Ciencias Históricas de Toledo*, 4 (1923), 129–183, and 5 (1925), 28–109. All citations in this study will be to the book edition of 1927.

[2] García-Rey, *Deán*, 10.

[3] (Diego de Castilla), *Historia del Rey Don Pedro, y su descendencia, que es el linaje de los Castillas*. (Written by Gratia-Dei, glossed and annotated by another author), ed. Antonio Valladares, *Seminario erudito*, v. 28, 1790, 267. For manuscript versions of the treatise, see n. 45 below.

[4] García-Rey, *Deán*, 33–34.

[5] See, e.g., Diego de Castilla, *Historia del Rey*, ed. Valladares, v. 29, 1791, 59–61.

Zamora, Don Diego built a chapel for her in the new monastery and made provision for priests to say masses and pray for her soul. In the agreement establishing the chaplaincy, Don Diego stated at one point that masses were to be said there on behalf of his mother, whom he did not name.[6] However, it seems logical to suppose that his mother was Doña María de Niño herself.

Don Diego imitated his father in more than one respect and fathered several illegitimate children, including Don Luis de Castilla, who succeeded him as Dean of Toledo Cathedral. Apparently, the Deanship served as a hereditary office for the Castillas during the sixteenth century. Perhaps because of increasingly conservative moral standards in Toledo, Don Diego did not publicly acknowledge Don Luis as his son in the same manner that Don Felipe had recognized him. Despite the significant difference of thirty-six years in their ages, nearly all authorities until recently had accepted Don Diego's repeated assertions that Don Luis was his stepbrother. However, a document discovered by Dr. Gregorio Andrés proves that Don Luis was indeed Don Diego's son.[7] It seems likely that three young women for whom Don Diego made generous provisions in his will were also his children.[8]

Don Diego was officially appointed Dean of Toledo Cathedral in 1551 and retained the office until his death; he actually began to act in this capacity in 1546 on behalf of his ailing father.[9] As Dean, one of Don Diego's primary responsibilities was to ensure that masses were celebrated in a proper spirit and at appropriate intervals throughout the archdiocese.[10] His duties included the supervision of parishioners as well as their priests. He disciplined boisterous churchgoers and was supposed to prevent anyone other than males of noble rank from entering the choir during the celebration of the Mass.[11] He was also obligated to conduct personally masses at Toledo Cathedral for the most important feasts. In addition, he directed the collection of rents and other monetary benefits accruing to the Cathedral. Undoubtedly, this responsibility, so essential to the economic well-being of the Cathedral, helped to strengthen the Dean's actual political power. As the second-ranking official, the Dean conducted meetings of the Canons when the Archbishop was not present.

Because the Inquisition imprisoned Archbishop Carranza between 1559 and 1576, Don Diego served as effective head of the Cathedral for more than seventeen years. Don Diego's actual authority was limited by the provision that a special Council

6 García-Rey, Deán, 34.
7 I wish to thank Dr. Gregorio Andrés for showing me this document and allowing me to mention it here. Dr. Andrés is preparing a study on Don Luis de Castilla in which this and other important documents will be published.
8 García-Rey, Deán, 56, 62.
9 Richard L. Kagan, 'The Toledo of El Greco,' in J. Brown, et al., El Greco of Toledo, Boston, 1982, 64.
10 Bernardino de Sandoval, Tratado del officio ecclesiastico canonico de Toledo, Toledo, 1568, 153.
11 Sandoval, Tratado, 125–126.

appointed by the Inquisition had to approve all the decisions of the Canons. Nevertheless, the circumstance of Carranza's arrest enabled Don Diego to exercise more power and to enjoy greater prestige than would otherwise have been the case. The widespread mourning which marked Don Diego's death on November 3, 1584, may reflect the esteem which he gained while he supervised the activities of the Cathedral.

During his lifetime, Don Diego was considered a dedicated scholar. He owned a major collection of books,[12] but he does not seem to have been dedicated to scholarship as an end in itself. Rather, he used his knowledge as an instrument to promote his career and as a weapon to defend the causes he favored. In defending his concerns, he did not hesitate to distort facts, and he even forged documents to support his arguments. Don Diego acted consistently as a skilled and dynamic politician, not as a disinterested scholar.

Today, Don Diego de Castilla is best known as the most important opponent of the statute of pure lineage (*estatuto de limpieza de sangre*), which Archbishop-Cardinal Siliceo ardently promoted and which the Canons of Toledo Cathedral approved in 1547.[13] This statute provided that anyone who held an ecclesiastical office or benefice in Toledo had to be descended from a noble 'old Christian' family with no trace of Jewish blood.[14]

The advocates of the statute claimed that all biblical denunciations of immorality exclusively concerned Jews and their descendants.[15] While they did not deny the doctrine of original sin, they did propose that Jews and their descendants had a stain of birth which could not be removed by baptism and which inevitably caused their condemnation. For this reason, they insisted that any persons of Jewish descent would undermine the stability of the Church if they were employed in its service. They also argued that those who had no Jewish or other non-Catholic ancestors enjoyed 'a special gift of God' that enabled them to advance in all courses of faith more than others could.[16]

It has often been presumed that Don Diego opposed the statute simply to protect his own position.[17] The Canons had unsuccessfully challenged his right to act as Dean because of his illegitimate origins, and it is possible that he feared that the new law would lead to attacks on all those whose ancestry could be considered dubious in any respect. Nevertheless, Don Diego's actions cannot be explained only in these terms.

[12] Dr. Andrés has discovered the inventories of the libraries of Don Diego and Don Luis, which he will publish shortly.

[13] García-Rey, *Deán*, 15–16; and Conde de Cedillo, *Toledo en el siglo XVI*, Madrid, 1901, 47–48.

[14] 'Relación de lo que pasó al hacer el Estatuto de Limpieza, Toledo, 1547,' MS. 13.038, Sala de Investigadores, Biblioteca Nacional, Madrid, 3/r–6/r.

[15] 'Relación...1547,' 76/r and *passim*. [16] 'Relación...1547,' 78/r. [17] See, e.g., García-Rey, *Deán*, 15.

Don Diego's opposition to the statute reflects the same mixture of self-interest and genuine concern for others which characterized much of his political activity. The statute might have created difficulties for him, but it certainly posed a greater threat to others. The statute specifically exempted from its provisions all persons currently holding offices, and it did not mention legitimacy as a qualification of future office-holders.[18] The papal dispensation apparently resolved the problem of his illegitimate birth and enabled Don Diego to defeat those who tried to prevent him from fulfilling the duties of Dean. By going against the will of the majority, Don Diego exposed himself to dangers which he probably could have avoided. Even before the statute was ratified by the Pope, Siliceo had declared that those who voted against it were either Jewish or supporters of a Jewish plot to take over the government of the Church, and he initiated action against them.[19] This circumstance might only have served to strengthen the resolve of Don Diego, a bold fighter, always ready to question the pronouncements of his superiors.

Immediately after passage of the statute, the Canons declared invalid Don Diego's vote of opposition and maintained that the Dean had no right to vote in the chapter meeting. Because the Dean was the most important official after the Archbishop, this argument seems hardly credible. Even though the papal bull had recognized Don Felipe de Castilla as Don Diego's father, the victorious Canons even implied that this might not have been the case by referring to Don Felipe as his putative father ('que se dice ser su padre'),[20] whereas they could have named him simply as Don Diego's father.

However, Don Diego was not treated as harshly as the other opponents of the statute, and his actual authority does not seem to have been reduced. The distinct treatment of Don Diego suggests that his position was relatively secure. All of the other canons who voted against the statute were declared to be of Jewish descent and a threat to the Church, and they were forced to resign their positions. One of them, Dr. Peralta, repented of his 'extremely evil statement' that, because of extensive intermarriage, all Spanish families had some Jewish or Moorish blood, withdrew his negative vote, and threw himself at the feet of Siliceo for mercy.[21] He was removed from office and sentenced to life imprisonment for disobedience. That opposition to the statute could be punished in this fashion demonstrates the extent to which the reactionaries dominated the Toledan Church.

At the time of his vote against the statute of pure lineage, Don Diego declared briefly that the proposition would destroy the authority and grandeur of the Church in Toledo.[22] He also probably contributed to the lengthy letter which the Canons

[18] 'Relación...1547,' 5/r. [19] 'Relación...1547,' 27/r–v.
[20] 'Relación...1547,' 28/v. [21] 'Relación...1547,' 30/v–31/r.
[22] 'Relación...1547,' 3/r–6/r.

opposed to the statute sent to the Royal Council in the vain hope that the king or his ministers would intervene on their behalf.[23]

The authors of the letter found the firmest support for their position in the writings of Saint Paul, who promoted the idea that believers became part of a single Christian family and directed criticisms for disobedience against both Gentile and Hebrew Christians.[24] The opponents of the statute envisioned the early centuries of the Church in Toledo as an era of great liberality and pointed out that the most famous ecclesiastics of that time, such as Saint Julian the Doctor, would have been denied office by the statute.[25] According to the letter, the division among the faithful, the political scheming, and the loss of good members of the Church which would result from passage of the statute would necessarily damage the reputation of both Toledo and Spain and lead to Toledo's loss of status as the second most important center of Christianity in the world.[26]

Because of his liberal sentiments on the statute of pure lineage, it is not surprising that Don Diego supported the cause of Siliceo's successor, Archbishop Bartolomé Carranza de Miranda.[27] Carranza opposed the sort of restrictions on ecclesiastical office which Siliceo enacted and strongly favored an 'open Church' responsive to the needs of all its members. He sought to revive the Apostolic spirit of active charitable service and emphasized the obligations of the Church to fulfill all of its spiritual duties and to deal with social problems. Carranza became Archbishop in 1558, and although he had served in this office for less than twelve months before his arrest, he succeeded in instituting some reforms.

The Inquisition imprisoned Carranza on charges that he had promulgated heresies in his *Comentarios sobre el Catechismo christiano*, published in Antwerp in 1558. At the end of a long, infamous inquisitorial process which lasted until 1576, the *Catechismo* was finally prohibited.[28] But the final decision was ambiguous because Carranza was allowed to retain his office. (His death shortly after the end of the trial prevented his resumption of duties.) The final decree stated that the *Catechismo* contained sixteen heretical propositions.[29] Some of these were not actually included in the book; others follow from a literal reading of unfortunately worded sentences removed from context.[30] Tellechea Idigoras's extensive researches

[23] 'Relación...1547,' 48/r–63/v. [24] 'Relación...1547,' 50/v–52/r.

[25] 'Relación...1547,' 52/v. [26] 'Relación...1547,' 52/r–53/r.

[27] José Ignacio Tellechea Idigoras, *El arzobispo Carranza y su tiempo*, 2 vols., Madrid, 1968, 1:80–81.

[28] José Ignacio Tellechea Idigoras, 'El libro y el hombre,' in Bartolomé Carranza de Miranda, *Comentarios sobre el Catechismo christiano* (Antwerp, 1558), ed. by J. I. Tellechea Idigoras, Biblioteca de Autores Cristianos Maior 1–2, 2 vols., Madrid, 1972, 1:43–45. (This essay will henceforth be cited as Tellechea Idigoras, 'El libro.')

[29] Pedro Salazar de Mendoza, *Vida y sucesos prósperos y adversos de don fray Bartolomé de Carranza y Miranda*, ed. by A. Valladares, Madrid, 1788, 164–170. This will henceforth be cited as Salazar de Mendoza, *Carranza*. [30] Tellechea Idigoras, *El arzobispo*, 1:81–99.

on the case against Carranza have shown that his opponents were actually most disturbed by his emphasis on the necessity of charitable works inspired by faith and by his liberal and dynamic interpretation of the Scriptures.[31]

The Inquisition's view of the *Catechismo* was not shared by the Council of Trent. After Carranza's arrest in 1559, the Council passed a resolution describing the *Catechismo* as the most outstanding modern manual of the sacraments of the Church.[32] Carranza had participated in the sessions of the Council of Trent held between 1545 and 1552, and the ideas which he presented in the *Catechismo* are fully in accord with the Decrees of the Council.[33] Today, the *Catechismo* seems to be a detailed explanation and justification of points of doctrine briefly stated in the Decrees. Throughout the *Catechismo*, Carranza supported assertions by referring to the writings of Saint Paul, the early Fathers of the Church, and Saint Thomas Aquinas – precisely the same sources that the Council cited in formulating its positions. More importantly, Carranza deduced from these venerated authorities the same ideas as did the members of the Council. The correspondence between the Decrees and the *Catechismo* is especially remarkable because the Council had not finished formulating its positions when the *Catechismo* was first published. Carranza must have fully comprehended the intentions of the Council in order to produce a treatise which so well elucidated its goals.

On November 21, 1562, Don Diego de Castilla appeared before the Inquisition at Carranza's request and made a strong statement in favor of the Archbishop.[34] Don Diego praised Carranza's orthodoxy, honesty, and zeal in the fulfillment of his duties. Furthermore, he described Carranza as one of the holiest prelates who had ever served Toledo and maintained that among earlier bishops only the deeply venerated Saint Ildefonsus equalled him in piety and saintliness.[35] Don Diego argued that Carranza's imprisonment constituted a great loss to the Toledan Church because during his brief tenure in office he already had done much to ensure that ecclesiastics fulfilled all the obligations of their offices.[36] The Dean astutely contrasted Carranza's efforts with Siliceo's lack of interest in corruption and proposed that Carranza's concern with reform actually prompted his arrest.[37]

Don Diego's defense of Carranza corresponded with the dominant mood in Toledo. Many public manifestations protested Carranza's arrest and expressed widespread popular support for him.[38] Most of the Canons also publicly proclaimed

[31] Tellechea Idigoras, *El arzobispo*, 1:98–99. [32] Tellechea Idigoras, 'El libro,' 1:42.

[33] Tellechea Idigoras, 'El libro,' 1:13, 81–83, 86–96.

[34] José Ignacio Tellechea Idigoras, *Bartolomé Carranza, documentos históricos*, 3 vols., Madrid, 1962–1966, 3:142–149.

[35] Tellechea Idigoras, *Carranza, documentos*, 3:149.

[36] Tellechea Idigoras, *Carranza, documentos*, 3:144–145.

[37] Tellechea Idigoras, *Carranza, documentos*, 3:147. [38] Salazar de Mendoza, *Carranza*, 145–147.

their belief in the innocence of their leader.[39] After Carranza's death, the Canons honored his memory by commissioning a portrait of him for the Chapter House (fig. 2) and a memorial plaque for the Cathedral. The protests against the treatment of Carranza may have reflected patriotic loyalty to the glory of Toledo, rather than commitment to the liberal ideas which he espoused. Most Toledans perceived the arrest of their Archbishop as an attack on the status of their Cathedral as the head of the Church in Spain.[40] Don Diego, who benefited so directly from Carranza's arrest, may have had no choice but to go along with the prevailing sentiments. However, his earlier opposition to the statute of pure lineage suggests that he probably genuinely favored Carranza's goals and his interpretation of the Scriptures.

Despite his involvement in various disputes, Don Diego remained loyal to Toledo as the most important center of Christianity in Spain. A striking and amusing demonstration of this attitude was provided by his response to the efforts of Philip II and his ambassador, Esteban de Garibay, to arrange the transferral of the body of Saint Leocadia from the Benedictine monastery of Saint Gilsen in Belgium to the church dedicated to her in Toledo.[41] Acting as leader of the chapter of Toledo Cathedral, Don Diego insisted that the church of Saint Leocadia in Toledo already contained the authentic remains of this early martyr and that the body in Saint Gilsen was necessarily that of another saint of the same name.[42] For Don Diego, the relics already in Toledo were a treasure which ought to be preserved as a sign of the indubitable grandeur of the archbishopric; to question the authenticity of the remains was to challenge the authority of Toledo. Although Don Diego did not succeed in preventing the transferral of the body from Belgium to Toledo (and the desanctification of the remains already in the city), he seriously delayed the negotiations. Ironically, the Dean's denial of the papal bull declaring that Saint Leocadia had been buried in Belgium revealed the same arrogance and self-righteousness which the proponents of the statute of pure lineage demonstrated when they questioned the Pope's legitimization of him. Apparently, Toledans did not hesitate to question any pronouncement of the Roman Church that might undermine the status of their city.

Like other members of his family, Don Diego labored zealously to establish the descent of the Castillas from King Peter I of Castile (reigned 1350–69), commonly called Peter the Cruel, and to improve the reputation of that king.[43] Don Diego basically followed the arguments which his cousin, Don Francisco de Castilla, had

[39] Tellechea Idigoras, *El arzobispo*, 1:80. [40] Salazar de Mendoza, *Carranza*, 145–147.
[41] García-Rey, *Deán*, 27.
[42] Esteban de Garibay y Zamalloa, *Memorias*, Memorial histórico español, no. 7, Madrid, 1854, 345–347.
[43] García-Rey, *Deán*, 36–39.
[44] Francisco de Castilla, *Practica de las virtudes de los buenos reyes de España y otras obras*, Murcia, 1518, no pagination.

outlined in a long poem, first published in 1518.[44] Don Diego's efforts to document his ancestry constitute the least attractive aspect of his career because he distorted evidence in order to support his assertions. Nevertheless, his concern for his ancestry must be understood within the context of a society that increasingly emphasized lineage as the primary criterion of worth.

Don Diego's genealogical claims were promoted in a lengthy history of King Peter and his descendants, which was widely distributed in manuscript form although it was not published until 1790.[45] The chronicle is composed of two basic parts: a text, detailing the achievements of King Peter and his descendants, and a gloss, presenting documentary evidence and other proof for many of the assertions made in the text. The Dean insisted that he was responsible only for the gloss and the accounts of his father and himself and that Gracia-Dei, the official chronicler of the Catholic Kings, wrote the main text. However, it is virtually certain that Don Diego composed the entire treatise and attempted to increase its prestige by assigning the text to Gracia-Dei. In the seventeenth century, Luis de Salazar and Sancho Hurtado de la Fuente already suggested that Don Diego or Don Luis de Castilla wrote the entire treatise, although many subsequent historians accepted the attribution to Gracia-Dei.[46]

The attribution of the entire treatise to Don Diego is supported by an objective analysis of its style and a comparison of it with authentic writings of Gracia-Dei. There are no marked differences in style either between the text and the gloss or between the earlier and later sections of the manuscript. Throughout the treatise, claims are presented forcefully and passionately and are substantiated by subjective analysis of selected passages of relevant documents. The manner of argumentation is remarkably similar to that found in the letter sent to the Royal Council by the Canons opposed to the statute of pure lineage.

The style of the author of the treatise was very different from that of Gracia-Dei, who presented his ideas in simple declarative sentences and avoided the more ornate and complicated phrasing found in the chronicle. Gracia-Dei's most important published work, *Genealogía universal*, is largely a factual, unimpassioned record written in a concise, unadorned style.[47] Throughout his writings, Gracia-Dei devoted a great deal of attention to the evolution, meaning, and accurate representation of heraldic devices. Therefore, a strong argument against his authorship of the

[45] Several of the manuscript versions are preserved in the Biblioteca Nacional, Madrid.
 [Diego de Castilla,] *Historia del Rey Don Pedro y su descendencia, que es el linaje de los Castillas*, MS. 628, MS. 18.732(27), MS. 10.640, MS. 10.419, MS. 1.652, Sala de Investigadores, Biblioteca Nacional, Madrid. The published version is cited in full in n. 3 above.

[46] Don Rafael de Floranes, *Vida literaria del Canciller mayor de Castilla, don Pedro Lopez de Ayala*, Colección de documentos inéditos para la historia de España, tomo 19, Madrid, 1851, 80.

[47] Gracia-Dei, *Genealogía universal*, Seville, 1515. The Sala de Investigadores, Biblioteca Nacional, Madrid, has a collection of unpublished manuscripts by Gracia-Dei, nearly all concerning genealogical matters.

treatise is that it does not even mention the arms of any of the families discussed. Gracia-Dei loyally served the Catholic Kings and at no point questioned the established order. It is difficult to imagine him preparing a treatise that attempted to prove that the descendants of King Peter had been unjustly deprived of the throne.

In seeking to vindicate the memory of King Peter, Don Diego argued that supporters of Peter's brother Henry, who usurped the throne, had written most of the preserved accounts of Peter's reign and that these authors had lied in order to glorify their master. Don Diego further claimed that Juan de Castro, Bishop of Osma, had secretly written a chronicle which vindicated Peter's reign. Gerónimo Zurita, with whom Don Diego corresponded concerning these matters, doubted that the mysterious chronicle by Juan de Castro existed and refused to accept its supposed contents without seeing it.[48] The Dean insisted that it had been preserved for many years at the Hieronymite monastery of Guadalupe.

Don Diego must have found it difficult to prove the goodness of Peter. Whether or not Peter deserved the name Cruel, his reign was a period of civil war, turmoil, and widespread suffering.[49] Under these circumstances, it is not surprising that Don Diego largely focused his arguments upon the will which Peter prepared at the age of twenty-six or twenty-seven.[50] The Dean maintained that Peter's appeal to God and Mary for mercy, which followed standard practice, proved his deep Christian piety. Further, the Dean argued, the grand scale of the king's provisions for his entombment reflected extraordinary faith in the Church. Peter ordered that a burial chapel be built for himself, his mistress Doña María de Padilla, the Infante Don Alonso, and other of his relatives in the church of Santa María in Seville and provided for twelve chaplains to pray for their souls continuously.[51] In addition, Peter made several other donations to religious institutions for the sake of his soul.[52]

Don Diego's praise of the king's funerary arrangements revealed his belief that these fully and accurately reflected the quality of a Christian's life and spirit.[53] Don Diego considered Peter's lavish patronage of his burial chapel as the model for his own disbursement of nearly all his income on chapels for his parents and himself. Don Diego also seems to have tried to imitate some of the details of Peter's funeral.

[48] Gerónimo Zurita y Castro, *Emiendas y advertencias a los cronicas de los reyes de Castilla, D. Pedro, D. Enrique el Segundo, D. Juan Primero, y D. Enrique el Tercero*, ed. Diego Josef Dormer, Zaragoza, 1685. 'Razon desta obra,' no pagination, and 283–296 present Zurita's arguments against Don Diego's claims. Letters from Don Diego to Zurita (July 3, 1570, and September 12, 1570) and Zurita's replies (July 20, 1570, and September 20, 1570), which are particularly useful, are reprinted in 'Razon desta obra.'

[49] Luis Suárez Fernández, 'Pedro I el Cruel,' in German Bleiberg, ed., *Diccionario de historia de España*, 3 vols., Madrid, 1969, 3:199–200.

[50] Diego de Castilla, *Historia del Rey*, ed. Valladares, v. 28, 1790, 240.

[51] Diego de Castilla, *Historia del Rey*, ed. Valladares, v. 28, 1790, 246.

[52] Diego de Castilla, *Historia del Rey*, ed. Valladares, v. 28, 1790, 246–247.

[53] Diego de Castilla, *Historia del Rey*, ed. Valladares, v. 28, 1790, 239.

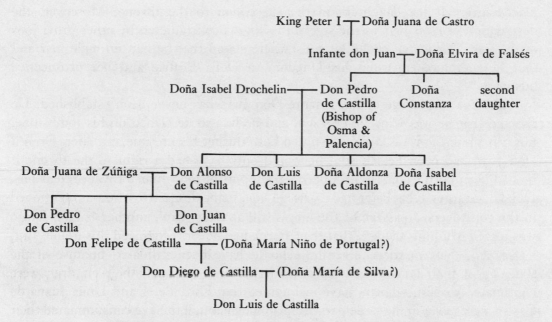

Genealogical table for Don Diego and Don Luis de Castilla.

King Peter's declaration that he was to be buried in the habit of an ordinary Franciscan monk can be related to Don Diego's requests that he be given the funeral of a simple parish priest with no marks of his high office and that Franciscan friars carry his body to his tomb.[54]

Don Diego maintained that he was a direct fourth-generation descendant of King Peter, according to the scheme which I have outlined in the genealogical table. To support his claims, Don Diego first of all had to try to establish that the Infante Don Juan, from whom the later Castillas were supposed to have descended, was the legitimate son of King Peter. Don Diego's primary evidence was a single sentence in the will of King Peter. This passage described Don Juan as Peter's son by Doña Juana de Castro and stated that he was to inherit the throne if the king's three daughters and all their children had died.[55] To the naked eye, it is evident that the line of the will which mentions Don Juan has been changed,[56] perhaps by the Dean himself, as the sixteenth-century scholar Zurita already surmised.[57] The reference to Don Juan in the will hardly constitutes definitive proof of his status. If Don Juan had been the king's legitimate son, it seems improbable that he would have been

[54] Diego de Castilla, *Historia del Rey*, ed. Valladares, v. 28, 1790, 240; García-Rey, *Deán*, 55–56. Don Diego's grandfather, Don Alonso, and his father, Don Felipe, also favored the Franciscan Order.

[55] Diego de Castilla, *Historia del Rey*, ed. Valladares, v. 28, 1790, 241.

[56] See García-Rey, *Deán*, plate 2.

[57] Zurita, *Emiendas y advertencias*, 285.

placed after all the daughters in the succession to the throne. Moreover, the designation of Don Juan as the son of the king is contradicted by other provisions of the will. For instance, the king elsewhere stated that he had no male heir and that he therefore entrusted his kingdom to Doña Beatriz and her prospective husband.[58]

The actual parentage of the Infante Don Juan has never been established. He claimed that he was King Peter's son, and he was so described on his tombstone, but this pretension was widely disputed both during his lifetime and later. Even if Don Juan had been Peter's son, he would only have had a right to the throne if he had been born to the lawful queen. In support of Don Juan's royal pretensions, Don Diego argued that Peter had married Doña Juana de Castro, who was mentioned in the controversial passage of the king's will as Don Juan's mother.[59] Don Diego was forced to admit, though, that the Church had never recognized this union. But, he argued, their marriage ceremony should have been validated because of the sincerity of their commitment to one another and, thus, all their children were legitimate. Modern scholars have maintained that King Peter and Doña Juana de Castro were never in the same part of Spain long enough to have consummated their supposed marriage.[60]

Don Diego continued his account of the descendants of King Peter by claiming that Don Pedro, Bishop of Osma, was the son of the Infante Don Juan. Once again, Don Diego had to base his arguments on shaky premises. Contemporary sources indicate that Don Juan, who spent many years of his life in prison, had three children but record the name only of Doña Constanza, prioress of the convent of Santo Domingo el Real in Madrid.[61] However, Don Diego maintained, the bishop was the son of Don Juan by Doña Elvira de Falsés, who supposedly married him and somehow managed to visit him regularly in jail.[62] Whatever his origins, Don Pedro enjoyed the special protection of Queen Catherine, wife of King Henry, who had assumed the throne after defeating his brother Peter. Through her influence, Don Pedro obtained various ecclesiastical honors, including the bishoprics of Osma and Palencia.

Don Pedro really provides the starting point of Don Diego's certain ancestry. Don Pedro's children – including the eldest, Don Alonso de Castilla, Don Diego's grandfather – were legitimized by the king. Don Felipe, Don Diego's father, was the second son of Don Alonso, who had participated in the final stages of the reconquest of the peninsula.

[58] Diego de Castilla, *Historia del Rey*, ed. Valladares, v. 28, 1790, 258–260.
[59] Diego de Castilla, *Historia del Rey*, ed. Valladares, v. 28, 1790, 240–241; see also Zurita, *Emiendas y advertencias*, 280.
[60] See, e.g., García-Rey, *Deán*, 39. [61] Zurita, *Emiendas y advertencias*, 285.
[62] Diego de Castilla, *Historia del Rey*, ed. Valladares, v. 28, 1790, 258–260.

Faith in the veracity of the material which Don Diego assembled would culminate in the conclusion that a member of the Castilla family should be king. Of course, Don Diego did not state the royal pretensions of his family so directly because to do so would have constituted treason. Nevertheless, his assertions concerning his ancestry were certainly intended to promote this assumption. Clearly, Don Diego interpreted the overthrow of King Peter as an unjust action which had deprived his family of its rightful position. According to the information which Don Diego presented, his uncle, Don Pedro de Castilla, would have been the heir to the throne if King Peter had not been deposed and if the rights of the Infante Don Juan and his descendants had been recognized.

The belief that under different historical circumstances a close relative would have governed Spain explains why the treatise on King Peter was Don Diego's longest and most detailed written work. Today, using objective methods of analysis, it is easy to perceive that Don Diego's claims had virtually no factual basis. However, his commitment to this cause cannot be doubted.

Don Diego's proposed lineage does not seem to have been accepted outside his family. But his efforts to improve the reputation of Peter the Cruel may have influenced the favorable estimations of the king's rule by Toledan writers of the second half of the sixteenth century. In the *Flos Sanctorum*, Alonso de Villegas declared that accounts of Peter's cruelty were entirely unfounded.[63] Salazar de Mendoza defended the reign of Peter in his history of Spanish nobility.[64]

Lack of public recognition of his ancestral claims did not diminish Don Diego's commitment to glorifying the heritage of his family. Indeed, it seems likely that his reconstruction of Santo Domingo was at least partly intended to promote this cause.

The Institution: Santo Domingo el Antiguo

Santo Domingo de Silos, commonly called *el Antiguo*, is a convent of cloistered Cistercian nuns who still retain the strict rules of their original foundation.[65] During

[63] Alonso de Villegas, *Flos Sanctorum y historia general de la vida y hechos de Iesu Cristo y todos los santos de que reza y haze fiesta en la Yglesia Catholica*, rev. ed., Madrid, 1588, 336/v. This edition of the *Flos* will be cited as Villegas, *Flos*, 1588.

[64] Pedro Salazar de Mendoza, *Origen de las dignidades seglares de Castilla y Leon*, Madrid, 1657, 105/r–109/v. Henceforth cited as Salazar de Mendoza, *Dignidades*.

[65] Nearly all modern art historical studies incorrectly describe the convent as Bernardine. This error may have originated because Saint Bernard of Clairvaux was one of the founders of the Cistercian Order. However, the Bernardines constitute a distinct order with an independent government.

The Bernardines originated in the late sixteenth century as a reformation of the Cistercian Order, which in turn had developed as a reformation of the Benedictine Order in the twelfth century. Although many Spanish Cistercian monasteries became Bernardine, the order never received the support of many Spanish nuns; and only two convents of nuns joined this reformation. Nevertheless, the Bernardines influenced

the sixteenth century, it was regarded as one of the most holy and ancient religious institutions of the city. In his history of Toledo published in 1554, Alcocer described Santo Domingo as 'very ancient and Catholic' and claimed that it deserved special veneration because it was the first convent founded in Toledo.[66] In his monumental history of the Benedictine Order, Yepes maintained that Santo Domingo el Antiguo was not only the oldest convent in Toledo but one of the oldest in all of Spain.[67]

The exceptional status of Santo Domingo el Antiguo was due in large measure to the widespread belief that it had been founded in the seventh century by Saint Ildefonsus. Many sixteenth- and seventeenth-century writers maintained that Saint Ildefonsus had belonged to the Benedictine Order (from which the Cistercian Order grew) and that he had converted houses owned by his family on the present site of Santo Domingo into a convent for nuns of the Order.[68] These authorities insisted that the convent established by Saint Ildefonsus was to be identified with Santo Domingo el Antiguo, even though it was suppressed during the period of Moslem rule. They also conceded that the original convent must have borne a different name because Saint Dominic of Silos is first recorded in 1063, when he joined the Benedictine Order. The belief that Ildefonsus founded Santo Domingo would certainly have appealed to Don Diego, who considered the Archbishop one of his patron saints and whose intervention before God he invoked for the salvation of his soul.[69]

The later history of the convent is most important to understanding Don Diego's intentions in rebuilding the church and in using its presbytery as his burial chapel. The convent was favored by the royal ancestors of King Peter, from whom Don Diego claimed descent. After the reconquest of Toledo from the Moors in 1085, Alfonso VI re-established the convent originally founded by Ildefonsus, dedicated it to Saint Dominic of Silos, and entrusted it to a community of Benedictine nuns[70] who joined the Cistercian Reform of the Benedictine Rule in 1140.[71] Alfonso's successors granted the convent many privileges. For instance, Alfonso X (1252–84) assigned the convent the rents of several properties; and Ferdinand IV (1295–1312),

Cistercian nuns because Bernardine friars frequently served as the priests of Cistercian nunneries. (Both the Cistercian and Bernardine Orders claim strict observance of the Rule of Saint Benedict.)

For an excellent concise review of the history of both the Cistercians and the Bernardines in Spain, see E. Martín, *Los Bernardos españoles*, Palencia, 1953.

[66] Pedro de Alcocer, *Hystoria o descripción de la Imperial ciudad de Toledo*, Toledo, 1554, cii/v–ciii/r and cxvii/r.

[67] Fray Antonio Yepes, *Cronica general de la orden de San Benito, patriarca de los religiosos*, 7 vols., Real de Yrache and Valladolid, 1609–1621, 1:188/v.

[68] Alcocer, *Hystoria*, cii/v–ciii/r; Yepes, *Cronica general*, 1:188/v; Pedro Salazar de Mendoza, *El Glorioso Doctor San Ildefonso, Arçobispo de Toledo, Primado de las Españas*, Toledo, 1618, 177–178.

[69] García-Rey, *Deán*, 54.

[70] Alcocer, *Hystoria*, cii/v–ciii/r; Yepes, *Cronica general*, 6:369/v; Salazar de Mendoza, *Ildefonso*, 178.

[71] Luis Moreno Nieto, *Guía de la Iglesia de Toledo*, Toledo, 1975, 193.

Peter's grandfather, exempted the nuns from the payment of any sort of taxation or tribute.[72] Several members of the royal family were buried in Santo Domingo. The tombs of the Infante Don Alfonso, son of King Ferdinand III the Holy (1217–52), and the Infantes Don Juan and Don Miguel, sons of Alfonso X, were located in the presbytery near the main altar.[73] Among those buried elsewhere in the church were Doña María, wife of Alfonso X, and a nephew of Ferdinand III.[74] Although Santo Domingo retained its prestige as an ancient convent, it did not receive comparable favors from the families who ruled Spain after the death of Peter. Indeed, its connection with the earlier dynasty probably discouraged later monarchs from granting it special privileges.

It seems probable that Don Diego's concern with establishing his descent from the line of kings that ended with Peter inspired his lavish patronage of Santo Domingo. In directing that the church be entirely rebuilt, he was imitating Alfonso VI, who constructed the convent after the reconquest. Moreover, Don Diego affirmed his status as a descendant of the royal house by placing his tomb in the presbytery, near the main altar, where three Infantes had previously been buried. Although Don Diego mentioned himself only briefly at the conclusion of his treatise on the Castilla family, he presented his own case for descent from a line of kings very forcefully indeed through the establishment of his burial chapel. The circumstances of the project will be examined in the next section.

The Opportunity to Reconstruct Santo Domingo

Don Diego utilized his authority as executor of the Estate of Doña María de Silva (d. 1575) to obtain the right to reconstruct the church of Santo Domingo and to use its presbytery as a burial chapel for himself, his son, and Doña María. Doña María had neither requested burial in Santo Domingo nor provided for the construction of a new chapel, let alone an entire church. However, Don Diego skilfully manipulated a number of circumstances to realize his goal of creating a conspicuous monument glorifying his memory and the heritage of his family.

Doña María de Silva, a Portuguese lady-in-waiting to the Empress Doña Isabel, was renowned for both beauty and virtue.[75] Her father, Don Juan Saldaña, served

[72] García-Rey, *Deán*, 69.

[73] Yepes, *Cronica general*, 6:370/r; Pedro Salazar de Mendoza, *Cronica de el gran Cardenal de España, Don Pedro Gonçalez de Mendoça*, Toledo, 1625, 374. The last-named source will henceforth be cited as Salazar de Mendoza, *Mendoça*. [74] Salazar de Mendoza, *Mendoça*, 374.

[75] García-Rey, *Deán*, 71–73; Luis Salazar y Castro, *Historia genealógica de la casa de Silva*, 2 vols., Madrid, 1685, 1:256.

Doña María is considered to have been of distinguished lineage, but her ancestry has not yet been traced very far back. Salazar y Castro's definitive study of the house of Silva mentions her only as the lady-in-waiting to the empress, although Salazar traces the ancestry of her husband in some detail.

the Empress as an overseer and managed many of her financial affairs. When Doña Isabel married Charles V in 1526, Doña María accompanied her mistress from her native Portugal to the court of Castile. In 1528, the monarchs arranged Doña María's marriage to Don Pedro González de Mendoza, steward of Charles V, principal accountant of tributes, and knight of the Order of Santiago. At this time, Charles V and Isabel endowed the couple with the rents of several properties and gave them other privileges. After her marriage, Doña María often resided in Cuenca, her husband's native town, where he died in 1537.

In 1538, when the court was resident in Toledo, the Empress Isabel ordered Doña María to take up residence in the convent of Santo Domingo. Gossip of the time ran that Doña María's great beauty inspired the Empress to send her to a convent because she did not want to be attended by one whose physical charms so greatly exceeded her own.[76] The widowed Doña María refused the several distinguished offers of marriage which the Empress subsequently arranged on her behalf and chose to live for the rest of her life in a private apartment in the cloisters of the convent. Although she never took the vows of a nun, she wore the habit of the Cistercian Order and demonstrated exemplary piety. She was considered especially zealous in her devotion to the Eucharist and received Communion daily.[77]

In deciding not to remarry and to devote herself to contemplation and worship, Doña María exemplified the behavior established as proper for widows by contemporary religious authors. For example, Bernardino de Sandoval, a Canon of Toledo Cathedral, maintained that both the Bible and the Doctors of the Church had proved that widows had a special obligation to lead devout lives, to withdraw from the secular world, to attend Mass frequently, and to pray more than other women.[78] The Dean's provision that Doña María's tomb be always draped with a black cloth[79] may have been intended to commemorate her fulfillment of the ideal of Christian widowhood.

In her will of October 26, 1575, Doña María requested that her tomb be built in the principal chapel of the conventual church of Madre de Dios in Toledo.[80] She specified that no other person was to be buried in the chapel and that her family arms were to be the only ones displayed in it.[81] The income derived from her properties was to pay for the establishment of a chaplaincy to pray for her soul.

[76] Salazar y Castro, *Historia genealógica*, 1:256. Cf. García-Rey, *Deán*, 72.
[77] Cedillo, *Siglo XVI*, p. 107, n. 37. [78] Sandoval, *Tratado*, 141–142.
[79] García-Rey, *Deán*, 77. [80] García-Rey, *Deán*, p. 73, n. 1.
[81] The will of Doña María de Silva included the following provision:

That they [the nuns of the convent of Madre de Dios] are to give her the Chapel and that it is to be eternally the property of Doña María; that located in it will be the tomb and the arms of the Silvas which are those of the said lady; that nobody [else] will be allowed to be buried in it, nor will anyone be allowed to put inscriptions on the walls; that in it [the chapel] and by the chaplains will be said as many masses, vigils, and feasts as the Dean provides; that the convent is obligated

Because of her long residence in Santo Domingo, it is surprising that Doña María decided to be buried in Madre de Dios. The association of Madre de Dios with the memory of one of the most distinguished persons of the Silva family may have influenced Doña María to establish her funerary chapel there. Doña Beatriz de Silva, founder of the Order of the Conception, had established Madre de Dios as one of the first convents of this order and was buried within its walls.[82] All of the Silvas claimed the same ancestry, so there would have been a link between these two women even though the available genealogical information does not indicate a close family connection.[83]

In accord with her wishes, Doña María was buried at Madre de Dios shortly after her death. However, Don Diego quickly took advantage of several factors to obtain the transferral of her body to Santo Domingo on February 6, 1576.[84] For one thing, the officials of Madre de Dios were dissatisfied with several provisions of Doña María's will and were unwilling to devote the entire principal chapel solely to her tomb. In addition, the nuns at Santo Domingo wanted to have returned to them the remains of one who had lived so long in their midst. Therefore, Don Diego claimed to be fulfilling the wishes of both convents when he ordered the removal of her body to Santo Domingo. It seems likely that the nuns at Santo Domingo did not yet realize the Dean's actual intentions because they subsequently opposed his plans for rebuilding the church and acquiesced to the project only after he had brought to bear on them the pressure of other leading Toledan ecclesiastics. Don Diego must have already decided to rebuild the church by February 6 because work was begun on this project less than three weeks later, on February 26.

In publicizing his plans for the reconstruction of Santo Domingo, Don Diego claimed to be acting selflessly on Doña María's behalf.[85] In his petition to the Council of the Inquisition, which had to approve all major undertakings in the archbishopric during Carranza's imprisonment, the Dean cited the necessity of creating a burial place worthy of the devout Doña María as his sole motivation. He

to sing and recite the offices [for] assigning to it the gift of 50 thousand *maravedís* of rents and tribute established by Doña María over the testamentary estates of the city of Requena, and finally, that in the Sacristy all the ornaments will be preserved.

Que le dén la Capilla mayor y que fuese siempre propria de Doña María; que se ponga en ella un túmulo y las armas de los Silva que son las proprias de dicha Señora; que nadie se pudiera enterrar en ella, ni poner en las paredes inscripciones; que en ella y por los capellanes se digan cuantas misas, vigilias y fiestas que el Deán ordenara; que el convento se obligue a cantar y decir los oficios asignandole la dote de 50 mil mrs. de juro situados por Doña María sobre las alcabalas de la villa de Requena, y por último, que en la Sacristía se guardaran todos los ornamentos.

García-Rey, *Deán*, 73. In this, and in all other citations, I have retained the spelling and punctuation of the original texts.

[82] Salazar y Castro, *Historia genealógica*, 2:33–39.
[83] Salazar y Castro, *Historia genealógica*, Introduction, no pagination. Arturo García Carrafa, *Enciclopedia heráldica y genealógica*, Madrid, 1960, v. 84, 183–186.
[84] García Rey, *Deán*, 74–76. [85] García Rey, *Deán*, 74–76.

stated that Doña María's funds were inadequate to pay for the project and declared that he intended to finance it entirely himself, but he did not indicate that he was also going to construct a monument for himself in the church. It is impossible to establish with certainty exactly when Don Diego decided to build the tombs for himself and his son in the presbytery, but it seems most probable that he intended to do so from the beginning of the project. In any case, by the end of 1579, the monuments for Don Diego and Don Luis had been completed on the Gospel side of the main chapel, directly opposite Doña María's tomb on the Epistle side.

In carrying out the reconstruction of Santo Domingo, Don Diego violated several important provisions of Doña María's will. Most obviously, he disregarded her request to be buried in Madre de Dios. He also ignored her stipulation that nobody else was to be buried in her funerary chapel. In his own will, Don Diego claimed that Doña María had granted him an exemption from this order,[86] but no support for his assertion can be found in her will. Doña María wanted only the arms of the Silva family to be displayed in her funerary chapel[87] and, in his petition to the Council of the Inquisition, Don Diego asserted that he intended to honor her request.[88] However, the arms of the Castillas were prominently displayed on the choir screen and in the main chapel, and those of the Silvas were represented only in the nave.

Don Diego's provisions for the government of Santo Domingo show the same combination of professed respect for Doña María's memory and apparent self-interest that was evident in his handling of other matters. The Dean began the ordinances which he established for the convent with the declaration that Santo Domingo was to be perpetually the property of Doña María de Silva.[89] This statement accorded with her wish that the convent housing her tomb always honor her memory. However, Don Diego did not give any known members of the Silva family a role in the government of the convent. Instead, he appointed his son, Don Luis, and his lifelong associate, the Reverend Don Francisco de Huerta, as patrons of the institution.[90]

In reviewing the political manoeuvres involved in the construction and decoration of the chapel, it is easy to lose sight of its essential spiritual function of promoting the salvation of those buried in it. Actually, even the prominent location of the chapel and its lavish scale and decoration were related to this purpose because they were intended to inspire worshippers to remember the dead buried there and to offer prayers on their behalf. In accord with traditional Christian practice, Don Diego funded chaplaincies to celebrate masses at Santo Domingo for the repose of the souls

[86] García Rey, *Deán*, 55.
[88] García Rey, *Deán*, 77.
[90] García Rey, *Deán*, 76.

[87] García Rey, *Deán*, 73.
[89] García Rey, *Deán*, 76.

of himself and Doña María.[91] Amusingly, he placed his own interests ahead of Doña María's even in this regard. He provided for seven priests to say masses in his own memory, but only for six to intercede on behalf of Doña María.

Don Diego's establishment of a burial chapel with its own chaplains reflected the emphasis placed by the Tridentine Church upon preparing for death in this way.[92] Don Diego's colleague, Bernardino de Sandoval, expounded at length upon the benefits conveyed by masses in memory of the dead and argued that masses and prayers were required to liberate souls from Purgatory and to enable them to enter heaven.[93] In constructing monuments and funding chaplaincies for others, Don Diego further promoted the health of his soul because, according to Sandoval, those who cared for others in this fashion received special benefits when they died.[94]

One of the most controversial aspects of the undertaking was probably the Dean's insistence upon building the tombs in the presbytery near the main altar. Many contemporary ecclesiastics opposed this practice, and later in the sixteenth century, Cardinal Quiroga formally prohibited it in Toledan churches.[95] However, Sandoval's treatise could have been used to support Don Diego's actions. Sandoval claimed that burial near the main altar was an honorable practice of the Early Church, and he recommended that it be revived because it inspired Christians to pray for the dead. His description of burial near the main altar as a privilege to which kings and their descendants had a special right[96] may have influenced Don Diego, who devoted so much energy to proving his descent from King Peter.

Finally, it seems appropriate to inquire why Don Diego chose to combine his own burial chapel with that of Doña María. Obviously, he found his role as the executor of her estate a convenient means of obtaining burial for himself in one of the most prestigious churches in Toledo and one, moreover, linked to the memory of his supposed royal ancestors. However, the Dean's decision to locate the tombs of himself and his son opposite that of Doña María presupposes some special relationship among these people. In fact, the arrangement of the tombs suggests that Doña María was the mistress of Don Diego and the mother of Don Luis. The existence of an amorous relationship between Don Diego and the beautiful Doña María would explain her appointment of him as the executor of her estate, his profound interest in her tomb, and the freedom with which he changed her original

[91] García Rey, Deán, 77.

[92] The Council of Trent, The Canons and Decrees of the Sacred and Ecumenical Council of Trent, trans. J. Waterworth, London, 1848, Session 22, 152–161. (This edition will henceforth be cited as Trent.)

[93] Sandoval, Tratado, 50–51.

[94] Sandoval, Tratado, 50.

[95] Gaspar de Quiroga, Constitutiones sinodales hechas por el illustrissimo y reverendissimo Señor, D. Gaspar de Quiroga, Madrid, 1583, 46/r.

[96] Sandoval, Tratado, 108–109.

proposals. If Don Diego had been trying to create a family chapel, some of his modifications of her requests would seem less arrogant than they have done. The exclusive use of the arms of the Castillas in the presbytery might have been intended as a clue to the true character of the chapel. Moreover, if Don Luis were Doña María's son, his appointment as patron of the institution would actually have helped to preserve it as her property in perpetuity.

The Selection of the Architects and Artists and their Contributions

The zeal with which Don Diego undertook the construction and decoration of the new church of Santo Domingo is attested by the remarkable speed with which it was completed. Ground was broken for the new building on February 26, 1576, and it was ready for use three years and seven months later. The Dean celebrated the first mass in the new church on September 27, 1579, in the presence of many of Toledo's religious and political leaders. To design and execute the project, Don Diego enlisted the services of the most advanced contemporary artists whom he could afford. The architects, artists and craftsmen whom he employed together created a building harmonious in form and decoration.

The leading architect of the region, Nicolás de Vergara, the director of construction of Toledo Cathedral and supervisor of public works in the city of Toledo, provided the first plans for the church, which Don Diego accepted on March 10, 1576.[97] Vergara created an austere, monumental and beautifully proportioned structure which clearly showed the influence of the Escorial, undoubtedly the most important building constructed in Spain during the sixteenth century. It seems likely that Don Diego encouraged Vergara to imitate the style of the royal monastery because he later tried to involve its architect, Juan de Herrera, in the rebuilding of Santo Domingo. On August 10, 1576, the Dean announced that Herrera was replacing Vergara as architect and was going to provide new plans for the church. In reality, Herrera confined himself to making a few minor changes in Vergara's plans and took no further interest in the project. Vergara continued to supervise construction but did not receive official credit for the design. Don Diego probably described Herrera as the architect because of the prestige which the name of the king's architect would confer upon the undertaking.

Don Diego also sought to emulate royal patronage by obtaining the services of a painter associated with the Italian school. However, he could not have afforded to follow Philip's practice of employing artists who had already gained fame in their native land. Instead, Don Diego obtained the services of El Greco, who was little known in Rome outside a small circle of scholars and connoisseurs associated with

[97] García Rey, *Deán*, 81–87, remains the best analysis of the history of the construction of the church.

the Farnese Palace, including the librarian Fulvio Orsini and the painter Giulio Clovio. With his characteristic disregard for truth, Don Diego advertised the imminent arrival of El Greco in Spain by claiming that he was one of the most famous artists in Italy. Although economic circumstances restricted the Dean's choice, subsequent generations have recognized that El Greco was a greater painter than any of those who worked at the Escorial.

Don Diego entrusted the task of finding an artist to his son Don Luis, who was studying in Italy in 1576.[98] Don Luis, who shared his father's interest in Church reform, must have understood Don Diego's requirements quite well.[99] Pedro de Chacón, a distinguished Toledan scholar who accompanied Don Luis in Italy, probably introduced him to Fulvio Orsini, an intimate friend, and to others associated with the Farnese Palace, where El Greco was living. In El Greco, Don Luis found an artist who was at once willing to go to Spain and able to express beliefs and complex ideas in a clear, dramatic and thoroughly contemporary Italianate style. Don Luis and El Greco signed in Rome the first contract for the altarpieces at Santo Domingo, and this commission directly motivated the artist's voyage to Spain, whatever may have been his hopes of obtaining royal patronage there.[100] It would be tempting to posit that Don Luis's action on behalf of his father demonstrated extraordinary perception on his part. But Don Luis's choice of El Greco probably resulted from a fortuitous combination of circumstances.

For El Greco, Don Luis's proposal was a great opportunity. Because of intense competition and prejudice against foreign artists, he had not succeeded in obtaining any monumental commissions in Rome and had to confine himself to small-scale works. If El Greco had not been called to Spain, he might never have been able to reveal the full scope of his talents.

While living at the Farnese Palace, El Greco had been exposed to the movements for reform both in the Church and in the art produced for it. This experience probably helped to prepare him to serve the Toledan ecclesiastics, who were committed to spiritual reform and who sought an artist capable of visualizing their concerns. El Greco may have been especially influenced by the ideas of Giovanni Andrea Giglio, who helped to shape the artistic patronage of Cardinal Farnese. In his treatise, *Degli errori e abusi dei pittori circa l'historia* (Camerino, 1564), Giglio maintained that painters should represent essential doctrines and key events of

[98] Francisco de Borja San Román y Fernández, 'Documentos del Greco, referentes a los cuadros de Santo Domingo el Antiguo,' *Archivo español de arte y arquelogía*, 10 (1934), 2–4.

[99] On Don Luis de Castilla, see Nicholas Antonio, *Bibliotheca hispana nova*, 2 vols., Madrid, 1788, 2:229, and the forthcoming study by Gregorio Andrés. Don Luis explained his views on Church reform in a treatise preserved in manuscript form: 'Sobre el estado ecclesiastico,' 1604, MS. 945 (pp. 101–132), Sala de Investigadores, Biblioteca Nacional, Madrid.

[100] San Román, 'Santo Domingo,' 2–4.

Christian history in a clearly legible, theologically accurate and emotionally effective manner.[101] The numerous versions of Christ's Expulsion of the Money-Changers from the Temple which El Greco created during his Roman period exemplify his depiction of themes of a Counter-Reformation character in accord with Gilio's recommendation.

Despite their small scale, the outstanding paintings of El Greco's Roman years, such as the magnificent *Pietà* now at the Hispanic Society of America (c. 1574–76), have many of the qualities which characterized his work at Santo Domingo. The strongly three-dimensional, tightly knit group has a monumental force that exceeds the limits of the small scale. Through emotionally charged facial expressions and subtle but effective gestures, the artist vividly conveyed the tragedy of Christ's death and Mary's immense sorrow. The pyramidal composition of the *Pietà*, its Michelangelesque figures and beautiful Venetian coloring lead directly to the *Trinity* for Santo Domingo. The continuity between the Roman work and the paintings for Santo Domingo suggests that Don Luis admired El Greco's Roman work and that he encouraged the artist to develop the style which he had already begun to formulate in Italy.

Preserved documents indicate that Don Diego supervised both the style and content of El Greco's altarpieces very carefully.[102] An agreement of August 8, 1577, required El Greco to represent the Nativity with Saint Jerome and the Resurrection with Saint Ildefonsus for the lateral altarpieces.[103] The subjects of the six paintings for the main retable were not specified in any contract. However, El Greco was supposed to indicate the names of these paintings on the plan of the main retable.[104] He also had to prepare detailed drawings of all the altarpieces for Don Diego's approval. Don Diego reserved the right to reject any part of the completed work.[105]

In addition to the paintings, El Greco was responsible for preparing designs for the architectural frames and the statues which crowned them (see fig. 3). It is uncertain to what extent El Greco's original intentions were modified by Juan Bautista Monegro, the Toledan sculptor entrusted with executing them. Most authorities maintain that Monegro increased the height of all the frames and thereby modified their proportions.[106] It has also been proposed that Monegro discarded

[101] Giovanni Andrea Giglio's most famous treatise, *Degli errori e abusi dei pittori circa l'historia* (Camerino, 1564), has been reprinted in Paola Barocchi, *Trattati d'arte del Cinquecento fra Manierismo e Contrariforma*, 3 vols., Bari, 1960–1962, 2: 3–125. Barocchi's critical comments (2: 522–543) are very useful for understanding the importance of Giglio's work.

[102] San Román, 'Santo Domingo,' 3. [103] San Román, 'Santo Domingo,' 5.

[104] San Román, 'Santo Domingo,' 5.

[105] San Román, 'Santo Domingo,' 3–4.

[106] Harold Wethey, *El Greco and His School*, 2 vols., Princeton, 1962, 2:4, with previous bibliography. See also Alfonso E. Pérez Sánchez, 'On the Reconstruction of El Greco's Dispersed Altarpieces,' trans. E. Sullivan, in J. Brown, *et al.*, *El Greco of Toledo*, Boston, 1982, 150.

El Greco's plans and created entirely new ones.[107] This thesis is supported by the evident similarity between the main retable of Santo Domingo and that of the Toledan church of San Antonio de Padua, a certain work of Monegro.[108] Whether designed by Monegro or El Greco, the simple classicizing retables of Santo Domingo provided an appropriately dignified and monumental setting for the paintings.

It has been argued that the stipulation of El Greco's contract that he was not to leave Toledo until he had finished all the paintings for the church proves that Don Diego lacked confidence in his honesty and willingness to complete the project.[109] However, Don Diego frequently revealed himself to be suspicious of others, and the restriction upon El Greco's movement does not attest to a special distrust of the artist. In Monegro's contract for the execution of the altarpieces, Don Diego insisted that the sculptor renounce all legal rights that he might have with respect to the completion of the altarpieces and the possible modification in price.[110] Further, if the sculptor was himself unable to complete the work for any reason, he was to be held responsible for the full price of the execution by others, even if this were to cost more than what he was scheduled to be paid. Don Diego's suspicion (or exaggerated prudence) about the intentions of others was evident in many documents besides his contracts with artists. For instance, before his death, he made his servants sign pledges that they would not contest his will because he feared that they would attempt to deceive his executors.[111]

The magnificent results of the collaboration of Don Diego and El Greco indicate that the two achieved a harmonious and productive working relationship. While the program attests to a more sophisticated understanding of the doctrines of the Church than the artist could have been expected to possess, El Greco probably suggested the appropriate visual expression for the patron's ideas. That Don Luis de Castilla later granted El Greco the privilege of burial in Santo Domingo suggests that the family was indeed pleased with his work.

The Altar of the Gospel: 'The Adoration of the Shepherds'

The pictorial program devised by El Greco and Don Diego de Castilla clearly reflects the function of Santo Domingo as a funerary chapel and illustrates the means of

[107] Fernando Marías and Agustín Bustamante García, *Las ideas artísticas del Greco*, Madrid, 1981, 27.
[108] Marías and Bustamante García, *Las ideas*, 27, maintain that Monegro's retable at San Antonio de Padua is dated 1568. Significantly different dates are indicated by documents previously published by García-Rey. These indicate that the convent of San Antonio de Padua commissioned the retable in 1578. See Verardo García-Rey, 'Juan Bautista Monegro, escultor y arquitecto,' *Boletín de la Sociedad Española de Excursiones*, 40 (1932), 29. (This source will henceforth be cited as García-Rey, 'Monegro.')
[109] García-Rey, 'Monegro,' 24, 28; San Román, 'Santo Domingo,' 3, 10.
[110] Francisco de Borja San Román y Fernández, *El Greco en Toledo*, Madrid, 1910, documento 6, 130–140.
[111] García-Rey, *Deán*, 58–59.

Christian salvation. The large narrative paintings represent four events in the history of redemption which are re-enacted in every celebration of the Mass: the Birth of Christ, his Resurrection, the Father's acceptance of the sacrificed Son as atonement for the sins of the world, and the Assumption of the Virgin to heaven, where she serves as the advocate of sinners.

Although the *Adoration of the Shepherds* (now in the collection of Emilio Botín Sanz, Santander, 2.10 × 1.28 m.; fig. 4) was probably not the first painting executed by El Greco for the commission,[112] it can logically be considered first because it marks the beginning of Christ's earthly life.

In accord with the provisions of his contract, El Greco represented in the lateral altarpieces two of the saints whose aid Don Diego invoked in his will. Saint Jerome was shown before the Nativity, and Saint Ildefonsus was portrayed before the Resurrection in the painting for the altar of the Epistle. Standing in the immediate foreground of the paintings, the saints literally functioned as intermediaries between the viewer and the appearance of Christ. When the paintings were displayed directly on the altar tables as the artist intended, the saints would have appeared on approximately the same level as the officiating priests and thus would have been ideally situated to convey the prayers of the celebrants to God.

The representation of Saint Jerome before the stable in the *Adoration of the Shepherds* was in accord with his legend. Jerome lived in the cave where Christ was born and there prepared a large part of the Vulgate,[113] which is probably the book he is shown holding in El Greco's painting. The representation of Jerome before the Child also supported the argument of the Tridentine Church that the Vulgate was divinely inspired and therefore infallible.

Don Diego's devotion to Saint Jerome reflected the importance of the Hieronymite Order in his life and the historical association of the Order with King Peter. As a child, Don Diego lived with Doña María Niño de Portugal in the Hieronymite monastery at Montamarta near Zamora.[114] According to the *Flos Sanctorum*, the veneration of Jerome in Spain necessarily recalled the memory of King Peter, who had introduced the Hieronymite Order into his territorites.[115] In his treatise, Don Diego praised the Hieronymites for their loyalty to the good memory of King Peter and argued that the preservation of the secret chronicle of Bishop Juan de Castro in the Hieronymite monastery at Guadalupe attested to the Order's concern with countering malicious propaganda against his reign.[116]

[112] The *Assunption*, signed and dated in 1577, was probably El Greco's first painting for the commission.
[113] Jacobus de Voragine, *The Golden Legend*, trans. Granger Ryan and Helmut Ripperger (1941), reprint ed., New York, 1969, 589–592.
[114] Diego de Castilla, *Historia del Rey*, ed. Valladares, v. 29, 1791, 59.
[115] Villegas, *Flos*, 1588, 336/v.
[116] Diego de Castilla, *Historia del Rey*, ed. Valladares, v. 29, 1791, 384–385.

There are sufficient similarities between the anonymous portrait of Don Diego still preserved in the convent at Santo Domingo (fig. 1) and the representation of Jerome in the foreground of the *Adoration of the Shepherds* to posit that the saint was modelled upon the Dean. Until now, Saint Ildefonsus in the *Resurrection* has been considered to be a portrait of Don Diego,[117] but the Dean did not look at all like El Greco's Ildefonsus, a heavyset man with a squarish face. The penitent guise of Jerome would have been particularly appropriate to the situation of the Dean, who was seeking forgiveness for his sins in order to gain salvation.

The theory that Jerome represents Don Diego is substantiated by a careful comparison of El Greco's saint with the portrait. Both Saint Jerome and Don Diego are depicted with egg-shaped heads which greatly decrease in width beneath the eyes, so that the lower parts of their faces are almost triangular. Like Don Diego, Jerome is represented with a high forehead and strongly pronounced cheekbones. Both Jerome and Don Diego have narrow aquiline noses with slight but noticeable beaks, breaks in the middle, and sharply defined nostrils. The eyebrows of both figures show the same asymmetry, with one arched and the other straight. Despite his status as a humble penitent, Saint Jerome's pose and gestures reveal the same aristocratic bearing evident in the stance of the Dean.

The differences which exist between the two figures can be attributed to the variation in their ages. Judging by appearance, the formal portrait of Don Diego was probably painted while he was still relatively young, perhaps in his early thirties. By contrast, El Greco's Saint Jerome seems to represent the same man in his late sixties, the age at which the Dean commissioned the altarpieces for Santo Domingo. The wrinkled skin, bald head, and thinner face are likely effects of ageing.

In representing the Adoration of the Shepherds, El Greco combined a monumental centralized composition inspired by Central Italian art with elements derived from Northern Italian art – including the nocturnal setting, the frank depiction of the poverty of the shepherds, and the candle.[118] However, only in the interchange of the two figures behind Mary did El Greco suggest the genre-like effect of Northern Italian versions of the scene. He reduced the back wall of the stable to a flat plane opening on the right to a view of the night sky, a somewhat darker surface marked only by the crescent moon. The virtual elimination of the background enforced the viewer's concentration upon the figures and helped to emphasize the universal meaning of the event.

Although El Greco followed traditional iconography, he introduced some original variations which enhance the meaning of the scene. For example, he represented Jerome with the lighted candle which Northern Italian artists had shown shepherd

[117] See, e.g., Wethey, *El Greco and His School*, 2:7.
[118] Wethey, *El Greco and His School*, 1:36.

boys holding in scenes of the adoration of the newborn Child. As an attribute of Jerome, the candle would suggest that he conceived the Vulgate as an offering to God and also represent the prayers which he makes on behalf of the Dean.

The crescent moon at the upper right may have been intended to emphasize the relationship between Christ's birth and the Immaculate Conception. While it is, of course, possible that the moon was shown simply as an indication of nighttime and has no iconographic significance, the isolation of the crescent against the flat, black sky endows it with a sense of special importance that encourages the viewer to interpret it as a symbol. Uncertainty about the purpose of this detail reflects a basic problem in studies of Renaissance art: it is frequently very difficult to know what elements are symbols.

The crescent moon was one of the most important emblems of the Immaculate Conception[119] and one of the few iconographic devices retained in the definitive pictorial formula which emerged near the beginning of the seventeenth century. In representations of this subject, the Virgin was generally shown standing above a crescent moon in accord with John the Evangelist's vision of the Apocalyptic Woman: 'a woman clothed with the sun, and the moon under her feet' (Revelation 12:1).

The moon was also one of several images from the Song of Solomon which were interpreted as metaphors of the Immaculate Conception: 'Who is she that looketh forth as the morning, fair as the moon, clear as the sun, and terrible as an army with banners?' (6:10). Throughout the sixteenth century, the Virgin of the Immaculate Conception was depicted as a young woman suspended in the sky above the earth and surrounded by the moon and other symbols from the Song. Like many other artists, Díaz Pardo showed the crescent moon both underneath the Virgin's feet and next to her right shoulder in his altarpiece in the church of San Saturino, Artajona.

The moon was not described as a crescent in any of the biblical passages which have been related to the Immaculate Conception. However, artists consistently showed the moon in this form. The crescent moon may have been associated with the Immaculate Conception because it was an ancient, widely recognized symbol of chastity.

Artists adapted the crescent moon to contexts other than iconic representations of the Immaculate Conception. For instance, Dürer showed the Virgin suckling the

[119] Useful discussions of the iconography of the Immaculate Conception include Manuel Trens, *La Inmaculada en el arte español*, Barcelona, 1952; Mireille Levi d'Ancona, *The Iconography of the Immaculate Conception in the Middle Ages and Early Renaissance*, New York, 1957; Engelbert Kirschbaum, *Lexikon der Christlichen Ikonographie*, 2 vols., Rome, 1970, 2:338–339; Jutta Seibert, ed., *Lexikon von Christlichen Kunst*, Frieburg, 1982. I also benefited from the examination of paintings of the Immaculate Conception catalogued in the photographic archives of the Frick Art Reference Library, New York.

Child above a crescent moon on the title page of his *Marienleben*. However, an earlier representation of the Nativity with the crescent moon as an evident symbol of the Immaculate Conception has not been found. Thus, the moon in the painting now in Santander may be an instance of El Greco's original handling of traditional iconographic motifs.

Don Diego's cousin, Don Francisco de Castilla, had helped to promote the spread of the cult of the Immaculate Conception through the publication of a lengthy poem, popular in the mid sixteenth century.[120] In this verse treatise, Don Francisco explained that, by preserving the Virgin from the taint of original sin, the Immaculate Conception had predestined her to serve as the mother of Christ, who could only have been born to an absolutely pure woman. Don Diego may have directed the artist to include the crescent moon in order to affirm the beliefs propounded by Francisco. In consideration of Don Diego's pride in the achievements of his family, it seems likely that he also hoped to recall the contribution of his cousin to the diffusion of the cult.

The scene at the stable in Bethlehem represents both the beginning of Christ's earthly career and an important stage of the Mass, in which he is continually reborn. The Tridentine Church strongly affirmed the doctrine that Christ's assumption of human form was essential to salvation because it instituted a new sort of relation with the divine, based on mutual love rather than fulfillment of the Law.[121] In El Greco's painting and many other sixteenth-century representations of the Nativity and the Adoration of the Shepherds, the fully exposed nude body of the Child emphasizes the reality of his corporeal presence in accord with the belief that he was fully 'humanized' (*humanizado*), a concept which frequently occurs in Spanish devotional literature of the period.[122] At the same time, light radiating from the Child's body expresses his divinity, which he miraculously retained during his earthly existence. Christ's birth constituted his first step toward the Passion, through which he freed mankind from the consequences of sin. Such traditional details of the scene as the manger barely raised off the floor and the animals were interpreted by sixteenth-century theologians as symbols of Christ's earthly poverty and humiliations, which culminated in his death on the Cross.[123]

[120] Francisco de Castilla, 'De la preservación del pecado original en la concepción de nuestra señora,' in *Practica de las virtudes de los buenos Reyes de España en coplas y otras obras*, Murcia, 1518 (no pagination). Other editions of 'De la preservación' were published in Seville, 1547; Alcalá, 1552; Alcalá, 1564. (Henceforth cited as Francisco de Castilla, 'De la preservación.') [121] Trent, Session 6, 31, 118.

[122] See, e.g., Carranza, *Comentarios*, 1:194–202. Alonso de Orozco, *Epistolario cristiano*, Alcalá de Henares, 1567, 103/r, also discusses this idea. (This book will henceforth be cited as Alonso, *Epistolario*.) Leo Steinberg's witty and highly informative essay, 'The Sexuality of Christ in Renaissance Art and Modern Oblivion,' in *October*, 25 (1983), analyzes the emphasis placed in fifteenth- and sixteenth-century European theology on Christ's full human nature and relates this to the frank depiction of Christ's sexuality in Renaissance art. [123] Alonso, *Epistolario*, 25/r–32/v.

According to Sandoval, the priest's consecration of the Host transforms the altar table into the stable, and the newborn Child lies on it as he did on the original manger.[124] Immediately after the consecration, Sandoval advised, the priest and all communicants should visualize the scene at Bethlehem in order to appreciate the significance of the service and to derive full benefit from it.[125] The light radiating from the Child in El Greco's painting can be related specifically to Sandoval's description of Christ's appearance as a 'spiritual fire radiating from the sacred table.'[126] Like virtually all other representations of the Adoration of the Shepherds, El Greco's painting shows the shepherds kneeling before the manger. Although the poses are characteristic of this scene, it is interesting to note that they also occur in Sandoval's discussion of the consecration of the Host – the event which causes Christ to be reborn on the altar. According to Sandoval, the congregation should kneel in reverent contemplation of the Host immediately after its consecration.[127]

Don Diego may have intended the *Adoration of the Shepherds* to serve as propaganda against the statute of pure lineage. The letter of the Canons opposed to the statute repeatedly cited the event as proof that the new law was contrary to Christian principles. The Canons interpreted the circumstance that the shepherds were the first to receive the news of Christ's birth as proof that God loved people of undistinguished ancestry more than others and wanted them to govern his Church.[128] The opponents of the statute also insisted that the shepherds' humble adoration of the Child exemplified the simple faith which provided the only means of becoming a Christian. In El Greco's painting, the repetition of Mary's pose and gesture in the shepherd to her right serves to emphasize the saintly character of the man's devotion.

This analysis of the *Adoration of the Shepherds* reveals some of Don Diego's conflicting aspirations. It is likely that the Dean intended the painting to affirm the equality of all Christians. Yet, his pride in the grandeur and achievements of his family is suggested by the figure of Saint Jerome, who recalls the memory of King Peter, and by the crescent moon, a symbol of the cult of the Immaculate Conception which had been promoted by his cousin. In fact, the Dean's preparations for death were based on contradictory goals. He declared that he wanted to be buried as a simple parish priest, but he constructed a costly, monumental church to house his tomb.

The Altar of the Epistle: 'The Resurrection'

In a painting still on the altar of the Epistle, El Greco represented Ildefonsus, the most popular Toledan saint and the model of all the Archbishops who succeeded him,

[124] Sandoval, *Tratado*, 277. [125] Sandoval, *Tratado*, 276–277. [126] Sandoval, *Tratado*, 279.
[127] Sandoval, *Tratado*, 276–277. [128] 'Relación…1547,' 66/v–67/r.

witnessing the Resurrection of Christ (2.10 × 1.28 m.; fig. 5). Appropriately, the saint was shown clad in the white vestments used for Easter services. The prominent depiction of Ildefonsus commemorated the Dean's personal devotion to the saint and affirmed that he built the original convent of Santo Domingo. As the patron saint of King Alfonso, who rebuilt the institution after the reconquest of the city, Ildefonsus was additionally linked to the convent. The worshipper at Santo Domingo was certainly meant to associate the figure of Ildefonsus with that of Jerome in the *Adoration of the Shepherds*. Within the respective altarpieces, each saint was shown on the side close to the center of the church. By relating the two saints visually, the artist expressed the Toledan view that Ildefonsus was equal in stature to the most important Doctors of the Church.[129]

To understand the relationship between the Resurrection and Saint Ildefonsus, it is necessary to review part of the history of his cult. At the Council of Frankfurt in 794, Bishop Felix of Urgel and his follower, Archbishop Elipando of Toledo, defended their belief that Christ was not part of the Godhead by claiming that Ildefonsus had propounded the same idea in the previous century.[130] The Council found Felix and Elipando guilty of heresy and, accepting their citations of Ildefonsus's sermons as accurate, declared that the saint had also entertained unorthodox beliefs. The precise character of Ildefonsus's views on the divinity of the Son remained an urgent issue for Toledans in the sixteenth century because non-Spaniards still tended to accept the Council's ruling as valid.[131] For example, the prestigious Italian scholar Cardinal Cesare Baronio maintained that many of Ildefonsus's ideas were incorrect and even suggested that he had revived the heresy of Nestorius.[132]

It seems likely that Don Diego intended the *Resurrection* to serve as visual propaganda in support of Ildefonsus's orthodoxy, which was defended verbally by contemporary Toledan writers such as Pisa and Salazar de Mendoza.[133] These defenders of Ildefonsus contended that he nowhere expressed any of the ideas attributed to him by Felix – as, indeed, he had not – and declared that he had strongly affirmed the divinity of the Son. From the earliest period of the Church, it had been recognized that the Resurrection established Christ's divinity, as Saint Paul explained (Romans 1 : 3–4). Therefore, in representing Ildefonsus as a witness to this event, El Greco effectively illustrated the saint's belief in the natural divinity of the Son.

[129] Francisco de Pisa, *Descripción de la imperial ciudad de Toledo, y historia de sus antigüedades* (Toledo, 1605), reprint ed., Madrid, 1974, 104/r–v.
[130] Pisa, *Toledo*, 107/r; Salazar de Mendoza, *Ildefonso*, 239–245.
[131] Salazar de Mendoza, *Ildefonso*, 243–244.
[132] His comments especially angered Salazar de Mendoza, *Ildefonso*, 243–244.
[133] Pisa, *Toledo*, 104/r–107/r; Salazar de Mendoza, *Ildefonso*, 239–245 and *passim*.

Also especially relevant to understanding the didactic meaning of El Greco's painting is the commentary on the Resurrection by Arias Montano, the librarian of the Escorial and an important theologian and biblical scholar, who was a close friend of Don Luis de Castilla.[134] Arias Montano maintained that the Resurrection proved that truth would eventually prevail over heresy in the Church and that those who were falsely accused of holding incorrect ideas would eventually be vindicated.[135] The depiction of the Resurrection transpiring in Ildefonsus's presence would thus refer to the inevitable universal recognition of the saint's orthodoxy. The way in which El Greco's Christ inclines his head down towards Ildefonsus suggests divine concern for and approval of the saint.

It is probable that the defense of the memory of the most famous and holy archbishop of Toledo was meant to be applied to the case against Archbishop Carranza. Both prelates were accused of professing heretical ideas, although the charges were made in very different contexts. Don Diego's description of Carranza as the 'most holy and Christian prelate since Ildefonsus'[136] indicates that the Dean had already associated his contemporary with his most distinguished predecessor.

The resemblance between El Greco's image of Ildefonsus and authentic portraits of Carranza further supports the theory that the altarpiece contained propaganda in support of the Archbishop's case. Certainly, El Greco's Ildefonsus bears a much greater resemblance to existing portraits of Carranza than to the single portrait of Don Diego which has thus far been identified. Among the portraits of Carranza, that painted in 1578 by Luis de Carvajal (fig. 2) can be considered his definitive official portrait because it was commissioned for the Chapter House in Toledo. Both the Archbishop and Saint Ildefonsus are portrayed with broad, very full, squarish heads. Both the saint and Carranza have distinctive cauliflower ears. The Archbishop and El Greco's Ildefonsus are characterized by low foreheads, sharply arched eyebrows, and large hooked noses with wide nostrils; the jaws of both are especially prominent, large and fully rounded; and their lips are notably full. Like Carranza in all his portraits, the saint is shown without a beard or moustache. The short, closely cropped hair of El Greco's saint corresponds with those portraits of Carranza in which he is shown without the bishop's mitre. The full, heavyset torso of Ildefonsus follows Carvajal's portrait of the Archbishop. The gestures of the saint seem forthright and direct when compared to those of Jerome and, in this respect, accord with both Carvajal's portrait and contemporary accounts of the Archbishop.[137] The portrayal of Carranza in front of the Resurrection of Christ would have been

[134] Angel Vegue y Goldoni, 'En torno a la figura del Greco,' *Arte español*, 7 (1926), 76, 79. See also B. Rekers, *Benito Arias Montano*, London, 1972, 60, 66.

[135] Benito Arias Montano, *Elucidationes in Quator Evangelia*, Antwerp, 1575, 105–109.

[136] Tellechea Idigoras, *Carranza, documentos*, 3:149.

[137] Salazar de Mendoza, *Carranza*, 196–197.

especially appropriate because the Archbishop had described this as his favourite religious image and the source of all his hope and consolation.[138]

In creating the *Resurrection*, El Greco borrowed from the work of earlier sixteenth-century Italian artists. The spiral pose of El Greco's Christ is related both to Titian's *Resurrection* in Urbino and to Michelangelo's *Risen Christ* in Santa Maria sopra Minerva.[139] Whatever the precise source, the suggestion of an upward-turning spiral movement helps to visualize the doctrine that Christ resurrected himself without the assistance of the Father or an intermediary power. Many of the guards were inspired by works of Michaelangelo.[140] The outstretched figure on the right, based upon Michaelangelo's statue of Night in the Medici Chapel, well conveys the impression of sleep, unaffected by the surrounding confusion, and thus illustrates the belief that some people are unable to comprehend the meaning of the Resurrection because they are entirely unilluminated by the Holy Spirit.[141]

Among the other figures, the guard stretched out on the lid of the tomb deserves special attention. This figure follows the proposals of Molanus, who recommended that painters show a guard sleeping on top of the tomb to demonstrate that it was still sealed and that Christ's transformed, glorious body was able to pass through it without moving it.[142] Through his handling of the strong, fully three-dimensional, well-muscled nude body of the Resurrected Christ, El Greco visualized the doctrine that Christ's body was still fully corporeal, although miraculously spiritualized and unaffected by normal earthly limitations.[143]

While the Adoration of the Shepherds represents the initial consecration of the Host, the Resurrection signifies the triumphant conclusion of the Mass, in which Christ is eternally born, sacrificed and resurrected anew.[144] According to Sandoval, the re-enactment of Christ's Resurrection in the Mass is not an abstract concept but the living means by which Christians receive justification. Sandoval recommended that, while singing the final antiphony, communicants try to evoke within themselves the same surprise and joy that the Disciples experienced when they learned of Christ's Resurrection. In El Greco's painting, the light radiating from Christ expresses the miraculous nature of the transformation of the Host into his body. El Greco further illustrated the belief that the Resurrection actually recurs in the Mass by creating the impression that the tomb rose directly out of the altar

[138] Carranza, *Comentarios*, 1:285–286.
[139] Wethey, *El Greco and His School*, 1:92, n. 129. On Michelangelo's *Risen Christ*, see Charles De Tolnay, *The Medici Chapel*, Michelangelo 3, 2nd ed., Princeton, 1970, 90–91.
[140] Wethey, *El Greco and His School*, 1:35.
[141] Carranza, *Comentarios*, 1:287.
[142] Emile Mâle, *L'art religieux de la fin du XVI^e siècle, du XVII^e siècle, et du XVIII^e siècle, étude sur l'iconographie après le Concile de Trente* (Paris, 1953), reprint ed., Paris, 1972, 292–294.
[143] Carranza, *Comentarios*, 1:281.
[144] Sandoval, *Tratado*, 286.

table on which the painting originally rested. Most of the empty tomb is concealed behind the dense web of figures and the prominent rock in the left foreground, but the one corner which is clearly visible projects forward between the bowed legs of the standing guard on the right and extends down almost to the lower edge of the canvas.

The subject of Christ's Resurrection was especially relevant to the function of Santo Domingo as a funerary chapel. According to traditional Catholic doctrine, which was strongly affirmed by the Tridentine Church, Christ's Resurrection not only constituted his personal victory over sin and death but also conquered these forces for his followers.[145] Thus, the Resurrection provided the basis of salvation through the Church and exemplified how the faithful would be glorified on the day of judgment.

The High Altar: 'The Trinity'

The Trinity (Madrid: Prado, 3 × 1.78 m.; fig. 6), originally located on the upper level of the principal altarpiece, concisely and vividly represents the Father's acceptance of the sacrifice of his Son and culminates the Eucharistic imagery of the program. The response of the Father validates Christ's atonement for the sins of mankind and makes the repetition of his sacrifice in the Mass effective.

The iconographic formula of El Greco's painting, in which God the Father holds the dead Christ upon his lap and the Dove of the Holy Spirit hovers above them, originated near the end of the fourteenth century in Burgundy.[146] Various terms – including the Man of Sorrows as the Second Person of the Trinity, the *Not Gottes*, *Pitié de Nostre-Seigneur*, and the *Compassio Patris* – have been proposed for representations of this theme.[147] Because all these terms are unwieldy, it seems best to retain the traditional title of *The Trinity* in the present discussion. This subject was especially popular in the Netherlands and Germany, where it was frequently represented in the sixteenth century.[148] However, it seldom occurred in Spain, where only four examples predating El Greco's painting have been located.[149]

This iconographic type was evidently derived from the Throne of Mercy, a considerably older subject, in which an enthroned figure of God the Father holds in his outstretched arms a Cross to which Christ is attached. By the end of the fifteenth century in Northern Europe, the representation of the Father with his dead

[145] Carranza, *Comentarios*, 1:283–292.
[146] German de Pamplona, *Iconografía de la Santíssima Trinidad en el arte medieval español*, Madrid, 1970, 144.
[147] Pamplona, *Iconografía*, 144; Gertrud Schiller, *Iconography of Christian Art*, trans. Janet Seligman, 2 vols., Greenwich, CT, 1971–1972, 2:219.
[148] John B. Knipping, *Iconography of the Counter Reformation in the Netherlands: Heaven on Earth*, trans., 2 vols., Leiden, 1974; 2:478. [149] Pamplona, *Iconografía*, 144–148.

Son on his lap generally replaced the image of him displaying the Crucified Christ.[150] The new variation, to which El Greco's painting belongs, permitted a more direct relationship between Christ and the Father and therefore produced a more emotionally tender interpretation of the subject. For this reason, the term Throne of Mercy could be very aptly applied to the new theme, as well as to its prototype. Further, El Greco incorporated into his painting several motifs which illustrate the doctrinal basis of the theme of the Throne of Mercy.

It has generally been assumed that the Throne of Mercy virtually disappeared in Spain after the fifteenth century.[151] However, most Spanish altarpieces of the sixteenth century represent the same theme in a distinct way which takes full advantage of the large scale and multitude of wood statues popular in this period. Nearly all sixteenth-century Spanish retables include a half- or full-length image of the Father above the Crucifixion, customarily located on the attic of the central vertical row. Generally, the Father in some way responds to the scene below him, as he is depicted, for example, in Juan de Juni's famous retable now in the Cathedral of Valladolid (originally at La Antigua, Valladolid). At the very top of the altarpiece, the enthroned Father looks down to the Crucifixion and raises his right arm in a gesture of blessing which expresses his approval of the sacrifice. It seems possible that El Greco intended his formally and emotionally unified image to demonstrate the superiority of his work to that of Spanish sculptors, who required several figures and two compartments to represent the theme.

As has frequently been noted, El Greco's principal model for the composition was Dürer's famous and widely distributed woodcut of the Father holding the sacrificed Christ on his lap (fig. 7).[152] In contrast to most earlier artists, Dürer had shown the Father looking at Christ, rather than at the spectator, and El Greco further developed the sense of relationship between the two by tilting the Father's head down toward the Son and by depicting him with an expression of quiet sorrow. Neither Dürer nor El Greco showed a throne but instead, in both the woodcut and the painting, the Father's seated position, the largeness of his figure, and his enclosing cape suggest that he himself constitutes the Throne. Other elements which El Greco borrowed from Dürer include the heavenly setting and the cortege of angels. However, El Greco eliminated the Instruments of the Passion which are held by angels in Dürer's print. The omission of these elements accords with El Greco's consistent goal of interpreting the program in concise, monumental terms.

Although the composition follows Dürer's print, the full musculature of the figures reveals the influence of Michelangelo.[153] The gesture of Christ's right hand, inspired

[150] Schiller, *Iconography*, 2:220–223; Knipping, *Iconography of the Counter Reformation*, 2:478.

[151] Pamplona, *Iconografía*, 118, 143–144. [152] See, e.g., Wethey, *El Greco and His School*, 1:35.

[153] Wethey, *El Greco and His School*, 1:35, and 92, n. 127. José Camón-Aznar, *Dominico Greco*, 2 vols., 2nd ed., Madrid, 1970, 1:291.

by Michelangelo's statue of Lorenzo de Medici, and the positioning of the legs, related to certain examples of the Pietà by Michelangelo, indicate a struggle for life within Christ and thereby suggest his rebirth through the Resurrection and the continuous re-enactment of his life in the Mass.

El Greco has made two seemingly minor, but actually very important innovations in his interpretation of this image. He put heads of cherubs under the folds of the Father's cape and replaced the papal tiara shown in Dürer's print with the mitre of an ancient Jewish high priest. These details are easily overlooked by modern viewers, but they would have greatly enriched the meaning of the painting for El Greco's well-educated patron because they elucidate the biblical and theological foundations of the subject. An engraving opposite the title page of the first edition of Alonso de Orozco's very popular *Libro de la suavidad de Dios* (Salamanca, 1576) is a likely visual source for the representation of the Father with cherubs under his cape and wearing the distinctive mitre of ancient Jewish high priests on his head (fig. 8).[154]

The cherubs' heads attached to the Father's cape accord with the directions for the construction of the Throne of Mercy, the most sacred altar of the ancient Hebrew temple and the place where God appeared to announce his will:

Thou shalt make two cherubims of gold, of beaten work shalt thou make them, in the two ends of the mercy seat. And make one cherub on the one end, and the other cherub on the other end: even of the mercy seat shall ye make the cherubims on the two ends thereof (Exodus 25:18–19).

By incorporating cherubs' heads into folds of the cape on both sides of the Father's shoulders, El Greco indicated that God himself constituted the Throne of Mercy, where the ultimate sacrifice was presented. This important iconographic point was reinforced by the gold color of the outer side of the cape, which accords with the direction that the Throne of Mercy was to be covered with pure gold (Exodus 25:17).

The identification of the Father with the Throne of Mercy was based directly on the Epistles of Paul. In such passages as Hebrews 9:1–26, Paul elucidated the doctrines that the Crucified Christ was presented to the Father in the same way that rams had been sacrificed to him at the Throne of Mercy in the innermost sanctuary

[154] This engraving shows God the Father blessing and igniting the fire on the main altar of the Temple and does not include other members of the Trinity.

The scene shown in the engraving is analyzed in Alonso de Orozco, *Libro de la suavidad de Dios*, Salamanca, 1576, 6/r–v, 43/v–44/v. Interestingly, Alonso compares God's blessing of the fire in the Temple to his later acceptance of the Crucified Christ, which is depicted in El Greco's painting. Alonso maintained that God's deep love for mankind inspired both these actions.

Alonso, *Suavidad*, 1576, 146/v–148/v, relates the Father's acceptance of the Crucified Christ to the Throne of Mercy.

Carranza, *Comentarios*, 1:301, also discusses this idea.

of the ancient Hebrew temple and with the same goal of placating his anger. Unlike the slaughtered animals, the dead Son succeeded in permanently appeasing the Father so that the Crucifixion had made any other sacrifice unnecessary and futile. Finally, because of his acceptance of the Crucifixion as atonement for the sins of mankind, the Father became the Throne of Mercy and demonstrated the kindness implied in that name.

While the cherubs' heads equate the Father with the Throne, the mitre suggests that he is also to be considered as the ancient Jewish high priest, the only person qualified to stand before the Throne of Mercy. For this reason, the image reflects the dual role of the Father in the sacrifice of Christ, which was offered to him to propitiate his anger and completed in fulfillment of his will. The Father's white surplice might also have been associated with his role as high priest because the Levites, who supervised the temple of Solomon, were believed to have worn white inner vestments when offering sacrifices.[155]

El Greco's use of seemingly minor details to express important ideas accords with the approach of sixteenth-century Spanish theologians and devotional writers, who minutely analyzed the significance of every aspect of Christian history and spiritual experience.[156] Sandoval, for instance, interpreted the Mass by carefully studying the relation of each of its parts to major incidents in the lives of Christ and Mary.[157] Other writers pondered such events as the Incarnation and the Passion by detailing the meaning of all the physical elements of their settings and by seeking to evoke the emotions of each of the participants.[158] However, El Greco's restriction of details to a few of the most prominent gives the *Trinity* a monumental simplicity and coherence frequently missing in the literary works of his contemporaries.

The *Trinity* concisely and vividly illustrates the basic purpose of the Mass: the offering of the Son to the Father.[159] According to Sandoval, the Father enthroned in the heavens receives the dead body of the Son and accepts it as atonement for sins during the consumption of the consecrated Host by the congregation.[160] Sandoval emphasized the intimate connection between the Father's action and the celebration of the Eucharist on earth by identifying the altar table with the Throne of Mercy.[161] To prepare themselves to conduct the communion of the faithful in

[155] Yepes, *Cronica general*, 1:24/v.
[156] Melquiades Andrés, *La teología española en el siglo XVI*, 2 vols., Biblioteca de Autores Cristianos Maiores 13–14, Madrid, 1972, 1:45–46; 2:331, 376, 378f., 560ff. and *passim*.
[157] Sandoval nowhere presented his ideas about the Mass in general terms. Instead, he presented many different points, deduced from his descriptive analysis of each stage of the service. Some of Sandoval's concepts have been used to interpret each of the major narrative paintings at Santo Domingo. (For the full citation, see no. 10.)
[158] Saint Thomas of Villanueva described the Incarnation in this way in his sermons on this event. See Saint Thomas of Villanueva, *Sermones de la Virgen y obras castellanas*, ed. by Santos Santamarta, Biblioteca de Autores Cristianos, Madrid, 1952, 234–312.
[159] Sandoval, *Tratado*, 277, 266. [160] Sandoval, *Tratado*, 276–277, 285. [161] Sandoval, *Tratado*, 276.

an appropriate spirit of humility and awe, priests should spiritually join the angels who gather before the Throne of Mercy to watch the Father receive the crucified body and to plead with him to show mercy.[162] Thus, El Greco's painting represents an image upon which priests should meditate throughout the service.

According to Sandoval, the celebration of the Mass breaks down barriers between heaven and earth and, at the moment of consecration, angels descend to earth to adore Christ on the altar. When the Host is consumed, angels gather before the Throne in heaven and before the altar on earth to mourn the dead Christ and to plead with the Father to extend mercy to the faithful.[163] The sorrowful facial expressions and gestures of the angels in El Greco's painting vividly illustrate their response to the offering of the dead Savior to the Father. El Greco may have included six angels in the painting because that is the number of candle-bearers who are present at the altar during Masses for the Dead,[164] which were to be celebrated at Santo Domingo on behalf of Don Diego and Doña María. Although the angels do not carry candles, the numerical reference to specific participants in the Mass would have been comprehended by those familiar with the liturgy and would have emphasized the identity of the Throne with the altar.

By showing the angels attending Christ, El Greco literally illustrated the meaning of the concept 'bread of angels' which occurs in many sixteenth-century Spanish devotional manuals. Christ referred to himself as the 'living bread' come down from the heavens (John 6:35). Sandoval linked this concept explicitly with the Mass and defined the 'bread of angels' as the privilege enjoyed by celestial beings of witnessing the offering of the sacrificed Son to the Father.[165]

The High Altar: 'The Assumption of the Virgin'

The Assumption of the Virgin (Art Institute of Chicago, 4.01 × 2.29 m.; fig. 9) was originally located in the center of the principal altarpiece of Santo Domingo. Signed and dated in 1577, it was probably the first of the large narrative paintings which El Greco completed for the church. It is considered last here because it completes the history of redemption visualized in the other altarpieces. The Assumption ensured that the faithful would benefit from Christ's advent, death, and resurrection.

The *Assumption* was by far the largest painting which El Greco created for Santo Domingo. Because of its scale, location, and brilliant coloring, it would have been especially prominent in its original setting. The emphasis upon this scene attested to the importance which Spanish Catholics of the sixteenth century attached to the intermediary role of the Virgin.

[162] Sandoval, *Tratado*, 262. [163] Sandoval, *Tratado*, 266–277.
[164] Edmund Bishop, 'Of Six Candles on the Altar: an Enquiry,' in *Liturgica Historica*, Oxford, 1962, 301–313.
[165] Sandoval, *Tratado*, 278.

The name saints of both Don Diego and Doña María de Silva are represented in this altarpiece. Saint James the Greater, Don Diego's patron, kneels in the right foreground as he gazes up at the Virgin. The large book which he holds reflects the contemporary Spanish conception of Saint James as one of the most important theologians of the Early Church.[166] His pose and his upraised hand indicate his supplication for the soul of the Dean.

Although the formula for the representation of the Assumption had become fairly standard by the late sixteenth century, most art historians have claimed that El Greco based his interpretation of the scene on Titian's famous painting in Santa Maria dei Frari.[167] However, El Greco posed his figures quite differently than had Titian and omitted the figure of God the Father. In terms of composition, El Greco most obviously followed Titian in projecting the upper and lower levels from different viewpoints. In addition, El Greco imitated Titian's free, painterly technique. The bright colors of the Chicago painting accorded with a long tradition of representing the Assumption in a festive manner. Nevertheless, it is interesting to note, Sandoval declared that vivid colors were to be used in paintings of this event to demonstrate that Mary's virtues made her appear resplendant as she arose to heaven.[168] Sandoval's comments probably were influenced by actual practice.

In composing the *Assumption*, El Greco could have drawn upon many Italian versions of this theme. Andrea del Sarto's *Assumption*, originally in S. Antonio dei Servi, Cortona (now in the Pitti Palace, c. 1527–29), may have particularly influenced El Greco's conception of the lower part of his painting. Like Sarto, El Greco arranged the Apostles in compact groups on the two sides of the tomb that project forward at an oblique angle. El Greco's Saint James is related to the Apostle kneeling by the tomb in the foreground of Sarto's painting; and the pose of the saint seen from the back in the left foreground of El Greco's painting could have been suggested by the figure standing just to the right of the middle of Sarto's altarpiece.[169] In comparison with the paintings of both Titian and Sarto, El Greco greatly increased the scale of the figures and compacted them more closely together. This simultaneous expansion and compression of the figures helps to eliminate any sense of conventional space and endows the scene with an otherworldly quality that encourages the viewer to contemplate its eternal validity.

Beneath the feet of the Virgin in El Greco's painting is the crescent moon, a symbol of the Immaculate Conception which was often included in Spanish paintings of

[166] Salazar de Mendoza, *Mendoça*, 7.
[167] See, e.g., Wethey, *El Greco and His School*, 1:34; Camón-Aznar, *Dominico Greco*, 1:273, 279.
[168] Sandoval, *Tratado*, 34.
[169] The reversal of Sarto's placement of these two figures suggests that El Greco was familiar with an engraving rather than the original painting.

the Assumption from the early sixteenth century onwards.[170] This motif was certainly intended to express the widespread belief that the Assumption was a direct consequence of the Immaculate Conception.[171] Because death resulted from sin (Genesis 3:19), it was argued that one who was absolutely pure could not have been allowed to decay in the grave. The Dean's cousin, Francisco de Castilla, thus related the Assumption to the Immaculate Conception in his poem of 1518:

> A body that in its conception
> was preserved from fault:
> God wanted her spared
> from every corruption,
> and resurrected living.
>
> Carne que en su concepcion
> de culpa fue preservada
> dios la quiso reservada
> de ninguna corrupcion,
> y fresca resuscitada.[172]

The Assumption of the Virgin was one of the most popular religious images in sixteenth-century Spain and was often shown in the central row of altarpieces, in the compartment immediately above the tabernacle.[173] Despite the popularity of the subject, however, it seems likely that its use here expressed specific concerns of the patron.

The Assumption can be connected with Don Diego's pride in the grandeur of the Toledan church and with his desire to glorify the achievements of the Castilla dynasty from which he claimed descent. By the mid sixteenth century, the Assumption had become so closely linked to Toledo that Luis de Estrada, Rector of the University of Alcalá de Henares, claimed that celebration of the feast should inspire Christians throughout the world to think about and pray for the Holy Church of Toledo, 'which is one of the greatest and most sacred oratories that the Virgin has in the entire world.'[174] In the sixteenth century, it was widely held that Alfonso VI, who re-founded (or rebuilt) the convent of Santo Domingo after the reconquest

[170] Jonathan M. Brown, 'Painting in Seville from Pacheco to Murillo: a Study of Artistic Tradition,' Ph.D. Dissertation, 1964, 43–44.

[171] See, e.g., Saint Thomas of Villanueva, *Sermones*, 392.

[172] Francisco de Castilla, 'De la preservación,' no pagination.

[173] Juan José Martín-González, 'Tipología e iconografía del retablo español renacimiento,' *Boletín del Seminario de Estudios de Arte y Arqueología*, Universidad de Valladolid, 30 (1964), 10–11.

[174] Luis de Estrada, *Rosario della Madonna et Sommario della vita di Cristi*, trans., Rome, 1588, 279–280. Despite the numerous editions printed in Castilian, very few Spanish copies of this book are still extant. The book was so widely read that numerous copies might have been literally 'worn out.' The small format of the book made it a convenient devotional manual. The Biblioteca Nacional in Madrid has only the Italian edition which I used. For general comments on Estrada's writings, see Martín, *Bernardos*, 43.

of Toledo, had established the Assumption as the most important feast of the cathedral.[175] Because Alfonso VI was one of the ancestors of King Peter, the Assumption could have been associated with Don Diego's proposed history of the Castilla family. Toledans connected the Assumption to the cult of Saint Ildefonsus, to whom the Dean was especially devoted, because the Virgin appeared to him on the day of this feast and invested him with the chasuble, signifying her high valuation of this servant of the Church.[176]

The *Assumption* also formed an essential part of the program of the history of redemption, which directly reflected the function of Santo Domingo as the burial place of Don Diego and Doña María de Silva. According to Estrada's very popular handbook on devotions to the Virgin and Villegas's *Flos Sanctorum*, the Assumption of the Virgin in body and soul was absolutely necessary for the salvation of the faithful.[177] Both Estrada and Villegas maintained that Christ's Crucifixion alone could not have redeemed people from the consequences of sin. By enabling the Virgin to take her place next to Christ in heaven, the Assumption empowered her to plead for mercy for sinners. If the Assumption had not thus permitted the Virgin's gentle influence to temper God's anger, people would have remained condemned. (These arguments may seem surprising because they imply that Mary's role in salvation was almost as important as Christ's, but it cannot be denied that they reflected widespread popular belief.)

The *Assumption* can also be related to the Eucharistic theme of the program because, as Sandoval explained, the Assumption provided the basis for the effective performance of the Mass.[178] From the seat of glory in the heavens which she gained through this event, Mary supervised the celebration of the Mass by the earthly Church and directed the angelic choirs who surround the Throne of God during the offering of the Son and join the earthly communicants in singing the Psalms, the Te Deum, and other parts of the Mass. Moreover, her advocacy of the faithful was supposed to inspire the priest's prayers during the Mass.

El Greco also sought to visualize the metaphoric description of Mary as the tabernacle of the Lord found in contemporary devotional literature.[179] This term was applied to Mary because she conceived Christ and literally sheltered him within her womb in much the same way that the tabernacle contains the consecrated Host. This concept referred not only to her biological role as Christ's mother, but also to her care and instruction of the growing Child and her continuous interest and participation in his works and in the development of the Church.

[175] Salazar de Mendoza, *Ildefonso*, 159–161.　　　[176] Salazar de Mendoza, *Ildefonso*, 162.
[177] Estrada, *Rosario della Madonna*, 267–280; Alonso de Villegas, *Flos Sanctorum, secunda parte*, Toledo, 1584, 77/v–78/r, 79/v.
[178] Sandoval, *Tratado*, 263–264.
[179] See, e.g., Saint Thomas of Villanueva, *Sermones*, 435–437.

The Apostle in the left foreground of El Greco's painting extends his hand directly underneath the Virgin and turns his palm upwards in the gesture which the artist habitually used to signify the presence of God.[180] Because the Virgin is not part of the Godhead – as even the most fervid Marian authors were careful to assert – this gesture could be directed towards her only in her role as the tabernacle of the Lord.

El Greco further visualized the relationship between Mary and the metaphor of her custody of the Church by arranging for the painting to be seen in conjunction with the actual tabernacle on the altar. Because he placed the *Assumption* directly on the altar table, the tabernacle stood directly in front of it. In creating this arrangement, El Greco broke with the long Spanish tradition of devoting the lowest compartment of the central row of the main retable exclusively to the display of the tabernacle.[181] To understand the artist's intentions, it is necessary to review what is known about the original tabernacle.

Both El Greco's original design and the tabernacle actually executed by Monegro have been lost, but documents which record the controversy between Monegro and El Greco over its final form provide information about the artists' intentions.[182] El Greco described his design as 'transparent' – apparently because he intended to use only two columns in the upper storey of the tabernacle so that it would not block the view of the painting.[183] However, Monegro persuaded the Dean to allow him to make the upper section of the tabernacle more ornate by adding eight columns to it.[184] There is no indication that Monegro wanted to change the height of seven *pies* (seven Castilian feet, about 1.95 m.) proposed by El Greco.[185] If Monegro respected El Greco's measurements, his tabernacle would have been less than half the height of the Chicago painting (4.01 m.) and would have allowed a clear view of the Virgin, although it might have partially covered the lower section.

When the painting was placed on the main altar, it seems likely that the strongly marked outward swing of the lower part of the Virgin's body would have created the illusion that she was actually hovering over the tabernacle below her. This effect would have illustrated her role as the primary defender of the Church because her movement could have been understood as an effort to shelter and protect the sacrament on the altar.

Whether or not it was made 'transparent' in accord with El Greco's intentions, it seems likely that the tabernacle would have been brought into a close visual

[180] Rudolf Wittkower, 'El Greco's Language of Gestures,' *Art News*, 56, no. 1 (March 1957), 53.
[181] Martín González, 'Tipología,' 9–14.
[182] Wethey, *El Greco and His School*, 2:4, with previous bibliography.
[183] San Román, *El Greco*, 134.
[184] García Rey, *Deán*, 88; San Román, *El Greco*, 134.
[185] García Rey, *Deán*, 87–89. A Castilian foot was a basic unit of traditional Spanish measurement equivalent to one-third of a *vara*. A *vara*, shorter than an English yard, was equivalent to 835.9 mm.; and a foot was approximately 278.6 mm.

relationship with the empty tomb. This configuration would have visualized the belief that the Church was developed specifically to replace the departed Mary.[186] The Virgin was supposed to have served as the focus of the Christian community after the Ascension and, in order to ensure the continuity of the faith, she established the Church as a formal organization and entrusted it with the administration of the sacraments. The display of the Host in the tabernacle was intended to provide the same consolation to the faithful which Mary had offered during her earthly existence.

Obviously, all of these proposals must remain hypotheses until more concrete information on the actual appearance of the tabernacle can be found. Nevertheless, it is probable that El Greco and his patron would have been aware of the iconographic implications of their unusual organization of the altarpiece and that they intended the visual link of the painting and tabernacle to enrich the meaning of the ensemble. Like the additions to the usual iconography in the *Trinity*, this variation from standard practice seems to reflect a profound understanding of the theology relevant to the subject.

Although El Greco did not attempt to link the two major scenes of the central altarpiece in any very obvious way, he provided a certain emotional continuity between them. The expression and pose of the Virgin in the *Assumption* indicate that she is contemplating the death of the Son, represented in the *Trinity*, which would have originally been located immediately above, in the attic of the main retable. Her large, tear-filled eyes and downturned mouth express sorrow, and her outflung arms with palms turned toward the viewer imitate the Crucifixion and accord with an ancient formula for profound grief.[187] The portrayal of the Virgin grieving over the loss of Christ as she is elevated to heaven corresponds with accounts in sixteenth-century devotional literature. Estrada, for example, maintained that the Virgin contemplated the Passion throughout her Assumption, and he advised artists never to portray her as joyful in representing this scene.[188] The illustration of the Virgin's emotional and spiritual participation in the sacrifice of the Passion further emphasizes the importance of her role in the history of the redemption of mankind.

The High Altar: The Four Paintings of Saints

The program of four large narrative paintings was complemented by five small paintings and by five large statues on the main altar. In the vertical rows on each side of the *Assumption* were originally displayed half-length paintings of saints of the Cistercian Order and full-length paintings of saints of more general significance.

[186] Villegas, *Flos, secunda parte*, 79/v–80/v. Saint Thomas of Villanueva, *Sermones*, 421–422, 435–438.
[187] Mosche Barasch, *Gestures of Despair in Medieval and Early Renaissance Art*, New York, 1976, 29–30.
[188] Estrada, *Rosario della Madonna*, 269–270, 273, 275–276.

The full-length standing figure of John the Baptist which is still located on the left side of the main retable of Santo Domingo (2.12 × 0.78 m.; fig. 10) is easily recognizable because of the saint's camel-hair garments, weathered skin, and emaciated body. The Baptist logically complemented the narrative paintings because he announced the arrival of the Messiah and the possibility of salvation.

The other full-length figure, still located on the right side of the main retable (2.12 × 0.78 m.; fig. 11), is an elderly, bearded saint who has been described both as John the Evangelist and as Paul. The large book which he holds accords with the iconography of both these saints. The usual identification of this figure as the Evangelist depends primarily on two factors.[189] Firstly, the two Saint Johns were frequently paired, and it has been assumed that El Greco would have followed this tradition. Secondly, a drawing in the National Library, Madrid, which is generally considered to be an authentic preparatory sketch by El Greco, includes an eagle, a traditional attribute of the Evangelist, not shown in the final painting (fig. 12). Although the Evangelist was generally portrayed as a handsome young man, he was sometimes depicted as an elderly figure as, for example, in Titian's painting now in the National Gallery (Washington, D.C.).

None of the arguments supporting the identification of the figure as the Evangelist can be considered definitive. Although the Baptist and the Evangelist were often paired, they also were shown with other saints. Paul, who proclaimed the Messiah to the Gentiles, could also have been used to balance the Baptist, who had announced his coming to the Jews. The pairing of the Baptist and the Evangelist would have complemented the combination of Christian and Hebrew imagery in the depiction of the Father in the *Trinity*.

The attribution of the drawing in Madrid is also doubtful. Admittedly, the poor condition of this drawing makes analysis of it difficult, but what is left of the image differs significantly from the style which El Greco employed in his paintings.[190] The figure does not convey the sense of physical weight and actual corporeal presence that characterizes authentic figures by El Greco. The open contours do not define the figure clearly, and the robe flares out like a weightless balloon just below the waist. In comparison with the painting of the saint in Santo Domingo, the proportions of the figure in the drawing seem to have been elongated and the head seems to have been reduced in size. The claw-like fingers found in the Madrid drawing do not occur in any authentic work by El Greco.

Although the bearded, elderly saint shown in the painting at Santo Domingo cannot be securely identified, it seems likely that he represents Paul. The portrayal

[189] Wethey, *El Greco and His School*, 2:6–7.
[190] Because no drawing can be securely attributed to the artist, attributions have to be based on comparisons with his paintings.

of this saint would have directly reflected Don Diego's concern for the history and grandeur of the Toledan Church. In the sixteenth century, the conversion of Spain to Christianity and the establishment of Toledo as the Primacy of Spain were traced back to the Apostle.[191] Paul was supposed to have sent his follower Dionysius the Areopagite from Athens to Paris to direct the conversion of Western Europe; in Paris, Dionysius ordered Saint Eugenius to go to Spain, where he solidified the authority of the Church by founding the archbishopric of Toledo as the Primacy of Spain. Such authors as Pisa and Illescas cited the historical connection of Toledo with Paul as proof of the importance of the city.[192] The image of Paul might also have been included because the Canons opposed to the statute of pure lineage regarded him as the leading proponent of an 'open church.'[193]

The half-length figures of Saints Benedict (originally located in the upper section of the right side of the lower storey of the altarpiece, now in the Prado, 1.16 × 0.80 m.; fig. 13) and Bernard (originally in the upper section of the left side of the lower storey, present whereabouts unknown, 1.13 × 0.75 m.; fig. 14) commemorated the advocation of the convent to the Cistercian Order because they were its founders and principal patrons. It may seem unusual that Dominic of Silos, the titular saint of the church, was not represented on any of the retables. However, the omission of Saint Dominic is fully in accord with the usual practice of Cistercians, who devoted their altarpieces almost exclusively to major scenes from the lives of Mary and Christ and seldom included in their churches images of titular saints other than the Virgin.[194]

The High Altar: 'The Veil of Veronica'

An elliptical image of the Veil of Veronica held by two gilded putti is still displayed in the broken pediment over the central compartment of the first storey, in which the *Assumption* was originally located (2.12 × 0.78 m.; fig. 15).[195] The *Veil of Veronica* is linked in several ways to the program of the chapel. Because the actual Veil was an authentic souvenir of the Passion, the image would have complemented the vivid depiction of the sacrificed Christ in the *Trinity*. As a reminder of a specific earthly incident of the Passion, the *Veil* may have been intended partly as an oblique replacement for the Crucifixion which was ordinarily a part of sixteenth-century retables. Because the Veil was considered a symbol of the powers at the disposal

[191] Gonzalo de Illescas, *Historia pontifical y catolica*, 2nd ed., 2 vols., Burgos, 1578, 1:16/r.
[192] Pisa, *Toledo*, 80/r–v. Illescas, *Historia*, 1:71/r–v.
[193] 'Relación...1547,' 50/v–52/r.
[194] Joan Evans, *Monastic Iconography in France from the Renaissance to the Revolution*, Cambridge, 1970, 18–19. Evans discusses Cistercian churches in France, but presumably the situation in Spain was similar.
[195] Wethey, *El Greco and His School*, 2:5, summarizes available data.

of the Church,[196] the painting would have affirmed the efficacy of the institution to which the Dean entrusted the care of his soul.

Another painting of El Greco, which shows Veronica holding the Veil, was originally displayed in a gold frame on the wall of the nave of Santo Domingo (now in the collection of María Luisa Caturla, Madrid; 1.05 × 1.08 m.).[197] The painting has been dated on grounds of style to the same years in which El Greco was working on the altarpieces for Santo Domingo and was possibly commissioned by the Dean as part of his decoration for the new church, although it is not mentioned in his known contracts with the artist. The presence in the church of this second representation of the same basic theme suggests that the devotion to the Veil of Veronica had special significance for the convent. Because the Veil was a gift to a woman who assisted Christ during the Passion, it would have been especially relevant to a community of nuns who witnessed the daily sacrifice of the Mass.

The High Altar: The Statues

Statues of the three Theological Virtues were displayed on top of the pediment of the main retable: Charity in the middle, Faith on the left, and Hope on the right. Although these would appear to be logical and typical choices for the crowning decoration of an altar, they were seldom represented so prominently in sixteenth-century Spanish retables.[198] El Greco and his patron may have been influenced by the sixteenth-century Italian practice of including large statues of virtues in funerary monuments.[199] The three Theological Virtues would have aptly commemorated the Dean's service to the Church. Faith, Hope, and Charity would also have complemented the Eucharistic theme of the program because the Tridentine Church emphasized that communicants would benefit from their participation in the Mass only if they received the Host with an attitude characterized by those three virtues.[200] At the same time, Communion also fostered the development of these virtues.[201]

The statues of Old Testament prophets above the outermost pilasters of the lower storey were the most traditional elements of the program. In accord with usual

[196] André Chastel, 'La Véronique,' *Revue de l'art*, no. 40–41 (1978), 73.

[197] Wethey, *El Greco and His School*, 2:148, no. 282.

[198] Martín González, 'Tipología,' 13 and *passim*.

[199] For instance, the tomb of Cardinal Ascenzio Sforza, created by Andrea Sansovino in the choir of Santa Maria del Popolo in Rome, included standing figures of Justice and Prudence in the side niches and seated figures of Faith and Hope above them. The tomb of Girolamo Basso delle Rovere, which Andrea Sansovino designed for the same church, showed Fortitude and Temperance below. Obviously, the representation of the three Theological Virtues on top of the main altar only reflected the basic idea of displaying prominently the Virtues and not the specific selection of Virtues or their placement.

[200] Trent, Session 13, 81–82.

[201] Trent, Session 13, 77.

practice, these statues were probably supposed to remind the worshipper of the doctrine that Christ was the Messiah proclaimed by the Hebrew prophets. Statues of the Hebrew prophets were generally placed on both sides of the Crucifixion group; by using them to enframe the *Trinity*, El Greco may have intended to indicate that he conceived the painting as a formally and iconographically innovative replacement for the standard Crucifixion scene surmounted by God the Father.

Conclusions

Don Diego de Castilla, Dean of Toledo Cathedral and El Greco's first Spanish patron, was an ambitious and clever ecclesiastical politician who probably intended his reconstruction of the church of Santo Domingo el Antiguo to affirm his supposed royal ancestry. It seems likely that Don Diego hired El Greco to paint the altarpieces because of the prestige which his association with Italy would confer upon the project. In Toledo, El Greco and Don Diego devised a program that commemorated the funerary significance of Santo Domingo by elucidating the means of salvation.

The altarpieces for Santo Domingo provide some clues about the course of El Greco's development. Although he utilized compositions by other artists and largely retained his earlier Italian manner, he introduced subtle but important changes of iconography and style. In all of the altarpieces, El Greco included original motifs which greatly enrich the meaning of each painting. Moreover, El Greco compressed the space in all the narrative paintings so that the figures literally overlap and are pushed toward the foreground. This effect endows the scenes with an otherworldly character that encourages the viewer to contemplate their spiritual significance and eternal validity.

In his next major undertaking – the altarpieces for the Seminary of the Incarnation in Madrid – El Greco developed astonishingly original and powerful interpretations of basic Christian themes.

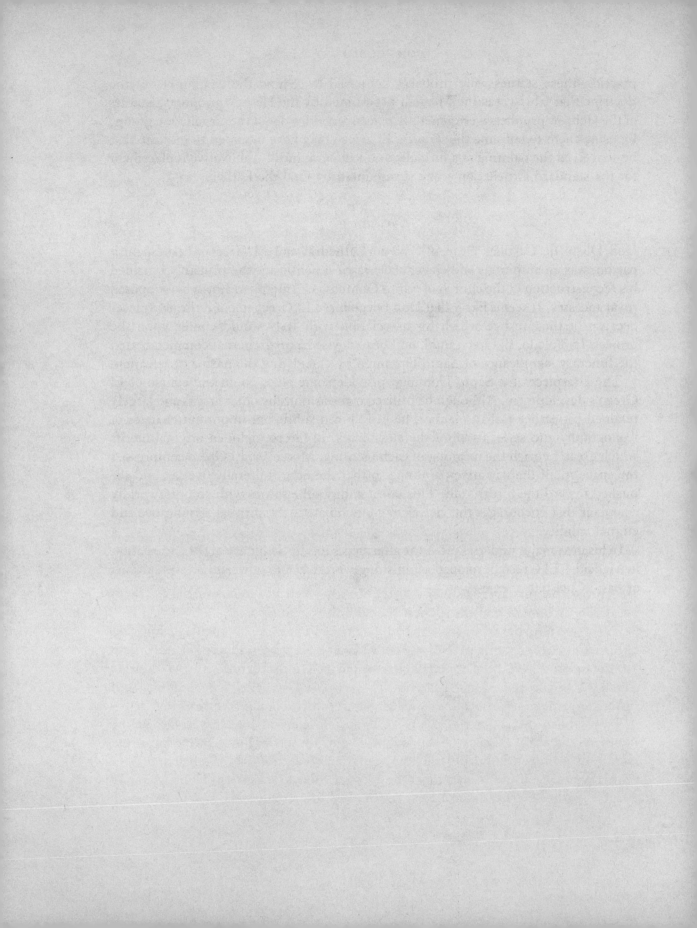

CHAPTER 2

THE SEMINARY OF THE INCARNATION IN MADRID

El Greco's altarpieces for the Seminary of the Incarnation in Madrid pose the question of the connection of his work to mysticism. These paintings visualize the mystical visions and meditations of the Blessed Alonso de Orozco, founder of the seminary. By illustrating accurately and vividly images and metaphors found in Alonso's writings, El Greco created exciting paintings with unique iconography. His bold expressionistic style enhanced his original interpretations of basic themes of Christian art.

El Greco probably considered his work at the seminary to be the most prestigious and important commission of his career. Near the end of the sixteenth century, the seminary was widely considered to be one of the most important religious foundations in the new Spanish capital, and the king and his entourage frequented its church. Thus, in executing the paintings for the seminary church, El Greco came closer to achieving the status of a court artist than at any other time in his career. However, El Greco did not succeed in obtaining royal patronage and depended on a fellow Toledan for this commission. The officials of the seminary must have recognized the outstanding quality of the works which El Greco created for them because they offered him the highest fee he was ever to receive.

Unfortunately, the seminary was badly damaged during the Napoleonic invasion of Spain, and its contents were dispersed without having been thoroughly recorded. No documents have been found which would positively identify all the subjects which El Greco represented. Previously overlooked stylistic, iconographic, and historical evidence provides the basis for the reconstruction of the retable.

To establish the context of this very important commission, the careers of the founders and early officials of the seminary and the history and purposes of the institution will be examined first. Four individuals determined the spirit and form of the Seminary of the Incarnation: the Blessed Alonso de Orozco, Doña María de Aragón, Father Hernando de Rojas, and Father Jerónimo Horaa de Chiriboga.

The Blessed Alonso de Orozco

Although the Blessed Alonso de Orozco (1500–91; fig. 16) has been largely overlooked by modern historians, he played an important role in the religious and political life of sixteenth-century Spain.[1] The program devised by El Greco and his patrons was probably intended to glorify his memory.

Like other great figures of the Golden Age of Spain, such as the considerably more famous Saint Teresa of Avila, the Blessed Alonso was both a mystic and a person of practical thought and action. Throughout his life, he felt overwhelmed by the love of God and received many visions; he was widely admired for his humility, charity, and religious zeal. A prolific writer, he published many books of pious and mystical meditations which enjoyed great popularity during his lifetime. As preacher to Charles V and Philip II, he participated in the life of the court and frequently advised the monarch. He also filled important offices in the Augustinian Order and founded several convents and monasteries.

Alonso was born to an impoverished family of noble descent in the small village of Oropesa in the province of Toledo on October 17, 1500. Shortly before his birth, Alonso's mother, María de Mena, offered him to the service of the Virgin, who had appeared to her in a vision and directed her to name her child Alonso in honor of Saint Ildefonsus, who had passionately defended Mary's virginity centuries before.[2] Like the mother of Saint Francis of Assisi, María de Mena withdrew from her house at the onset of labor and gave birth to her son in a stable in order that he might begin his life in faithful imitation of Christ.[3] In his later years, Alonso claimed that his sight of a burning candle at the exact instant he was born inspired him even as an infant to devote himself to the meditation of God.[4]

Shortly after his birth, Alonso's family moved to the larger town of Talavera la Vieja. There, at the age of six, Alonso pledged himself to the service of God while contemplating the Eucharist in the parish church for which El Greco's workshop

[1] The most thorough study of Alonso remains Tomás Cámara's lengthy *Vida y escritos del Beato Alonso de Orozco*, Valladolid, 1882, which was prepared to commemorate Alonso's beatification and to promote his canonization. Unfortunately, copies of this book are exceptionally rare outside of Spain and Italy. Alonso's own *Confessiones*, of which I have consulted the edition printed in Madrid in 1620, provides accounts of his education and visions (henceforth cited as Alonso, *Confessiones*).

Useful seventeenth-century sources include Juan Márquez, *Vida del Venerable P. Fr. Alonso de Orozco*, ed. Tomás de Herrera, Madrid, 1648; Gil González Dávila, *Teatro de las grandezas de la villa de Madrid*, Madrid, 1623; Tomás de Herrera, *Alphabetum Augustinianum*, Madrid, 1644; *idem.*, *Historia del Convento de S. Agustín de Salamanca*, Madrid, 1652.

Ana Julia Bulovas's doctoral dissertation (Universidad de Madrid, 1973), which has been published by the Fundación Universitaria Española, *El amor divino en la obra del Beato Alonso de Orozco* (Madrid, 1975), attempts to synthesize his mystical doctrine. Cámara is the primary source for the biography outlined here.

[2] Alonso, *Confessiones*, 16/r–v. [3] Herrera, *Convento*, 394.
[4] Alonso, *Confessiones*, 18/v–19/v.

later produced a retable.[5] After making his vow, Alonso began to devote many hours to prayer and to practice severe acts of penitence.[6]

Alonso began his long formal training for an ecclesiastical career through his childhood studies at the church in Talavera and in the choir school of Toledo Cathedral. At the age of fourteen, he entered the Augustinian College at Salamanca, where his brother Francisco was already enrolled. At Salamanca, Alonso studied under the direction of Saint Thomas of Villanueva, the famous preacher, reformer, and Marian author, who was then the prior of the College. Alonso became a fervent admirer of Saint Thomas and delivered the funeral oration for him in Madrid in 1554. With his brother, Alonso took the habit of the Augustinian Order in 1521; and on June 9, 1523, shortly after Francisco's death, Alonso made his final religious vows, which were administered to him by Saint Thomas. After his profession, Alonso became a chaplain dedicated to the Virgin at the College in Salamanca and continued to study theology, philosophy, and literature there. Later, he was appointed Preacher (*Predicador*) by the Order.

Within the Augustinian Order, Alonso held a number of important administrative posts, including the Priorate of the College of Soria (1538–41), the Priorate of the Monastery of Medina del Campo (1542–44), and the Priorate of the Monastery of Seville (1544–54). In 1541 and again in 1554, he served as the Definitor of Castile. In this capacity, he assisted the Superior of the Augustinians in governing the province and represented it at the general chapter meeting of the Order.

While Alonso was living at the Augustinian monastery in Seville, the Virgin appeared to him in a dream and commanded him to write. In his *Confessiones*, he recounted this event in a tone of humble wonder as the inspiration of his career as an author.[7] Alonso became a prolific writer in both Castilian and Latin. During his lifetime, he published twenty-seven individual books as well as two incomplete versions of collected works.[8] Several more books appeared posthumously, including his autobiography, named *Confessiones* in imitation of Sant Augustine's record of his life. Alonso's works were extremely popular in the sixteenth and early seventeenth centuries, and most of them were reprinted several times while he was still alive. However, after the mid seventeenth century, interest in Alonso's writings seems to have declined rapidly. Unfortunately, all of his works have become extremely rare, and only the Biblioteca Nacional in Madrid and the Vatican Library have collections which approach completeness. A modern edition of his writings is

[5] Alonso, *Confessiones*, 22/v. (The retable will be discussed later in this chapter.)

[6] Bulovas, *El amor divino*, 25.

[7] Alonso, *Confessiones*, 73/r–74/v.

[8] Bulovas's list of Alonso's writings is the most accessible (p. 49–67). The two editions of *Recopilación de todas las obras* (1554 and 1570) include a number of small treatises which do not seem to have been published elsewhere and which are not included in the figure of 27.

badly needed to help us evaluate one of the most important figures of sixteenth-century Spanish religious life.

In all of his books, Alonso treated basic themes with which he concerned himself in his private meditations, including the sufferings of the Passion, the sorrows and virtues of the Virgin, and the benefits of the Eucharist. Although he sometimes concentrated upon only one of these subjects, he still generally discussed them in conjunction because he believed that together the Crucifixion of Christ, the advocacy of the Virgin, and the continuous celebration of the Mass provided the basis for human salvation.

Even in books intended for a wide general readership, Alonso gave special attention to the behavior of members of religious orders and emphasized the importance of adherence to the three fundamental vows of poverty, chastity, and obedience. Because of his intense awareness of the sinful nature of all mankind, the privilege of ecclesiastics to come into contact with the Real Presence on the altar never ceased to amaze him. He was especially concerned that the education of candidates for religious vows prepare them to fulfill the obligations which they assumed. Therefore, he prepared a history of the Augustinian Order which was intended as a handbook for men and women considering a religious career.[9] In this book, he detailed the requirements for those who wanted to enter the Order and transcribed the original Rule without any later dispensations.

To explicate his ideas, Alonso used a relatively limited number of events and motifs drawn from the Scriptures. The consistency of his imagery endowed his writings with a sense of continuity, but he interpreted each event and symbol in so many different ways that he constantly expanded the range of ideas which could be comprehended in a single motif. Modern readers are apt to become impatient with what seem to be minor and almost imperceptible variations of the same ideas and images, which may explain why Alonso's works have been overlooked. However, for the author and his sixteenth-century admirers, these variations would have provided important insights into significant theological problems.

Alonso claimed that his manner of analyzing images to explain a multitude of theological concepts and rules of Christian behavior was inspired by the assertion of Dionysius the Areopagite that only comparisons and veiled similitudes can illuminate the human mind.[10] However, it should be noted, Alonso's lengthy, detailed studies of a few subjects contrast with Dionysius' romantic panoramic view of the ecclesiastical and earthly hierarchies. Actually, Alonso's approach appears to

[9] Alonso de Orozco, *Crónica del glorioso padre y doctor de la yglesia, Sant Agustín: y de los sanctos y beatos y de los doctores y su orden. Una muy provechosa instrución de religiosos*, Seville, 1551. Alonso included in this book a discussion of the training of candidates and a version of the original Rule with all dispensations omitted.

[10] Alonso, *Epistolario*, 242/r.

have been inspired directly by that of his teacher, Saint Thomas of Villanueva, from whom he also borrowed a number of motifs, such as the Burning Bush, which both theologians used as a symbol of the Incarnation.

Although Alonso's method was probably not based on the work of Dionysius, his reference to that writer typifies his constant invocation of the authority of the Scriptures and of venerated theologians and preachers of the Early Church.[11] Alonso's repeated citation of these sources relates his work to that of many other theologians and devotional writers of the sixteenth century, including Saint Thomas of Villanueva, Archbishop Carranza, and the members of the Council of Trent. Because interest in the Scriptures and the writings of the Early Church constituted such a prominent trend at the time, one cannot suppose that Alonso was uninterested in the work of his contemporaries, even though he never cited them.

Alonso presented his reflections in a highly sentimental manner which is often at variance with modern taste. Frequently, he adopted a soothing, coaxing tone in an attempt to gently encourage his readers to respond positively to the outpouring of God's love which he experienced. He evoked the pain and agony of the Passion with great vividness in order to arouse sorrow and empathetic pain in his readers. The enormous popularity of Alonso's books during his lifetime suggests that both his emotional and sentimental style and his subtle analyses of a restricted number of events and motifs greatly appealed to his contemporaries and satisfied a widespread religious need.

Alonso's early books brought him to the attention of Charles V, who appointed him to the office of Royal Preacher after the death of Saint Thomas of Villanueva in 1554; Alonso later served Philip II in the same capacity. He was the confessor of the Queens Doña Ana de Austria and Doña Juana de Austria and of other important ladies of the court. He did not confess the king, but in his capacity as advisor on both foreign and internal affairs, Alonso influenced Philip to adopt a strong policy against Protestant sects within Spain and abroad, especially in the Netherlands.[12] Although Alonso fervently desired to become a missionary and martyr in the Indies, he was denied permission to resign his official post and remained attached to the court for the rest of his life.

While serving the royal family, Alonso contributed to the reform of the Augustinian Order by founding a monastery and three convents for nuns, as well as the Seminary of the Incarnation in Madrid. In 1566, Alonso established in Talavera la Vieja the monastery of Nuestra Señora de la Paz, which was the first

[11] In *Liber orthodoxis, omnibus per utilis, et maximé Monachis, qui Bonum certamen appellatur*, Salamanca, 1562, Alonso provided a list of his primary sources, on *verso* of title page. I have not found a citation to any contemporary source in his works.

[12] Cámara, *Vida*, 116ff., 272, and *passim*.; Herrera, *Convento*, 395.

in Castile to be dedicated to a strict interpretation of the original Augustinian Rule.[13] In 1588, the Chapter of the Province of Castile praised this monastery as an example for the reform of all the institutions under its jurisdiction. Among those who professed there was Pedro Manrique, who later delivered the funeral oration for Alonso.

In the early 1570s, Alonso assisted his sister in founding the convent of Saint Ildefonsus for Augustinian nuns in Talavera.[14] In Madrid, he established two additional convents – La Magdalena and Santa Isabel, commonly referred to as La Visitación.[15] The latter, which was founded in 1588, was the first convent of Discalced Augustinian nuns, who followed the Primitive Rule with no dispensations whatsoever, and served as the model for all later institutions of this type in Spain.

Alonso's last foundation was the Seminary of the Incarnation in Madrid, which was intended to prepare outstanding candidates to serve as preachers and active reformers.[16]

Alonso's own life provided an inspiring model of the humble and chaste existence which he glorified in his writings. Although he ministered to the wealthy and powerful, he remained unaffected by their worldly concerns. As Royal Preacher, he was entitled to reside in the palace and could have obtained special dispensations from the Rule. Instead, he preferred to live in the smallest room of the Monastery of San Felipe in Madrid, where he observed the strictest regulations applied to novices. Moreover, his extremely austere manner of life and zealous performance of penitential acts far exceeded the requirements of his Rule and greatly impressed his associates, who considered him a saint.

The brief biography which Father Rojas prepared in support of Alonso's canonization described some of the practices so admired by his contemporaries.[17] Three times a week, Alonso ate a mid-day meal, consisting of a few spoonfuls of soup and some bread, but otherwise ate nothing. He wore a very rough habit, which he sewed for himself, and slept directly on the floor or on a wooden table and never used a blanket until his superiors ordered him to do so during his final illness. The abuses to which he subjected his body gave him chronic health problems throughout his life, but he never allowed any illness to interfere with his constant work.

Although Alonso deprived himself of all creature comforts, he dedicated much energy to improving both the material and spiritual condition of the physically poor.[18] He utilized his large salary to provide food for the hungry and to purchase

[13] Herrera, *Alphabetum*, 2:485; Cámara, *Vida*, 173–174; Márquez, *Vida*, 93.

[14] Cámara, *Vida*, 171–173. [15] Márquez, *Vida*, 193–194.

[16] The foundation of the seminary will be examined in greater detail below.

[17] Hernando de Rojas, 'Relación de la vida del Ven. P. Fr. Alonso de Orozco,' ed. T. Cámara, *Revista Agustiniana*, 6 (1891), 90.

[18] Cámara, *Vida*, 152, 182–183, 197, 235–236; Bulovas, *El amor divino*, 39–42.

the release of prisoners jailed for debt. In his sermons, he often solicited large contributions from his wealthy audiences, and he distributed their offerings freely to anyone who asked him for help. On Sundays, he usually preached in the churches of poor neighborhoods of Madrid as well as at the royal palace and at various convents. He visited and offered spiritual consolation to the sick of all classes. His prayers were considered to have miraculous powers,[19] and the testimony collected in support of his canonization in the early seventeenth century claimed that his appeals to God had cured seven persons and had resurrected seven others from the dead.

Because so many hours were taken up with tending to the needs of others, Alonso routinely slept little in order to be able to find time for prayer and contemplation. In fact, he was so deeply devoted to the cult of the Eucharist that he spent many nights in adoration of the Host.[20] When he moved from San Felipe to the Seminary of the Incarnation near the end of his life, he was overjoyed to have been granted a room overlooking the altar.[21] Even when he was seriously ill, he insisted upon rising from bed to perform Mass at least once a day in contradiction to firm orders of his doctors – claiming that something so beneficial to his soul could not harm his health.

After consecrating the Host, Alonso often saw the Christ Child in the paten.[22] The statue of Christ on the Cross on the altar of the church of San Felipe, which he spent many hours contemplating, once seemed to assume life and look lovingly upon him.[23] These visions were not rare occurrences, and Alonso lived in a spiritual world in which the barriers between the divine and the earthly were broken down. Frequently, he perceived angels accompanying him as he prayed late at night in the empty church of San Felipe.[24]

Conventional modern distinctions between the illusory and the real can only inhibit an understanding of the state of mystic exaltation in which he lived. Alonso's fervent thanks to God for saving his life by lifting him up when he fell off a high cliff in a dream demonstrate that he did not distinguish between the visionary and physical worlds; his comments show that he thought that he would have died if the dream had been resolved differently.[25]

Among the many influential persons devoted to Alonso was Cardinal Gaspar de Quiroga, Archbishop of Toledo, who consulted him frequently for spiritual guidance.[26] The Cardinal was persuaded by the friar to give extensive financial aid

[19] Bulovas, *El amor divino*, 33–34.
[20] Cámara, *Vida*, 132–135, details Alonso's devotions.
[21] Alonso de Orozco, 'Cartas a doña María de Córdoba y Aragón,' ed. T. Cámara, *Revista Agustiniana*, 4 (1889), 33.
[22] Cámara, *Vida*, 296.
[23] Alonso, *Confessiones*, 82/r–v.
[24] Márquez, *Vida*, 56; Cámara, *Vida*, 296.
[25] See Alonso, *Confessiones*, 88/v–89/v.
[26] Cámara, *Vida*, 229.

from his own personal resources to the poor Augustinian monastery in Madrigal (province of Salamanca), which the Definitor of the Order wanted to close, and to build his tomb there.[27] Quiroga also permitted Alonso to found the Convent of Santa Isabel (La Visitación) in Madrid, despite his lack of the legally required financial backing, declaring that God would certainly provide for the needs of such an outstanding servant of the Church.[28]

During Alonso's final illness, the Cardinal attended him and even fed him soup.[29] Quiroga felt unworthy to bless such an extraordinarily devout man and only agreed to do so when he had prevailed upon Alonso to bless his superior in return. After Alonso's death, Quiroga obtained for himself – to the dismay of Doña María de Aragón, who also wanted it – the crucifix from the altar of San Felipe which the friar had especially loved because Christ had appeared to him on it and which he had adored continually in his final days.[30]

Quiroga ordered that Alonso should be buried in an opening beneath the principal altar of the church of the seminary, in conscious imitation of the interment of Saint Ambrosius in Milan.[31] The Cardinal's reference to the tomb in Milan indicates that he believed that Alonso should be venerated as a saint. The exceptional character of this privilege is emphasized by the fact that Quiroga himself had ordered in 1583 that no persons were to be buried under the principal altars of churches and that tombs could be placed near altars only in private chapels.[32] Alonso's followers ignored his request to be buried under a font of holy water so that the blessing which people made on entering and leaving church would benefit his soul.

In his funeral oration for the friar, Pedro Manrique, Archbishop of Zaragoza, declared that Alonso deserved the honor of burial beneath the altar because he had been so devoted to the Eucharist celebrated upon it and because he exemplified the perfect life of a religious by his absolute fidelity to the vows of chastity, poverty, and obedience.[33] Although such a public honor was normally to be avoided, Manrique declared, it would serve for the edification of all in the case of Alonso.[34] Furthermore, Manrique claimed, life as holy as Alonso's delighted Christ because it justified his death on the Cross.[35] Manrique also expressed the conviction that Alonso should be canonized because of the exceptional service he had given to God through fervent preaching, his authorship of many inspiring devotional manuals, and his charitable activities.

[27] Cámara, *Vida*, 325–326. [28] Cámara, *Vida*, 329.
[29] Cámara, *Vida*, 329. [30] Cámara, *Vida*, 373.
[31] Cámara, *Vida*, 372. [32] Quiroga, *Constitutiones sinodiales* 46/r.
[33] Pedro de Manrique, 'Sermon que predicò el dia del entierro del Venerable Padre Fr. Alonso de Orozco, el illustrissimo señor D. Fr. Pedro Manrique, Arçobispo y Virrey de Zaragoça,' in Alonso, *Confessiones*, 114/r–v, 118/r–127/v.
[34] Manrique, 'Sermon,' 127/r–128/v. [35] Manrique, 'Sermon,' 114/r–v, 118/r–127/v.

At the time of his death, Alonso was so widely beloved for his moving orations and his care of the poor and so famed for his visions and miraculous cures that people of all classes thronged to the seminary to venerate his body.[36] In fact, to accommodate the crowds wishing to see his body, the church had to be left open for the twenty-four hours preceding his funeral. Friars zealously guarded his remains because they feared that someone would attempt to steal a finger, a foot, or part of his clothing in order to have a relic of one who seemed destined for canonization. The odor of sanctity from his body filled the church and was considered definitive proof of his holiness.

During the first two decades of the seventeenth century, Alonso's followers acted diligently to secure his canonization. In 1603, Rojas ordered that Alonso's body be exhumed to verify that it was still incorrupt, which was regarded as an important proof of sanctity.[37] (The state of the body was verified again in 1674 and 1738.) Testimony was collected from many distinguished people – including four members of the royal family, two cardinals, three archbishops, and five bishops. This evidence was approved in 1619 by Monsignor Francesco Cenino on behalf of Paul V.[38] Although Alonso's Spanish admirers fervently attested to his worthiness, they were unable to persuade officials in Rome that he merited the supreme honor which the earthly Church can bestow. In the eighteenth and nineteenth centuries, further efforts were made to gain official recognition of Alonso's holiness. On January 12, 1882, Pope Leo XIII finally beatified Alonso, who still has not been canonized.

Doña María de Aragón

Doña María de Córdoba y Aragón (d. 1593), who was generally known simply by the second of her family names, was the daughter of Don Alvaro de Córdoba and Doña María de Aragón, a Portuguese lady who lived at the Spanish court. The date and place of her birth are uncertain, but it is generally assumed that she was born in Madrid, where she spent her adult life.[39] The younger Doña María followed her mother into the service of the court and acted as lady-in-waiting to Queen Ana, the last wife of Philip II, and to the Infanta Isabel Clara Eugenia.

The elder Doña María provided an example of pious charity which her daughter emulated on a grand scale by funding the Seminary of the Incarnation. In her will of March 21, 1570, the elder Doña María left substantial sums to the churches of San Ginés, Santa María de Atocha, and San Felipe – all in Madrid – for masses in

[36] On Alonso's funeral, see Cámara, *Vida*, 368–373. [37] Cámara, *Vida*, 519.
[38] Herrera, *Convento*, 396.
[39] Florentino Zamora Lucas, 'El Colegio de doña María de Aragón y un retablo del "Greco" en Madrid,' *Anales del Instituto de Estudios Madrileños*, 2 (1967), 215.

her memory and for good works.[40] She requested that her tomb be built in the Augustinian monastery of San Felipe, where Alonso then resided.[41] In accord with her wishes, her daughter had her body deposited there in March 22, 1570, and initiated the construction of a family chapel in the church.[42]

The elder Doña María claimed that her special devotion to Saint Augustine motivated her request for burial in a church of the Order which he founded.[43] However, this stipulation of her will also attested to her conformity with the established patterns of worship at the court. By 1570, the association of the royal preacher with San Felipe had caused most of the nobles living in Madrid to use it as their parish church, and they went there in large numbers on Sundays to hear Alonso preach.[44] It seems safe to assume that the elder Doña María, like her daughter, attended the sermons which Alonso delivered at San Felipe.

According to the early seventeenth-century chronicler González Dávila, the younger Doña María was renowned for her beauty, grace, and virtues.[45] At the age of eleven, she made a vow of chastity to which she adhered for the rest of her life, and she firmly refused the numerous advantageous offers of marriage which the royal family arranged on her behalf.[46] She attended Mass frequently and always gave one hundred *ducados* in alms before going to church.[47]

Doña María was devoted to the Blessed Alonso and selected him as her spiritual advisor.[48] Deeply moved by his sermons, she is supposed to have transcribed many of them and to have written a treatise on his outstanding qualities. Unfortunately, none of these records has been found. However, the twenty letters from Alonso to Doña María which Cámara discovered and published in 1889 provide some insights into their relationship.[49]

Doña María persuaded Alonso to write his autobiography for the permanent edification of his admirers and encouraged him to concentrate upon descriptions of his visions and of his meditations. Although he entrusted her with a copy of this work, he made her promise not to publish it or even to show it to anyone other than Rojas until after his death.[50]

Doña María also managed to obtain a portrait of Alonso, despite his reluctance

[40] Doña María de Aragón, viuda (widow) de Don Alvaro de Córdoba, Last Will and Testament, March 21, 1570, Protocolo no. 904, Archivo Histórico de Protocolos, Madrid, f. 413/r–419/v.

[41] Doña María de Aragón, widow, Will, 1570, 414/v–415/r.

[42] 'Deposito del cuerpo de Sʳᵃ Doña María de Aragón,' Protocolo no. 904, Archivo Histórico de Protocolos, Madrid, f. 420/r–421/r.

[43] Doña María de Aragón, widow, Will, 1570, 413/r.

[44] Cámara, *Vida*, 347.

[45] González Dávila, *Teatro*, 259. [46] Cámara, *Vida*, 335.

[47] Cámara, *Vida*, 335.

[48] Cámara, *Vida*, 335–337, provides a good summary of the relationship of the two.

[49] Alonso, 'Cartas.' Unfortunately, Doña María's letters to Alonso have not been located.

[50] Alonso to Doña María, dated May 20 (1589?), 164–165. See also Cámara's note, 164.

to pose.[51] By convincing him that Juan Pantoja de la Cruz wanted to use him as a model for a representation of Saint Augustine, she persuaded him to allow the court artist to sketch him while he prayed. Although he realized that the finished painting did not look like standard images of Augustine, Alonso did not immediately notice the resemblance to himself because he took so little interest in his physical appearance. Naturally, Alonso's admirers greatly esteemed this portrait because it was the only authentic one. Thus far, the original portrait has not been identified.[52] However, it seems likely that it served as the model for an engraving of Alonso (fig. 16) which corresponds in style and iconography to Pantoja's portrait of Rojas, Alonso's confessor (see fig. 17).

Alonso frequently appealed to Doña María for money, and she assisted many of his projects.[53] For instance, she contributed to the convent of La Magdalena which he established in Madrid. Most importantly, she agreed to provide all the necessary funds for the building and functioning of the Seminary of the Incarnation, which she intended Alonso to direct. Until her death, she personally supervised many aspects of the construction of the seminary, and in so doing demonstrated financial acumen and a thorough attention to detail.[54]

Hernando de Rojas and Jerónimo Horaa de Chiriboga[55]

Both Alonso and Doña María died before the seminary was completed and, therefore, the project had to be finished under the direction of Rojas, the second Rector of the institution, and Chiriboga, the executor of Doña María's will. Thus far, little has been discovered about these men. However, it is known that both had obtained the degree of *licenciado* and both held important offices in the Church.[56]

Hernando de Rojas (fig. 17) was deeply devoted to Alonso during the last years of the friar's life and humbly served as his confessor. Shortly before Alonso's death, Rojas heard the friar's final and complete confession of his sins and was amazed

[51] Cámara, *Vida*, 276–277.
[52] Francisco J. Sánchez-Cantón, 'Sobre la vida y obras de Juan Pantoja de la Cruz,' *Archivo español de arte*, 19 (1947), 95–120; María Kusche, *Juan Pantoja de la Cruz*, Madrid, 1964.
[53] Cámara, *Vida*, 324.
[54] Fernando Marías, 'De nuevo el colegio madrileño de doña María de Aragón,' *Boletín del Seminario de Estudios de Arte y Arqueología*, Universidad de Valladolid, 45 (1979), 449–451.
[55] The various parts of Chiriboga's full name are spelled different ways in the documents, including Gerónimo Oraa de Chiriboga, and Gerónimo/Jerónimo de Chiriboya/de Choraa CH/de Hoxaa Chriboga. I have chosen what appears to be the most common variant.
[56] Brief notices on Rojas and Chiriboga have been included in Gregorio de Santiago Vela, 'Colegio de la Encarnación de Madrid,' *Archivo histórico hispano-agustiniano*, vols. 9–10 (1918), 12–13 and *passim*.; Agustín Bustamante García, 'El Colegio de doña María de Aragón, en Madrid,' *Boletín del Seminario de Estudios de Arte y Arqueología*, Universidad de Valladolid, 38 (1972), 427–428, 431; Kagan, in Brown, *et al.*, *El Greco of Toledo*, 68, provides further information on Chiriboga.

because it revealed a great purity of life and contained only very minor transgressions.[57] Rojas expressed his intention of writing a lengthy biography of Alonso, but he does not seem to have done so. However, in a brief statement which he prepared in support of Alonso's canonization, he summarized the friar's life and achievements, praised his devotion and charity, and recounted several of his visions.[58] At Alonso's request, Rojas succeeded him as Rector of the seminary.

Jerónimo de Chiriboga was a Canon of the College of Talavera la Vieja and a member of the cabinet of Cardinal Quiroga, who also appointed him an executor of his estate.[59] Chiriboga seems to have been especially proud of his association with Quiroga and referred to it in all the documents connected with the seminary – even those dated many years after the Cardinal's death.

The one reference to Chiriboga which I have been able to locate in a contemporary published source does not present him in a flattering light. In his paraphrase of a discussion between Quiroga and Chiriboga, Pedro Salazar de Mendoza sought to emphasize the Cardinal's charitable zeal by treating the Canon simply as a foil to his superior's kindness.[60] According to Salazar, Chiriboga suggested that the Cardinal should give only 1,000 *ducados* to the English Seminary of the University of Valladolid, which had appealed to him for assistance. However, the Cardinal found this amount much too stingy and ordered that the seminary be given 20,000 *ducados* annually. Admittedly, such a brief account can provide no certain basis for understanding Chiriboga's character, but Salazar must have been familiar with Chiriboga's behavior since he also was a member of Quiroga's cabinet. Because Chiriboga was accused of misappropriating funds of the Seminary of the Incarnation, Salazar's clear implication that his former colleage did not have a generous disposition is particularly interesting.

The Foundation and Purposes of the Seminary

On January 20, 1581, the king gave Doña María a large grant of land near the royal palace for the establishment of a monastery or seminary.[61] In his declaration, the king expressed his belief that the institution would greatly benefit religious life in the capital. Doña María continued to seek the support of the king for her undertaking and, in her will of 1593, she boldly placed the seminary under his care.[62] In so doing,

[57] Rojas, 'Alonso,' 91. [58] Rojas, 'Alonso,' 87–91.
[59] Kagan, in Brown, *et al.*, *El Greco of Toledo*, 68. [60] Salazar de Mendoza, *Mendoça*, 315.
[61] González Dávila, *Teatro*, 260, transcribes the relevant document.
[62] Doña María de Córdoba y Aragón, Last Will and Testament, September 1, 1593, in Santiago Vela, 9:87. Santiago Vela published only part of Doña María's will. The original document is preserved in its entirety in the Archivo Histórico Nacional, Madrid: Sección de Consejos, Legaje No. 27.831, Expediente No. 4. (I will cite this document as Doña María de Córdoba y Aragón, Will, 1593. When I discuss passages which Santiago Vela transcribed, I will also cite the appropriate page in his article.)

she maintained that the dedication of the work to pious ends and the long service of her family to him and his forebears obligated him to offer his special protection to her foundation.

The king's declaration establishes that Doña María had not determined the specified purpose of the institution when she made her petition for land. Although Doña María dealt with various financial and architectural problems efficiently and directly,[63] she was unable to reach a decision concerning the purpose of the foundation for many years. In several letters, Alonso pleaded with her to decide whether the institution would be a seminary or a monastery, and he reminded her that the purpose of the foundation had to be determined before rules could be devised.[64] Doña María must have seriously considered making the institution a monastery because she prepared statutes for the 'Monastery of the Incarnation.' These provided for a very rigid adherence to the Primitive Rule with the addition of severe acts of penitence, which even Alonso found too harsh to be practicable.[65]

Alonso encouraged Doña María to found a seminary to train Augustinian preachers for the entire province of Castile,[66] and he probably originated the idea that the institution should be devoted to this purpose. Alonso's writings attest to his deep interest in the selection and education of young men for ecclesiastical duties,[67] and he undoubtedly perceived the foundation of a seminary as an opportunity to give meaningful expression to his ideas on this subject. On the other hand, the statutes which Doña María prepared suggest that she originally may have intended to establish a monastic community. Perhaps Alonso's appeals made her waver from her original intention and thus caused her indecision.

Although Alonso was dedicated to the goal of providing a good education for preachers, Doña María seems to have been distinctly less interested in meeting a specific religious need. In fact, Doña María baldly stated that her intention in founding an institution was to preserve her memory eternally:

> I will found an institution, where the memory of my name will never end.

> Dexaré un mayorazgo, donde no tenga fin la memoria de mi nombre.[68]

González Dávila maintained that, because of her reputation for humility, her contemporaries were stunned by the bluntness of Doña María's declaration.[69] Her primary concern for obtaining eternal glory through her foundation may explain why

63 Marías, 'De nuevo,' 449–451.
64 Cámara, *Vida*, 333–347; Alonso, 'Cartas,' 165.
65 Doña María de Aragón, 'Constitucion que el monesterio de la encarnación ha de guardar,' ed. T. Cámara, *Revista Agustiniana*, 4 (1889), 266–268; Alonso, 'Cartas,' 262.
66 Alonso, 'Cartas,' 262.
67 See the biography of Alonso at the beginning of this chapter.
68 González Dávila, *Teatro*, 259. 69 González Dávila, *Teatro*, 259.

she took so long to decide to establish a seminary. She probably felt that a community of friars dedicated to prayers and to penitential acts on her behalf would have been more effective than a seminary in promoting her salvation. Alonso must have been aware of this concern, for he argued that her spiritual health would be served by any well-run religious institution.[70]

References in Alonso's letters indicate that Doña María also hesitated for some time before deciding to entrust the institution to the Augustinian Order.[71] For example, in a letter that was clearly written from his residence on the site of the future seminary, where he moved in 1589, Alonso declared that he would not be able to remain there if it were not placed under the control of his order.[72] Apparently, Doña María had already persuaded him to accept burial in the foundation, because he also argued that he could not allow his tomb to be placed in an institution run by another order.[73] Further, he appealed to her to appoint two chaplains to pray for his soul and specified that both should be of the same order.[74] This request indicates that she may even have considered dividing control of the foundation among various orders.

The apparent uncertainty of Doña María about the affiliation of the institution is difficult to reconcile with other circumstances of the foundation, especially with her intention of involving Alonso in the project. Doña María's determination to have Alonso shape the character of the new institution is indicated by the persistence with which she prevailed upon the Provincial of the order to force him to accept the office of Rector, which he had at first declined.[75] It is difficult to understand how she could have appointed him to this office without assigning the institution to his order. Nevertheless, unless Alonso's anxieties were entirely unjustified, she must have hesitated about the government of the institution.

Alonso also found that Doña María unnecessarily delayed the consecration of the church.[76] In another letter which can be dated to 1591 on the basis of internal evidence, Alonso appealed to Doña María to have the church consecrated so that the sacraments of the Eucharist and confession could legitimately continue to be administered within it.[77] It is surprising that in 1591 Alonso needed to appeal to

[70] Alonso, 'Cartas,' 164–165.
[71] Cámara, *Vida*, 336–337; Zamora Lucas, 'El Colegio,' 225.
[72] Alonso, 'Cartas,' 264. [73] Alonso, 'Cartas,' 264.
[74] Alonso, 'Cartas,' 265. [75] Cámara, *Vida*, 336.
[76] Santiago Vela, 'Colegio,' 9:19–21. The church about which Alonso was concerned was the original church on the site, which should not be confused with the final larger church building for which El Greco's retable was commissioned. The evidence for the existence of two churches on the site of the seminary will be discussed in connection with the construction of the buildings later in the chapter.
[77] Alonso, 'Cartas,' 265. Alonso indicates that he is writing the letter on Saturday and that this is the feast of Saint Lawrence. Cámara determined that the letter must have been written in 1591, when the saint's feast did occur on a Saturday. See his n. 2 to the cited source.

Doña María to attend to this matter, because it is known that Alonso celebrated the first mass on the site of the seminary on April 11, 1590, and that the Archbishop of Cordoba installed the Sacrament on the altar on May 16, 1590.[78] Although it seems logical to suppose that the site of the altar had been consecrated before the Archbishop installed the Sacrament, Alonso's letter indicates that this may not have been the case.

It is obvious that Doña María's delays and hesitations caused Alonso to worry about the future of the project. However, by the time of his death in 1591, she had resolved that the institution would be a seminary of the Augustinian order, and the church on the site had been consecrated.[79]

In her testament dated September 1, 1593, four days before her death, Doña María de Aragón clarified the purposes and government of the Seminary of the Incarnation.[80] She declared that twenty members of the Augustinian Order were to be attached to the site and that they were to include sixteen students of theology, two professors, a confessor, and the Rector and preacher. The restriction of the seminary to twenty friars was probably influenced by Alonso's assertion that precisely this number of persons had constituted the original Christian community, which, he maintained, served as the inspiration of the Augustinian Reform.[81]

Students were to remain at the seminary for five years and were to take courses in doctrine, rhetoric, literature, and other subjects intended to prepare them for a career of preaching. Candidates appointed by the patrons were to be given first preference, but the Provincial and Definitors of the Order were empowered to make the final decision regarding the admission of students. In accord with Alonso's recommendations on the selection of young men for a religious career,[82] Doña María declared that candidates were to be evaluated in terms of both their moral character and intellectual achievement, but the former was to be the more important criterion.[83] Her stipulations indicate that she wanted only outstanding students to promote the reputation of her foundation.

Other aspects of Doña María's provisions for the seminary reflect Alonso's ideas. For instance, she recognized that students needed dispensations from the Rule, as Alonso had argued.[84] Thus, she declared that, because frequent attendance at Mass could interfere with their work, students were required to be present in the choir only on the solemn feasts of Easter, Saint Augustine, and Saint Monica. Students were granted certain privileges, such as the right to visit their families in Madrid once a month.

[78] Zamora Lucas, 'El Colegio,' 217. [79] Zamora Lucas, 'El Colegio,' 217.
[80] Doña María de Córdoba y Aragón, Will, 1593, at the Archivo Histórico, no pagination.
[81] Alonso, *Crónica*, lxx/r. [82] Alonso, *Crónica*, lix/r–lxii/v.
[83] Doña María de Córdoba y Aragón, Will, 1593, quoted in Santiago Vela, 9:83–84.
[84] Cámara, *Vida*, 342–343.

Alonso had been particularly concerned that the institution – whether seminary or monastery – be adequately financed with rents, for the necessity of raising funds would distract students from their theological training and monks from their devotions.[85] To ensure that the seminary had adequate financial resources, Doña María endowed it with rents totalling 1,376,872 *maravedís* secured from a bequest of five separate properties.[86] However, it should be noted, the Augustinians were not to receive control of the funds until the church and other principal buildings of the seminary were completed. Until that time, Pedro de Salzedo, her servant, was to supervise all disbursements, which were to be used exclusively for the construction and adornment of the buildings of the foundation.

The seminary fulfilled Alonso's goal of equipping young men for distinguished careers as preachers, and it was soon recognized as one of the most important Augustinian seminaries in Castile.[87] Because of the excellent reputation which the seminary enjoyed, many requested that it offer courses in arts and theology for lay-persons, and it began doing so in 1679.

Through the provisions of her will, Doña María also sought to ensure that the seminary would benefit her soul. She clearly stated that she was founding the seminary so that its members would work for the eternal good of herself and of the dead to whom she was indebted.[88] She commanded that sixteen masses were to be said every day in honor of all the dead whom she wished to be remembered, including one sung mass dedicated exclusively to her own soul.[89] Furthermore, she declared, permanent ownership of the collegial buildings was to be vested in a group of patrons, who were to permit the friars to occupy them only so long as they continued to pray for her repose. Because the friars at the seminary were committed to working for the salvation of the souls of all the members of her family, Doña María ordered the bodies of her relatives to be moved from the chapel that she had founded in San

[85] Cámara, *Vida*, 343.

[86] The properties and rents were as follows:

Three testamentary estates at Córdoba – annual rent: 705,622 *maravedís*
100,000 *maravedís*
100,000 *maravedís*
One at Ocaña – annual rent: 411,250 *maravedís*
One at Alcalá – annual rent: 60,000 *maravedís*

(Doña María de Córdoba y Aragón, Will, 1593, in Santiago Vela, 9:87.)

[87] Santiago Vela, 'Colegio,' 10:402.

[88] Doña María de Córdoba y Aragón, Will, 1593, quoted by Santiago Vela, 9:82.

[89] The accounts compiled by Alonso de Arevalo between 1597 and 1601 indicate that Doña María's stipulations were carefully recognized by the seminary, at least in the form of payment. Fray Hernando de Rojas was paid four *ducados* a day for saying these masses.

Alonso de Arevalo, 'Cuentas tocantes al Colegio de Nuestra Sra de la encarnacion de la orden de sancto Agustín que en esta villa de Madrid fundo y docto la Sra Doña Maria de Aragon,' Protocolo de Antonio Fernandez, no. 1601, Archivo Histórico de Protocolos, Madrid, 167/r. (The accounts will be cited as Arevalo, 'Cuentas.')

Felipe to the new church of the seminary.[90] Upon completion of the final church structure, the remains of Doña María and her parents were translated to the principal chapel in accord with the provisions of her will.[91]

It is clear from references in Alonso's letters to Doña María that she also wanted the friar to be buried on the site of the new foundation,[92] although her plans for his tomb have not been recorded. Considering the emphasis which she placed on the glorification of her own memory, she may not have been entirely pleased with Quiroga's command that Alonso's body was to be placed underneath the main altar. The presentation of Alonso's body in such a prestigious place would have virtually converted the entire church into a memorial to him rather than to Doña María and would certainly have made his tomb more prominent than hers.

Seventeenth-century sources confirm that Quiroga's intention was realized, although only for two decades. According to Herrera, who drew upon documents and contemporary accounts no longer available, Alonso's body was solemnly translated to the main altar of the principal church of the seminary in 1603.[93] Rojas's account of Alonso, which was probably prepared before 1619 when all the documents in support of his canonization were sent to Rome, simply states that Quiroga's plans for the burial of the friar directly underneath the table of the main altar had been carried out.[94] However, in 1623, the third Rector of the seminary, Pedro Zuazo, arranged for Alonso's body to be removed to a sumptuous tomb in the wall of a side chapel dedicated to Christ of the Good Death.[95] Supposedly, this was done to make the tomb more accessible to the faithful who wished to offer prayers to Alonso, but reliquary use of the main altar may have been considered too bold a gesture for one who had not yet been canonized.

The importance which the seminary attached to the remains of Alonso is demonstrated by the arguments presented in the *Memorial del Rector y Colegio de la Encarnación de la villa de Madrid, en favor de su sitio*, which was published in support of its claim to adjacent property belonging to the Duke of Sesa. Although this booklet is undated, it can be securely assigned to either 1622 or 1623 because the foundation is therein described as being more than forty years old and because the only legal suit resulting from this matter was resolved in 1623.[96] In this tract, the directors of the seminary maintained that its status and function substantiated its right to the land it needed and cited its possession of the relics of Alonso first among the factors justifying its claim. In addition to preserving Alonso's remains,

[90] Zamora Lucas, 'El Colegio,' 229.
[91] Zamora Lucas, 'El Colegio,' 229; and Santiago Vela, 'Colegio,' 9:164.
[92] Alonso, 'Cartas,' 262–265.
[93] Herrera, *Convento*, 396. [94] Rojas, 'Alonso,' 91.
[95] Zamora Lucas, 'El Colegio,' 218.
[96] Santiago Vela, 'Colegio,' 9:328–333.

the seminary served as a monument to him by educating young men for religious careers in accord with his principles.

Obviously, the officials of the seminary did not doubt that Alonso would soon be canonized, and they even claimed that he should replace Saint Isidore as the patron of Madrid. Because of his noble lineage and association with the court, Alonso was thought to be more worthy of veneration than Isidore, who had only been a poor laborer. Ironically, such arguments directly contradicted the spirit of humility which Alonso sought to inspire in his followers. Although the officials of the seminary overlooked certain of Alonso's principles, their belief in his sanctity and their commitment to the preservation of his remains cannot be doubted.

It might seem that the memory of Doña María was neglected because of the efforts of the seminary to glorify Alonso. However, the friars continued to work for her salvation by offering masses on her behalf. Furthermore, the institution was popularly known in her honor as the *Colegio de Doña María de Aragón*.

The Roles of the Patrons and Executors of the Estate

Doña María distributed authority for the completion and government of the seminary among several different people with overlapping lines of authority. Therefore, it should have been no surprise that a bitter legal dispute developed between certain of the persons involved in the project.

As has been noted, Doña María placed the seminary under the patronage of the king. But his role seems to have been purely honorary, and there is no indication that he involved himself in the undertaking.

Doña María nominated another important authority, Cardinal Quiroga, Archbishop of Toledo, as a patron of the seminary and requested that he oversee all the arrangements made for the institution.[97] However, the Cardinal (d. November 20, 1594) did not confine himself to inspection of the work of others and actively participated in the affairs of the seminary. Shortly after Doña María's death, Cardinal Quiroga endowed the institution with the rent of properties which he owned near Toledo and Illescas (with a total annual rent of 975,000 *maravedís*) and took for himself the estates which Doña María had assigned to the seminary.[98] This appropriation was in violation of Doña María's stipulation that none of the rents which she gave was to be in any way modified.[99]

[97] Doña María de Córdoba y Aragón, Will, 1593, at Archivo Histórico Nacional, no pagination. See also Zamora Lucas, 223.

[98] Briefly mentioned by Zamora Lucas, 'El Colegio,' 222. For full information, it is necessary to consult unpublished documents, especially Fray Hernando de Rojas, Declaration concerning the provisions of the Will of Doña María de Aragón, August 1, 1597, Legajo 27.831, Sección de Consejos, Archivo Histórico Nacional, Madrid.

[99] Doña María de Córdoba y Aragón, Will, 1593, at Archivo Histórico Nacional, no pagination.

As the principal patron of the seminary, Doña María nominated her brother, Don Alvaro de Córdoba, who was to be succeeded in this position by his descendants according to a scheme which she outlined.[100] He had the responsibility of supervising all the activities of the seminary, and he received such privileges as the right to be buried in it. However, his actual power was limited because she entrusted financial affairs to others.

Doña María gave Jerónimo Horaa de Chiriboga extensive authority in the execution of her will, including disbursement of her testamentary rents and direction of all financial matters concerning the seminary.[101] Although she declared that Chiriboga was to treat the funds of the estate as though they were his own, she effectively limited his authority by declaring that her former servant, Pedro de Salzedo, had to approve all payments from her estate until the seminary had been completed and properly furnished.

Father Hernando de Rojas, who succeeded Alonso as Rector of the Seminary, and the Jesuit Father Sebastian Hernández, who had succeeded Alonso as Doña María's confessor, were requested to inspect the construction on the site at regular intervals. Doña María also asked Rojas to assist Chiriboga in superintending the upbringing of her niece, Doña Elena. But she explicitly stated that she did not want Rojas to handle any other affairs of her estate and that Chiriboga alone had final say in all matters involving the seminary.[102]

Doña María further stipulated that the buildings of the seminary would not be considered to have been completed until all the patrons and the Provincial of the Augustinian Order had inspected them and found them satisfactory. While work was in progress, four to six friars were to remain on the site in order to say the required number of masses each day. They could request financial support from the estate, but they were not to control the funds. Only when the seminary was finished and twenty friars lived there would the Order be entitled to supervise the financial resources which she had left.

Although Doña María clearly indicated that she did not intend Rojas to supervise the construction of the seminary, he assumed an important role in the project shortly after her death. In a statement signed on October 6, 1593, Chiriboga and Rojas declared that henceforth they would share equal responsibility for the affairs of the seminary.[103] They maintained that, although Doña María had restricted the authority of Rojas to the care of her niece, she had actually wanted him to govern

[100] Zamora Lucas, 'El Colegio,' 224–225.
[101] Doña María de Córdoba y Aragón, Will, 1593, transcribed by Santiago Vela, 9:87–88.
[102] Doña María de Córdoba y Aragón, Will, 1593, at Archivo Histórico Nacional, no pagination.
[103] Chiriboga and Rojas, Declaration concerning the execution of the Will of Doña María de Córdoba y Aragón, October 6, 1593 (scribe: Francisco de Valdevieso), Protocolo no. 1578, Archivo Histórico de Protocolos, Madrid. (This document will henceforth be cited as Chiriboga and Rojas, Declaration, October 6, 1593.)

the disposition of her bequest to the seminary and had expressed the intention of modifying her will in this respect. However, it is unlikely that she actually proposed to make any such change. The numerous codicils in her testament demonstrate her willingness to finalize changes in her intentions; during the four days between the declaration of her original testament and her death, she could have included the nomination of Rojas among the many provisions she added. Moreover, the appointment of the Rector to a position of authority equivalent to that of Chiriboga would have been in direct contradiction of her stipulation that the friars attached to the foundation were not to control the site or funds until the buildings were finished.

All the contracts, accounts, and other documents issued subsequent to October 6, 1593, indicate that Chiriboga and Rojas together directed the construction and decoration of the seminary.[104] There is no suggestion in any of the documents that Chiriboga and Rojas ever consulted Don Alvaro de Córdoba concerning the affairs they supervised. Perhaps because he was frustrated by his impotence as a patron, Don Alvaro initiated a long legal suit against Chiriboga and Rojas in 1595.

Don Alvaro charged the two friars with violating the terms of his sister's will and with mishandling the financial resources which she had left to the seminary. Only the documents which Rojas and Chiriboga prepared in their defense have thus far been discovered, but these clearly established the charges which they were defending themselves against.[105]

Rojas and Chiriboga freely admitted that they had violated provisions of Doña María's will, including her appointment of Chiriboga as the sole executor of her estate. But they claimed that they always sought to comply with 'the spirit rather than the letter' of her intentions.[106]

Quiroga's exchange of rents of properties in his possession for those left by Doña María to the seminary greatly disturbed Don Alvaro, who suspected that the Cardinal and Chiriboga had benefited from this transaction. In a declaration of July 20, 1594, Chiriboga deposed that the Cardinal had been motivated by charity and Christian zeal and that the exchange had greatly benefited the Seminary because it was much easier to collect the rents from the Cardinal's properties, which were all located near Madrid, than from those of Doña María's bequest, some of which were located in Andalusia.[107] However, Don Alvaro's contestation of the Cardinal's

104 Some documents have been published by Bustamante, 'El Colegio,' 432–438. Others are available at the Archivo Histórico de Protocolos and Archivo Histórico Nacional, both in Madrid.

105 I have identified and reviewed the following collections of documents for the defense: Protocolos nos. 1578 and 1579 (scribe: Francisco de Valdevieso), Archivo Histórico de Protocolos; Libro no. 6.828, Sección de Cleros, Archivo Histórico Nacional; Legajo no. 27.831, Sección de Consejos, Archivo Histórico Nacional.

106 Chiriboga and Rojas, Declaration, October 6, 1593. See also Chiriboga's independent statement of January 11, 1594 (scribe: Francisco de Valdevieso), Protocolo no. 1578, Archivo Histórico de Protocolos, Madrid.

107 Chiriboga, Declaration on the disposition of the properties of Doña María de Aragón, July 20, 1594, Legajo no. 27.831, Sección de Consejos, Archivo Histórico Nacional, Madrid.

action appears to have been well founded because the Cardinal's properties were valued at only seventy per cent of those taken in exchange and provided an annual return in rents of 401,872 *maravedís* less than Doña María's endowment.

From the statements presented in their defense, it is clear that Don Alvaro had also accused Chiriboga and Rojas of falsely elevating the costs of construction and of receiving 'kickback' payments from the artisans. Not surprisingly, the friars maintained that their direction of finances was thoroughly responsible and correct.

In 1601, the Royal Council of Castile (*Consejo Real de Castilla*) finally settled the case in favor of Chiriboga and Rojas. However, the possibility that Don Alvaro's accusations were justified cannot be overlooked. Certainly, the friars had acted in violation of some of the provisions of Doña María's will. Furthermore, it seems likely that the Royal Council would have been reluctant to declare that a person as important as Cardinal Quiroga had been involved in shady business transactions. Throughout the trial, Chiriboga and Rojas emphasized their association with Quiroga by using the Cardinal's former attorney to represent them and by continually mentioning his name in their testimony.

The protraction of the trial ensured that the expenditures of the seminary were supervised by the Royal Council from 1595 to 1601. For this reason, a summary of the accounts, which is still preserved in the Archivo de Protocolos, was prepared.[108] Because these accounts detail all the expenditures on the seminary, they enable us to reconstruct the progress of its construction and decoration.

The Construction of the Seminary

A conventual building of some sort must have been erected by 1589, when Doña María persuaded Alonso to leave San Felipe and to reside on the proposed site of the seminary.[109] The historical account which Father Alonso de Villarroel prepared in 1679 on the basis of the early records indicates that a small church was completed and ready for use shortly after Alonso moved to the site.[110] This was intended only to serve the religious needs of the Augustinian community until the more imposing principal church was finished, when it would be converted into a small chapel where sick friars could hear Mass.[111] Because Alonso's room had a window overlooking the altar, the small church was probably part of a single conventual building, not a separate structure. Despite its size, a large congregation was attracted to the chapel by Alonso's sermons, and it replaced San Felipe as the preferred place of worship

[108] See n. 89 for full citation.
[109] Cámara, *Vida*, 336.
[110] Alonso de Villarroel, 'Vida de Alonso de Orozco' (1679), manuscript partly transcribed by Santiago Vela, 'Colegio,' 9:8–9.
[111] Alonso, 'Cartas,' 265.

of nobles attached to the court. From contemporary accounts, it is known that Alonso's funeral was held in this original or 'old' church.[112]

Work on the principal church must have progressed substantially by 1593 because in her will Doña María declared that a 'large part' of it had already been built. However, her provisions concerning the future translation of reliquaries and other devotional objects from 'her oratory' (the 'old' church) to 'her church' indicate that it was not yet ready for religious services.[113]

Because the detailed summary of expenses for the period from 1596 to 1600 does not mention any basic structural work, it seems certain that the principal church had been largely constructed by 1596, although work continued on the site. Until 1600, masons were employed to enframe doorways and other openings with dressed stone.[114] Payments for the floors in the church and its chapels were begun in 1598, and the last was registered on September 23, 1600.[115] On September 20, 1595, it was noted that the steps of the principal altar had been finished.[116] Beginning in 1598, sums were disbursed for such decorative work as the arms of the foundress and the gilding of the choir screen, which was already in place.

Although the adornment of the church continued through at least 1600, the church was solemnly inaugurated on January 5, 1599; and on December 15 of the same year, Father Luis de los Rios arrived from Rome with the papal Bull endorsing the foundation of the seminary.[117] Instruction of candidates seems to have commenced by 1597 because payments for the ordinary expenses of the Rector and students were recorded in August of that year.[118] Apparently, Doña María's stipulation that courses could not be offered until all the decoration was finished had also been disregarded by Chiriboga and Rojas.

The authorship of the final plans for the church is still uncertain. It is known that Juan de Valencia, a student and assistant of Juan de Herrera, provided the original design of the church in 1581 and that Francisco de Mora assumed control of the project after Valencia's death in 1591.[119] Because there is no concrete evidence as to how much of the principal church had been completed by 1591, we do not know how much of it could have been built under Mora's direction and to what extent he modified its final appearance. It is quite possible that Mora would have been content to retain Valencia's plans because both developed a similar manner, ultimately inspired by Herrera's work on the Escorial.

The appearance of the completed church has only recently been determined.

[112] Bulovas, *El amor divino*, 45.

[113] Doña María de Córdoba y Aragón, Will, 1593, Archivo Histórico Nacional, no pagination.

[114] Arevalo, 'Cuentas,' *passim*.

[115] Arevalo, 'Cuentas,' 170/v, 180/v, 181/v, 188/r.

[116] Arevalo, 'Cuentas,' 177/v. [117] Arevalo, 'Cuentas,' 200/v.

[118] Arevalo, 'Cuentas,' 167/r. [119] Marías, 'De nuevo,' 451.

During the Napoleonic wars, the church was virtually destroyed and the other conventual buildings were badly damaged. Shortly afterwards, the site was deconsecrated, and the Senate House was built there between 1820 and 1823.[120] However, the fate of the seminary was forgotten by the early twentieth century, and most historians mistakenly identified the oval Senate chamber with the original church.[121]

The representation of the seminary on the maps of Espinosa and Texeira reveals that the church had been a rectangular structure corresponding to the type known to have been favored by both Herrera and Francisco de Mora.[122] The nave was covered with a wooden gable roof and on both sides of it were four lateral chapels, divided by buttresses. From the outside, the crossing and presbytery appear to have been united in a square which was slightly wider than the nave and which was covered by a tall pyramidal roof of the type associated with the Escorial.

As was true of most ecclesiastical structures built in Madrid at the time, the exterior consisted of plain brick walls interrupted only by the windows and portals, which had simple stone frames. The entrance in the main facade was a rectangular dorway surmounted by a tympanum containing a statue of Saint Augustine by the Castilian sculptor, Luis Venero.[123]

Although there are no detailed records of the appearance of the interior in the early seventeenth century, it is safe to assume that its architectural articulation was as severe as that of the exterior, in accord with contemporary practice.[124] The records of payments indicate that the church was not lavishly ornamented. According to the accounts, it was decorated only with the four coats of arms of Doña María in the ceiling of the presbytery and the gilded and painted screens in front of the chapels, in addition to the tombs and the paintings and tabernacles on the altars.[125] Within this austere setting, El Greco's paintings must have stood out vividly.

El Greco's Commission for the Main Retable

The loss of the original contract for the main retable is especially to be regretted because it might have indicated the subjects which were to be represented and thus resolved all uncertainty about its contents. Unfortunately, there is not much hope

[120] Pascual Madoz, *Diccionario geográfico-estadístico-histórico de España*, 16 vols., Madrid, 1846–1850, 10:745–747.
[121] See Wethey, *El Greco and His School*, 2:9–10, for this interpretation, with extensive bibliography.
[122] A. Bonet Correa, *Iglesias madrileñas del siglo XVII*, Madrid, 1961, p. 53, n. to fig. 1.
[123] Arevalo, 'Cuentas,' 183/v.
[124] Bustamante, 'El Colegio,' 430, suggests how the interior might have appeared by comparing it to other conventual churches.
[125] Arevalo, 'Cuentas,' 174/v–175/v, 180/v, 184/v.

of recovering it until the files of the scribe who prepared it – Pedro Gomez de Mendoça – can be located.[126]

However, other documents provide information about some aspects of the commission. It is clear that El Greco received the commission before the end of 1596 because on December 20 of that year he authorized Francisco Preboste to handle financial matters, such as the record of expenses and the collection of payments, related to his work for the Seminary of the Incarnation.[127] In this declaration, El Greco also agreed to deliver his finished work within three years, so that it could be assembled in the church before Christmas of 1599.[128] However, El Greco did not ship the retable to Madrid until July of 1600.[129] The records of expenditures of the seminary established that El Greco was responsible not only for executing the paintings, but also for supervising the construction and gilding of the architectural structure, the execution and painting of the statues, the transport of all the parts from Toledo to Madrid, and their assembly in the church.[130] Although it has been suggested that two of El Greco's paintings were displayed on the side altars,[131] the final evaluation of the retable in August 1600 specified that his work was intended only for the main altar,[132] and Ponz's description of the church confirms that El Greco created only the principal altarpiece.[133]

It is possible that El Greco was already expecting the commission in 1595 because on February 28 of that year he appointed Melchor Ruiz de Bustos, a resident of Madrid, to handle all his business affairs in the capital,[134] although he did not then have any commissions there. Whether because the commission did not immediately materialize or for another reason, El Greco later released Ruiz de Bustos from his service so that, at the end of 1596, he had to request payment in Toledo because he had no agent in Madrid.[135] The legal complications which resulted from the suit initiated by Don Alvaro could have delayed the awarding of the commission.

[126] I discovered the name of this secretary in the summary of accounts prepared by Arevalo, 'Cuentas,' 196/v–197/r. However, I have been unable to locate the files of P. Gomez de Mendoça in any of the public archives of Madrid or Toledo. Furthermore, his name is not included in any of the catalogues of scribes available for many regional archives. The Director of the Archivo Histórico de Protocolos in Madrid suggests that the files of this scribe may be among the many lost during wars in the nineteenth and twentieth centuries.

[127] Francisco de Borja San Román y Fernández, 'De la vida del Greco,' Archivo español de arte y arqueología, 3 (1927), doc. 3, 161–162. (Henceforth cited as San Román, 'De la vida.')

[128] San Román, 'De la vida,' 162.

[129] Cf. Wethey, El Greco and His School, 2:8.

[130] Arevalo, 'Cuentas,' passim. See also San Román, 'De la vida,' doc. 6, 164.

[131] August L. Mayer, El Greco, 1931, 105–106.

[132] Esteban García Chico, 'Nuevo documento sobre El Greco,' Boletín del Seminario de Estudios de Arte y Arqueología, Universidad de Valladolid, vols. 22–24 (1939–1940), 235–236.

[133] Antonio Ponz, Viaje de España, ed. C. Maria de Rívero, Madrid, 1947, vol. 5, division 4, nos. 20–21, p. 460.

[134] San Román, El Greco, doc. 11, 156.

[135] San Román, 'De la vida,' doc. 4, 162–163.

Both El Greco's authorization to Francisco Preboste to act as his agent and the provision of the Royal Council which enabled El Greco to collect in Toledo the payments for his work on the seminary indicate that the Council was officially responsible for entrusting the artist with the project.[136] However, it is most likely that the Council did not originate the commission but simply approved it as part of its supervision of the activities of the institution. Probably, Chiriboga and Rojas, who are known to have commissioned all of the other architectural and decorative work at the seminary, also decided that El Greco should execute the altarpiece.[137] This supposition is confirmed by the fact that Chiriboga and Rojas, on behalf of the estate of Doña María de Aragón, chose representatives to evaluate the completed retable on August 23, 1600.[138] Most probably, Chiriboga, who was associated with Toledo as a member of Quiroga's cabinet and as a Canon of the nearby College of Talavera, initiated the idea of awarding the contract to El Greco.[139]

The final evaluation of the retable at 63,500 *reales*, proposed by Juan Pantoja de la Cruz, who acted on behalf of the estate, and by Bartolomé Carducho, who represented the artist, must have pleased El Greco because it was the largest fee that he ever obtained. Obviously, those in charge of assessing El Greco's work did not attempt to penalize him for delivering the altarpiece seven months after the date stipulated. However, El Greco did not promptly receive the money owing to him and was forced to institute legal action to get it.[140]

Although the fee for this commission has been generally considered to have been extraordinarily high, it should be remembered that the sum was intended to cover not only El Greco's paintings but also the fees of all the artisans who worked on the project.[141] It is worth noting that the artist's contemporaries almost always paid more for the enframing structures than for the paintings which they displayed.[142] The accounts of the expenses of the seminary mention disbursements of 1,750 *reales* to Francisco Pérez for gilding the main retable; this sum is described as part of the money owed to El Greco.[143] It is known that El Greco paid 1,800 *reales* to have the altarpiece shipped to Madrid.[144] We do not know what the retable looked like, but it may have been quite large and included several statues.

[136] San Román, 'De la vida,' docs. 3 and 4, 161–163.
[137] Bustamante, 'El Colegio,' 427–438; Marías, 'De nuevo,' 450–451.
[138] García Chico, 'Nuevo documento,' 235–236. [139] Bustamante, 'El Colegio,' 431.
[140] Jonathan Brown, 'El Greco and Toledo,' in J. Brown, *et al.*, *El Greco of Toledo*, Boston, 1982, 105 (henceforth cited as Brown, 'El Greco').
[141] See, e.g., Arevalo, 'Cuentas,' *passim.*; San Román, 'De la vida,' doc. 6, 164.
[142] Halldor Soehner, 'Greco en Spanien,' *Münchner Jahrbuch der bildenden Kunst*, vols. 8–11 (1957–1960), 11:173–174. The Cathedral of Toledo, for instance, paid 3,500 *reales* for the *Espolio* and 5,900 *reales* for the frame in which it was placed.
[143] Arevalo, 'Cuentas,' 197/r.
[144] San Román, 'De la vida,' doc. 6, 164.

The amount awarded to El Greco does not seem inconsistent with the sums distributed to others who worked at the seminary. For example, Alonso de Vallejo, sculptor, and Pedro de Torres, painter, received 19,500 *reales* for the construction and gilding of the frames for the side altars; the paintings which they contained were by another artist.[145] Juan Pantoja de la Cruz was paid 2,500 *reales* for painting four shields on the ceiling.[146] The seminary paid 200 *reales* to the artisans who inscribed two stone plaques and another 300 *reales* to Pedro de la Torre for gilding the letters of these plaques.[147] It is possible that all these fees were falsely elevated by 'kickbacks' to Chiriboga and Rojas, as Don Alvaro maintained. If the accusation made by the chief patron was correct, the payment to El Greco could have been delayed by an attempt on the part of Chiriboga and Rojas to retain part of their award for themselves.

Despite these considerations, the evaluation of El Greco's retable was certainly generous, and his work must have been of outstanding quality. This circumstance demonstrates the importance of reconstructing his retable for the Seminary of the Incarnation.

El Greco's Paintings for the Seminary

Twentieth-century scholars have assigned various paintings by El Greco to the Seminary of the Incarnation, but as yet no agreement has been reached concerning the full program of the retable. A new reconstruction based on historical, stylistic, and iconographic evidence will be proposed here.

The remarks of early commentators provide us with little assistance. Ceán Bermúdez, the only published writer who mentioned the program of the retable before its dismemberment, simply stated that it represented the life of Christ.[148] Palomino and Ponz did not mention the subjects of the paintings but concentrated on their style. Palomino, who did not like the retable, claimed that the paintings exemplified the 'deformation' of El Greco's late period, when he ignored the manner of Titian,[149] and Ponz briefly mentioned their 'extravagance,' which he thought was characteristic of the artist.[150]

[145] Bustamante, 'El Colegio,' 437. [146] Arevalo, 'Cuentas,' 174/r and 175/v.

[147] Arevalo, 'Cuentas,' 178/r and 180/r. Payments for various goods by the seminary give some indication of the relative value of the *real* and also demonstrate that the amount given to El Greco may not have been excessive. The seminary paid 1,100 *reales* for cloth to make five habits for the rector (176/v). Sixty *reales* were spent to buy food for a dinner given to the friars of San Felipe (176/v). Francisco de Castro and Hernando de Rojas were given 550 *reales* to cover the cost of their transportation to Madrigal (near Salamanca), where a chapter meeting of the Order was held in 1599 (173/r).

[148] Juan Agustín Ceán Bermúdez, *Diccionario de los más ilustres professores de las bellas artes en España*, 6 vols. (Madrid, 1800), reprint ed., Madrid, 1965, 5:12.

[149] Antonio Palomino de Castro y Velasco, *El museo pictórico y escala óptica* (1715 and 1724), reprint ed., Madrid, 1947, 841. [150] Ponz, *Viaje*, 640.

Despite the difficulties involved in reconstructing the original appearance of the retable, a concensus has emerged among modern art historians that it included at least three paintings: the *Incarnation* (now in Villanueva y Geltrú, on permanent loan from the Prado, 3.5 × 1.74 m.; fig. 18), the *Baptism of Christ* (now in the Prado, 3.5 × 1.44 m.; fig. 19), and the *Adoration of the Shepherds* (now in the National Museum of Art, Bucharest, 3.46 × 1.37 m.; fig. 20). Scholars have mainly disagreed about whether or not the retable contained other paintings and what these might have been. Although some authorities maintain that El Greco created only three paintings for the seminary, others have assigned up to three more paintings to it. Before considering these additional works, we will first look at the three which can be most securely considered as part of the retable.

It is virtually certain that the *Incarnation* was originally displayed in the main retable of the church of the seminary. According to contemporary accounts, the *Incarnation* from El Greco's original retable was displayed on the high altar set up between 1824 and 1835 in the elliptical senate chamber (built 1820–1823) after the government of Ferdinand VII had disbanded the assembly and allowed Augustinian friars to return temporarily to the former site of the seminary.[151] After the seminary was permanently dissolved in 1836, the painting was requisitioned for the Museo de la Trinidad, founded in 1838 to house paintings removed by the government from redundant convents and churches in Madrid, Alcalá, and Toledo. A painting by El Greco of the Incarnation, corresponding in size and iconography to the painting now in Villanueva y Geltrú, was recorded in the catalogue without indication of provenance.[152] Like the rest of the contents of the Museo de la Trinidad, the painting later became part of the collection of the Prado. In 1883, when El Greco was little esteemed in Spain, the *Incarnation* was transferred to Villanueva y Geltrú, a Catalan seaport. The very unusual iconography of this painting makes it unique among El Greco's many versions of the Incarnation and substantiates its connection with the seminary because it closely follows Alonso's meditations upon the event.

It is also likely that the *Baptism* formed part of the original retable. The 1893 catalogue of the Prado included the *Baptism* in the list of paintings formerly housed in the Museo de la Trinidad and noted that it came from the church of the Colegio de Doña María de Aragón.[153] Several factors support this assertion. The *Baptism* corresponds in style with documented works of the late 1590s,[154] and it would

[151] Madoz, *Diccionario*, 10:746.

[152] Gregorio Cruzada Villaamil, *Catálogo provisional historial y razonada del Museo Nacional de Pinturas*, Madrid, 1865, p. 150, no. 120.

[153] Pedro de Madrazo, *Catálogo de los cuadros del Museo del Prado*, Madrid, 1893, no. 2.124c. Pedro de Madrazo was able to consult many documents which are no longer extant.

[154] Wethey, *El Greco and His School*, 1:47–48.

logically form part of a program of Christ's life. As in the case of the *Incarnation*, the writings of Alonso help to elucidate its very complex iconography.

In 1926, it was first suggested that El Greco created the *Adoration of the Shepherds* now in Bucharest for the seminary,[155] and this proposal has been widely accepted.[156] The close correspondence of its measurements with those of the *Baptism of Christ* and the evident stylistic affinity of the two works suggest that they were conceived as panels for the opposite sides of a retable. The existence of autograph replicas with identical dimensions (both in the National Gallery of Rome; each 1.11 × 0.47 m.) further suggests that El Greco conceived them as a pair. As in the case of the *Incarnation* and the *Baptism*, the relationship of the iconography of the Bucharest *Adoration* to Alonso's writings further supports its connection with the seminary.

A number of scholars have maintained that the retable included only these three scenes of Christ's early career.[157] It has been suggested that these paintings were arranged as a triptych, with the *Adoration* on the left and the *Baptism* on the right. Although a few retables of this type were produced in Spain during the sixteenth century, this scheme would not have corresponded with the contemporary manner of adorning important altars in major cities.[158] Moreover, the arrangement of three paintings of approximately equal size on the same level would have differed greatly from the organization of El Greco's other retables. By its very nature, such a scheme would tend to diffuse the viewer's interest among the images. In contrast, El Greco generally sought to focus attention upon the center of his retables. In the main retable at Santo Domingo, El Greco achieved this goal by several means. He added side panels only to the lower storey and extended the central section into the attic, in which he displayed the *Trinity*. Moreover, he emphasized the large narrative paintings in the center by enframing them with columns, rather than with pilasters, which he had employed at the outer edges of the lower storey. Therefore, if the original altarpiece contained only three paintings, they were probably displayed in some format other than the triptych scheme.

Alternative proposals concerning the number of scenes represented in the retable have included four or six canvases. In 1926 and again in 1938, it was suggested that El Greco painted the large *Crucifixion of Christ* now in the Prado (3.1 × 1.69 m.; fig. 21) – as well as the *Incarnation*, the *Baptism*, and the *Adoration* – for the

[155] August Mayer, *Dominico Theotocopuli, El Greco*, Munich, 1926, p. 5, no. 16a (henceforth cited as Mayer, *Greco*, 1926).

[156] See Wethey, *El Greco and His School*, 2:9–11, with full bibliography.

[157] Wethey, *El Greco and His School*, 2:9–11; Camón-Aznar, *Dominico Greco*, 2:720–725; Francisco J. Sánchez-Cantón, *El Greco*, trans., Milan, 1961, 38; David Davies, *El Greco*, London, 1976, 14; Ellis Waterhouse, *El Greco*, New York, 1980, 8.

[158] Martín-González, 'Tipología,' 6, 38.

seminary.[159] It was further proposed that the four paintings were displayed in a horizontal row.[160] However, this sort of arrangement was virtually unknown in Spain, although it was common in medieval Germany.

Two other paintings have frequently been assigned to the seminary: the *Resurrection* (now in the Prado, 2.75 × 1.27 m.; fig. 22) and the *Pentecost* (Prado, 2.75 × 1.27 m.; fig. 23). Although it has been suggested that the *Resurrection* and *Pentecost* were displayed on the side altars,[161] most scholars have recognized that works by El Greco were shown only on the main retable. Recently, several writers have maintained that the *Crucifixion*, the *Resurrection*, and the *Pentecost* were displayed on the upper level of a two-storey retable.[162]

A number of arguments have been used to support the theory that the retable contained six paintings.[163] Obviously, the three additional paintings would complete the history of Christ's early life shown in the *Incarnation*, *Adoration*, and *Baptism*. Furthermore, the organization of the principal scenes in two storeys of virtually equal width would correspond to the pattern favored in Madrid, to which, it is supposed, El Greco might have been compelled to adhere in this case. Because the figures in the foregrounds of the *Crucifixion*, *Resurrection*, and *Pentecost* are projected from very low viewpoints, it has been assumed that these works were intended to be placed high above the viewer.

However, none of these suppositions provides a firm basis for establishing the original organization of the retable. Although it is possible that other events in Christ's life were represented in the retable, at least some of these could have been shown in sculpture. Most other sixteenth-century artists working in Madrid designed retables with six paintings of approximately equal size, but such a scheme would have been in direct conflict with El Greco's usual approach. Moreover, El Greco's manner of conceiving a scene did not necessarily reflect its original placement; in many late works, such as the *Apocalyptic Vision* (fig. 37), El Greco represented figures from an exceptionally low viewpoint in order to enhance their impact upon a viewer standing almost directly in front of them.

Most probably, the Prado *Crucifixion* constituted the fourth and final part of the series of paintings which El Greco created for the seminary. The primary arguments supporting the thesis that the retable contained the *Incarnation*, the *Adoration*, the *Baptism*, and the *Crucifixion* derive from the possibility of organizing them in a

[159] Mayer, *Greco*, 1926, 4, 5, 9, 17. Ludwig Goldscheider, *El Greco*, London, 1938, 23–24.

[160] Wethey, *El Greco and His School*, 2:10.

[161] Mayer, *Greco*, 1931, 105–106. Soehner, 'Greco,' 11:201–202, accepted this proposal.

[162] Manuel Gómez-Moreno, *El Greco*, Barcelona, 1943, 34–35; Zamora Lucas, 'El Colegio,' 233–234; Pérez-Sánchez, in Brown, *et al.*, *El Greco of Toledo*, 161–164.

[163] Pérez-Sánchez, in Brown, *et al.*, *El Greco of Toledo*, 161–164, presents the most detailed arguments in support of this position.

manner consistent with El Greco's other projects and from the distinctive icono-
graphy of these four paintings. However, the evidence that the *Resurrection* and the
Pentecost were created for another commission must be examined first.

Both Ponz and Palomino recorded a Resurrection by El Greco in the shrine behind
the main altar in the church of Nuestra Señora de Atocha in Madrid.[164] Palomino
praised the painting as 'an excellent thing' and described it as life-size. His
description could refer only to the canvas now in the Prado because this is El Greco's
only life-size representation of the Resurrection other than his earlier painting of
the scene for Santo Domingo el Antiguo.[165] It has generally and logically been
assumed that the *Pentecost* was originally paired with the *Resurrection* in the church
of Atocha because they are exactly the same size and have similar rounded tops.
Neither Ponz nor Palomino recorded the *Pentecost* at Nuestra Señora de Atocha.
However, it should be remembered, they were not compiling complete catalogues,
but only noting works that particularly attracted their attention.

Only a group of four paintings can be arranged in a scheme that accords with
El Greco's consistent manner of designing retables with the goal of focusing the
viewer's attention on the central images. However, previous scholars have maintained
that a program of six paintings at the seminary could have been organized in the
same manner as the small retable (4.0 × 5.0 m.) which El Greco and his workshop
produced in 1591 and 1592 for the parish church of Talavera la Vieja.[166] It has
generally been assumed that the retable at Talavera originally had two storeys with
three compartments each, as it did when it was photographed before its destruction
in 1936 (fig. 24). But there is every reason to suppose that the original structure
at Talavera included only the central section of the upper storey and that the side
panels on top were added by a later artist.

El Greco's contract, which was published in 1924, required him to produce a
statue of the Virgin for the center of the altarpiece and three paintings, including
two images of standing male saints for the sides and the *Coronation of the Virgin*.[167]
The location of the latter was not specified, but was presumably intended for the
upper storey, where it was displayed early in the twentieth century. Although the
contract was very detailed, it did not mention any additional panels or images. The
stipulation that the artist was to execute three paintings logically explains why only
three have been found which can be connected with this project. By the early
twentieth century, the two upper lateral panels of the retable contained paintings

[164] Ponz, *Viaje*, 417; Palomino, *El Museo*, 841.
[165] The other paintings of the Resurrection which have been associated with El Greco are neither life-size nor
 excellent. For a comprehensive analysis of these works, see Wethey, *El Greco and His School*, 2:70–71, 194.
[166] See, e.g., Pérez-Sánchez, in Brown, *et al.*, *El Greco of Toledo*, 161. On the altarpiece for Talavera, see Wethey,
 El Greco and His School, 2:7–8, with previous bibliography.
[167] José Ramón Mélida, *Catálogo monumental de la provincia de Cáceres*, 2 vols., Madrid, 1924, 2:343–345.

of a style entirely unrelated to El Greco's work.[168] It has generally been assumed that two canvases not mentioned in the contract were lost, but they probably never existed. Probably, the upper lateral panels were added to the altarpiece in the eighteenth century, when the statue of the Virgin was replaced.[169]

The removal of the upper lateral panels produces a structure which is more aesthetically pleasing and more closely related to the rest of El Greco's work (see fig. 25). Because the panels on the upper level provided a wider space for paintings than existed on the lower level, the ensemble seemed top-heavy. The sagging frames over these panels suggested structural weakness possibly resulting from inept addition to the original retable. The two levels of pilasters on the outer edges of the retable also contributed to the cobbled effect because they failed to balance the tall central columns adequately.

Without the upper lateral panels, the retable at Talavera would have been a reduced, greatly simplified and admittedly less skilfully executed version of the scheme that El Greco had used for Santo Domingo. As well as being similar in their basic form, the two altarpieces would have shared such details as the bracket over the lower arch and the use of columns in the middle and pilasters on the outer edges of the lower storey.

It is proposed here that El Greco returned to the underlying four-painting format when he designed the retable for the seminary. The reconstruction of the original appearance of the retable at Talavera establishes that he retained into the 1590s an interest in the type of structure which he had created for Santo Domingo. Chiriboga may have encouraged the artist to employ the scheme which he could have admired in the two earlier retables, including one in the town which he served as Canon of the College.

The *Incarnation*, the *Adoration of the Shepherds*, the *Baptism of Christ*, and the *Crucifixion* reveal a consistently innovative approach to the subject matter. In all these works, El Greco incorporated many motifs which were extremely rare, if not unique, in visual art. Because the writings of Alonso de Orozco explain the most unusual aspects of these paintings, it seems logical to assume that they were created for the institution which sought to glorify his memory. In contrast, the *Resurrection* and the *Pentecost* do not differ from standard representations of these subjects, and they lack the iconographic richness and complexity which characterize the works here assigned to the seminary.

In these four paintings, El Greco prominently showed angels assisting and worshipping the Godhead. The participation of celestial beings in these scenes follows the meditations of Alonso, who described the angels' contributions to each of these events. In more general terms, the depiction of angels can be related to

[168] Wethey, *El Greco and His School*, 2:7. [169] Cf. Wethey, *El Greco and His School*, 2:7.

Alonso's deep devotion to them and his numerous visions of being joined by them in his adoration of the Host. The absence of angels from the *Resurrection* and the *Pentecost* provides a further justification for excluding these paintings from the program. Alonso maintained that angels had also appeared at the Resurrection and at the Pentecost, and it seems unlikely that the artist would have excluded them if he had painted these subjects for the seminary.

The *Incarnation*, the *Adoration*, the *Baptism*, and the *Crucifixion* form a tightly knit program commemorating the benefits of the Eucharist and the importance of the vows of those who join religious orders. Alonso had repeatedly used the four events represented by El Greco to explain his great devotion to the Eucharist and his belief in the strict adherence to the three major vows of chastity, poverty, and obedience. Obviously, these themes were directly related to the purposes of the institution, which was obligated to work for the salvation of Doña María and her family and to prepare young men for careers as preachers. The celebration of the Mass was one of the principal ways in which Doña María intended the foundation to work for the benefit of her soul. According to Alonso, strict adherence to vows was the most important goal of religious education.

Alonso's description of both the consecrated Host and Christ's earthly life as didactic paintings could have influenced the conception of the program realized by El Greco. Alonso exhorted the devout to stimulate their adoration of the Host by imagining it to be a retable showing the life of Christ:

That sacred Host is a retable of all the mysteries that the Redeemer enacted on earth.

Aquella hostia santa: un retablo es de todos los misterios que el redemptor del mundo en este suelo obro.[170]

Furthermore, Alonso claimed, through his own existence Christ had composed a 'perfect portrait' of the standards required for the prelacy:

Such a perfect image of what is required today to be a priest, the Lord of the world painted by his own hand. This is apparent from these words: that the King of Heaven Jesus Christ Our Lord, made a portrait of himself as an excellent painter: he delineated himself with his own hand.

Una imagen tan perfecta, la qual el señor del mundo de su mano pinto: que de oy mas debea ser perlado. Parece en estas palabras: que el rey del cielo Jesu Christo nuestro dios, dio un retrato de si mismo y como excelente pintor: se debuxo con su propria mano.[171]

Because the program was based so clearly on Alonso's writings, it seems likely that it was intended to support the efforts of his followers to secure his canonization.

[170] Alonso de Orozco, 'Regla de la vida cristiana,' in *Recopilación de todas las obras*, 2 vols., Alcalá de Henares, 1570, I:ccxxviii/v.
[171] Alonso, *Epistolario*, 24/v–25/r.

Certainly, the burial of the friar directly underneath the altar above which the paintings were displayed would have encouraged worshippers to relate the scenes to his devotions and visions. Rojas, Manrique, and other of Alonso's followers believed that the intensity of his devotion to the Eucharist and his exemplary dedication to the vows of his profession provided sufficient justification for him to be recognized as a saint.[172] The visualization of Alonso's discussions of the Eucharist and the vows would have served to remind worshippers of some of the reasons that Alonso deserved canonization and encouraged them to work for this end.

In devising the program, the artist must have worked closely with his patrons because he could not have been expected to have been familiar with Alonso's many books. It seems likely that Rojas, who served as Alonso's confessor and directed the campaign for his canonization, took an active role in determining the content of the paintings and in identifying appropriate motifs in Alonso's writings for the artist to illustrate.

As at Santo Domingo, the artist would have been expected to devise appropriate visual forms for the patron's concepts. However, El Greco was no longer as dependent on earlier images as he had been at Santo Domingo and created astounding and exciting works which directly illustrate Alonso's meditations.

'The Incarnation'

El Greco's representation of the Incarnation for the seminary (fig. 18) is iconographically original and visually stunning. This painting, which was probably displayed in the central opening of the lower storey of the main retable, commemorated the dedication of the institution. To provide a basis for interpreting this painting in its context, the meaning of the Incarnation in Alonso's writings will first be reviewed.

In accord with Pseudo-Dionysius the Areopagite, Alonso maintained that the Annunciation to Mary involved the entire celestial hierarchy.[173] As both Dionysius and Alonso explained, angels of the highest ranks – seraphim and cherubim – communicate directly with God and hold responsibility for informing the lower ranks of the divine will and for stimulating their devotion. Therefore, God entrusted his announcement to a cherub, who supervised its passage down through the ranks until Gabriel was informed of his duty to present it to Mary. Alonso, who considered

[172] Rojas, 'Alonso,' 89–91; Manrique, *Sermon*, 124/v–126/v, 127/v–128/v.

[173] Alonso de Orozco, *Obra nueva y muy provechosa, que trata de las siete palabras que la Virgen sacratissima nuestra Señora hablo*, Medina del Campo, 1568, xix/r–xx/r (henceforth cited as Alonso, *Siete palabras*). Cf. Dionysius the Areopagite, *pseud.*, *Hiérarchie céleste*, in *Oeuvres complètes du Pseudo-Denys l'Aréopagite*, trans. and ed. Maurice de Gandillac, rev. ed., Paris, 1972, 212 (henceforth cited as Dionysius, *Hiérarchie céleste*).

priests and other professed religious to be 'the imitators of angels on the earth,' found that Gabriel's faithful delivery of God's message provided a model for the obedience of ecclesiastics to their superiors.[174]

Most of Alonso's meditations did not concern the Annunciation, the transmission of God's message to Mary, but the Incarnation itself – i.e., the actual conception of Christ in Mary's womb, the subject of El Greco's painting. Today, the two events are frequently assumed to have been simultaneous, and the distinction between them may seem of little consequence. But Alonso and his contemporaries carefully differentiated all the stages involved in the history of the redemption of mankind and minutely analyzed the significance of each of them.

Alonso followed traditional Christian beliefs in frequently emphasizing that the Incarnation had made salvation possible because God was able to absolve man of sin only through the sacrifice that he made in human form,[175] and the friar further stressed the importance of Mary's willing participation in the conception.[176] According to Alonso, the Virgin enjoyed free will like all other mortals and could have refused the divine commission to become the mother of Jesus.[177] Alonso imagined that Gabriel's announcement had provoked a 'a great battle' within Mary's spirit and that she felt tempted to reject the heavy burden that God sought to place upon her, even though she finally accepted his will because of her deep devotion to him.[178] The Virgin's active role in the Incarnation was demonstrated, Alonso claimed, because the Father engendered the Son in her womb only after she had uttered the 'miraculous words': 'Behold the handmaiden of the Lord; be it unto me according to thy word' (Luke 1:38).[179]

Alonso also posited that the Incarnation marked the moment when chastity was established as a basic vow of the religious vocation.[180] By asking the angel, 'How shall this be, seeing I know not a man?' (Luke 1:34), Mary declared that chastity was an angelic virtue, expressed her resolution to guard her purity, and thereby established this quality as one of the three essential obligations of all who seek to devote themselves to Christ.[181] Further, Mary resolved at this instant to assist all those who subsequently dedicated themselves to chastity by helping them overcome the bodily suffering to which this vow subjected them.[182]

Before this event, Alonso maintained, virginity had not been considered an

[174] Alonso, *Siete palabras*, xix/r–xx/r; Alonso, *Crónica*, lxxx/v.

[175] Alonso, *Epistolario*, 103/v. [176] Alonso, *Epistolario*, 104/v.

[177] Alonso, *Siete palabras*, xl/r and *passim*.

[178] Alonso, *Siete palabras*, xxxv/v–xxxvi/r.

[179] Alonso, *Epistolario*, 104/v. [180] Alonso, *Siete palabras*, xxx/r.

[181] According to Alonso, Mary's question did not cast doubt on the Father's intentions but simply expressed her resolution and presented a humble inquiry about the means by which the miracle would be achieved. Alonso, *Siete palabras*, xxix/r–xxx/r.

[182] Alonso, *Siete palabras*, xxix/r–xxx/r.

important aspect of devout life, for the Old Law had condemned sterility.[183] Alonso revered Mary as the first person to consecrate her virginity to God, and he found her devotion especially remarkable because she had no examples to follow. In selecting Mary as his mother, Christ gave proof of the high valuation which he placed on chastity.[184]

The belief that the Incarnation established chastity as a basic obligation of religious life would have been especially relevant to the goals of the seminary, which tried to impress upon its students the importance of faithful adherence to all of their vows. Alonso maintained that contemplation of this scene inspired willing acceptance of the burdens of the vow of chastity. In addition, the theme would have commemorated the memory of the chaste Doña María. Alonso emphasized that those who did not officially join religious orders but were moved by contemplation of the Incarnation to retain their virginity deserved praise in heaven and on earth.[185] It is possible that Doña María resolved to dedicate her foundation to this miraculous event because of her exceptional devotion to the virtue which it glorified.

In accord with traditional Catholic belief, Alonso emphasized that the Incarnation was repeated in every celebration of the Mass.[186] He explained that Christ's conception in Mary's womb recurred as the Host was transformed into the body of Christ by the priest's reiteration of Mary's acceptance of the divine commission: 'fiat mihi secundum verbum tuum' (Luke 1:38).[187] Alonso further compared the priest's privilege of holding the Host to Mary's conception and protection of the Child in her womb. Throughout his writings, Alonso expressed awe at the power of priests to conceive Christ on the altar and claimed that even angels admired and venerated these mortals, who had a privilege not granted to celestial beings.[188]

The Eucharistic aspect of the Incarnation would also have had a special meaning for the foundation which was obligated to celebrate several daily masses for the benefit of the souls of Doña María and her family. Furthermore, the illustration of the greatest privilege which ecclesiastics enjoyed would have been an appropriate theme for the main retable of the seminary which prepared men for service to the Church.

Alonso did not present his beliefs simply as abstract concepts. Instead, he explained his ideas in the context of his visionary re-creations of scenes. In his meditations upon the Incarnation and other events, Alonso tried to imagine every aspect of the actions and emotions of the participants and to envision all the details of the settings, including both ordinary physical elements and supernatural

[183] Alonso, *Siete palabras*, xxx/r; Alonso, *Epistolario*, 128/v, 132/r.
[184] Alonso, *Crónica*, cxxix/r. [185] Alonso, *Epistolario*, 104/v.
[186] Alonso, *Epistolario*, 104/v. [187] Alonso, *Epistolario*, 104/v.
[188] Alonso de Orozco, *Historia de la Reyna Saba*, Salamanca, 1565, 184/v–185/r.

transformations of the environment. However, he did not usually adhere to chronological sequence, nor did he try to re-create a setting as a whole 'in a single glance.' Instead, he concentrated at length upon one detail or aspect of a scene, in effect breaking up the event into a series of thematically related motifs and movements. Because every aspect of the event was fraught with significance for Alonso, his minute analysis of the scene provided the basis of his elucidation of his ideas.

El Greco illustrated the friar's meditations on the Incarnation and included in his painting many of the motifs which Alonso had analyzed at length. By bringing together images derived from many different meditations, El Greco created a concise visual summary of Alonso's prolific writings. Because El Greco's painting has a coherence and directness which Alonso's rambling accounts lack, it can still have a direct impact on the modern viewer, while the friar's writings are likely to seem incoherent today. El Greco vividly captured the passion with which Alonso discussed the Incarnation. Many elements contribute to the emotionally intense mood of his painting: the stylized but deeply moving facial expressions and gestures, the emaciated proportions which enhance the upward striving apparent in the poses, the brilliantly lit clouds and heads of cherubim which close off the background, and the bold application of paint, especially notable in the white slashes on Mary's robes.

Appropriately, the artist utilized conventional motifs to visualize the most traditional aspects of Alonso's commentary. El Greco, like many other sixteenth-century painters, showed Mary kneeling at a prie-dieu with an open book upon it, thereby illustrating the belief common to Alonso, Saint Thomas of Villanueva, and other Marianists that the Virgin was in the midst of her prayers and pious reading when Gabriel arrived.[189] The sewing basket, another common motif which appears in the foreground of El Greco's painting, was supposed to contain the veil which Mary was engaged in creating for the tabernacle of the Temple.[190]

In contrast to most other artists, El Greco excluded all other references to the Virgin's chamber and filled the scene with clouds and cherubim. As in the altarpieces for Santo Domingo, the elimination of most of the vestiges of a conventional setting encourages the viewer to interpret the event in spiritual terms, but the brilliantly lit clouds filled with cherubim have a powerful, hallucinatory impact which the plain backgrounds in the earlier paintings lack. The artist's innovative handling of the setting illustrated Alonso's description of the moment of the Incarnation. Although Alonso detailed all the furniture and decoration of the Virgin's room, he declared that it had been transformed by the appearance of divine light and celestial beings

[189] Alonso, *Siete palabras*, xxlx/r; Saint Thomas of Villanueva, *Sermones*, 235–236, 241, 247–248.
[190] Allen Rosenbaum, *Old Master Paintings from the Collection of Baron Thyssen-Bornemisza*, Washington, D.C., 1979, no. 55. Alonso, *Siete palabras*, xxlx/r; Saint Thomas of Villanueva, *Sermones*, 247–248.

at the precise moment she accepted God's commission, and El Greco vividly depicted this miraculous occurrence.

Through her gesture, expression, and pose, El Greco visualized the Virgin's acquiescence. He depicted her with her right hand held palm outwards in front of her breast, in accord with a formula that was often used in ancient and later art to signify adoration.[191] Through this device, the artist illustrated Alonso's declaration that Mary's absolute devotion to God impelled her to accept the divine commission.[192] The extension of the left arm away from her body, with her left hand held palm downwards and raised only slightly above the level of the horizontal, suggests that the Virgin is seeking to keep something at a distance. Probably, the artist was trying to express Mary's rejection of her temptation to deny the divine will. Her face expresses both her humility, which led her to accept the divine command, and her sorrowful realization of the pain she will have to endure. Because the Virgin was frequently shown kneeling at her prayer stand in representations of the Annunciation, we cannot be certain that the artist intended her pose to have a special significance. Nevertheless, it should be noted, her pose accords with the meditations of Alonso, who maintained that Mary knelt specifically in order to reveal her submission to God's will.[193]

In portraying Gabriel, El Greco explicitly illustrated Alonso's description of the Archangel's reaction to Mary's acceptance of her role as the Mother of Christ. According to Alonso, Gabriel crossed his arms in front of his chest and gazed at Mary in wonder after she had accepted the divine commission.[194] The representation of the Archangel in this attitude, rather than in the conventional pose of the Annunciation in which his arm is extended toward the Virgin, clearly establishes that the moment of Christ's conception is shown.

Both the figure of Gabriel and the cloud beneath him are devised so that they seem to extend beyond the other elements in the foreground out into the viewer's space. In the original setting above the altar table, this illusionistic projection of the Archangel would have created the impression that he was adoring the Host in the tabernacle which must have been displayed in front of the painting. This effect would have visualized Alonso's belief that Archangels descend to earth and join mortals in worshipping before the altar when the Incarnation is re-enacted through the transformation of the liturgical bread into the body of Christ.

El Greco's representation of the descent of the Dove also corresponds with the account of Alonso, who maintained that the Spirit was literally enflamed by intense

[191] Richard Brilliant, *Gesture and Rank in Roman Arts*, Memoirs of the Connecticut State Academy of Arts and Sciences 14, New Haven, 1963, 23–25.
[192] Alonso, *Siete palabras*, xl/r.　　　[193] Alonso, *Siete palabras*, xxxix/r.
[194] Alonso, *Siete palabras*, lvii/v.

love as it approached the Virgin.[195] The bright yellow surrounding the Dove and the streaks of yellow reflected in the clouds vividly represent the Spirit's ardor. Furthermore, the resplendent white highlights which cover the Virgin's garments suggest the impact of the fiery Spirit upon her.

Among the most unusual and immediately striking elements of the paintings are the ranks of cherubim. The patrons may have requested that the artist include these celestial beings to illustrate the idea that heavenly hosts accompany Christ everywhere and continually adore him.[196] By ranging cherubim alongside the light-filled space extending from the Dove to Mary, El Greco showed that the divine essence had filled this area and was in the process of being transmitted to Mary. Additionally, because cherubim were responsible for ensuring that the Archangel followed his orders, their proximity to Gabriel would also illustrate the functioning of the celestial hierarchy.

El Greco's handling of the cherubim could have been inspired by the description of them in the *Celestial Hierarchy* of Pseudo-Dionysius the Areopagite, which was included in the artist's library.[197] According to Dionysius, angels of this rank were immaterial so that they were able to receive and reflect divine light.[198] El Greco illustrated this concept by painting the heads and wings of the cherubim freely and loosely, without precise contours, and by differentiating their heads only slightly from the brilliantly lit clouds which encompass them. Through the rapid brushstrokes and the variety in the positions of the heads, the artist also evoked their swirling movement around God, which Dionysius had described.[199]

At the top of the painting, El Greco showed angels of another rank playing a variety of musical instruments to celebrate the conception of Christ. Although glories of angels bursting into Mary's chamber became increasingly common in paintings of the Annunciation and the Incarnation after the first quarter of the sixteenth century,[200] angelic musicians were not usually included among them. Most probably, El Greco's representation of this group was inspired by Alonso's description of the heavenly music which marked the Incarnation. According to the friar, one angel began to sing at the moment of the conception, and others quickly responded by singing and playing instruments so that the heavens were soon filled with their music.[201]

Between Mary and the Archangel, El Greco introduced the Burning Bush which had previously appeared to Moses (Exodus 3:2–5). Alonso maintained that the Burning Bush had miraculously reappeared in Mary's chamber at the moment of

[195] Alonso, *Siete palabras*, xxxii/v–xxxiii/r.
[196] See, for example, Alonso, *Epistolario*, 117/r; Alonso, *Reyna Saba*, 184/v.
[197] San Román, *El Greco*, doc. 52, 196. [198] Dionysius, *Hiérarchie céleste*, 209–210.
[199] Dionysius, *Hiérarchie céleste*, 211. [200] Mâle, *L'art religieux*, 1953, 240.
[201] Alonso, *Siete palabras*, xlvii/r.

the conception.[202] In effect, the bush replaced the potted palms and vases of flowers which had been included in many medieval and later representations of the Annunciation and Incarnation. Few earlier representations of the Incarnation with a Burning Bush can be identified,[203] and it was quite certainly included at the specific request of the patrons, who recognized the importance of this motif in Alonso's meditations.

From an iconographic point of view, it is most surprising that the Burning Bush had not been previously represented in scenes of the Incarnation. The Church had long considered it to be a symbol of the virgin birth and, in fact, the Roman Breviary defined it in this way in the liturgy of the Octave of the Birth of Our Lord.[204] Sixteenth-century Marian authors frequently associated the Burning Bush with the Incarnation.[205]

In his writings, Alonso referred repeatedly to the appearance of the Burning Bush at the Incarnation and assigned it meanings which are particularly relevant to the program of the retable. In accord with the Roman Breviary, Alonso described the bush as a symbol of the virgin birth.[206] He claimed the fire of God's presence had descended upon Mary in the same way that it had come upon the bush. Just as the leaves of the bush remained alive in the midst of the flames, Mary retained her purity while experiencing the full ardor of God's love and conceiving his Son.

For Alonso, the Burning Bush was an ideal symbol of the vow of chastity to which all members of religious orders were committed.[207] According to him, the intense love which God inspired in the devout enabled them to retain their purity as intact as the leaves of the bush, which were consumed by flames but did not wither. For those familiar with Alonso's meditations, the prominently placed bush would have expressed the belief that the Incarnation had established chastity as an obligation of religious life. Interpreted in accord with Alonso's ideas, the Burning Bush would have also commemorated the virtue to which Doña María was particularly dedicated.

Alonso further described the Burning Bush as a prototype of the Real Presence

[202] Alonso, *Siete palabras*, lvii/r.

[203] I have examined images recorded in the Index of Christian Art (Princeton) and in published sources. Nicholas Froment illustrated the relationship of the Burning Bush to the Annunciation by showing Mary and the Child seated on the Bush, before which Moses kneels (see Enriquetta Harris, 'Moses and the Burning Bush,' *Journal of the Warburg and Courtauld Institutes*, 1 (1937–1938): 281–286). Harris suggests that the angel was meant to evoke the Annunciation. Titians's *Annunciation* (1560–65, San Salvatore, Venice) is inscribed with Exodus 3:2. David Rosand, *Painting in Cinquecento Venice: Titian, Veronese, Tintoretto*, New Haven, 1982, 73–75, argues that the loosely painted branches at the lower right represent the Burning Bush.

[204] From the Octave of the Birth of the Lord: 'Rubum quem viderat Moyses incombustum, conservatam agnovimus tuam laudabilem virginitatem.'

[205] E.g., Saint Thomas of Villanueva, *Sermones*, 306. [206] Alonso, *Siete palabras*, lvii/v–lviii/r.

[207] Alonso, 'Desposorio espiritual,' in *Recopilación*, 1570, 1:cccxiii/r (henceforth cited as Alonso, 'Desposorio').

in the Host, which could contain the full divine being without suffering destruction.[208] He maintained that priests should approach the altar in the humble, reverent manner that Moses came near to the bush. In accord with these theories, the bush in El Greco's painting would have symbolized the nature of the miraculous transformation which recurred whenever a priest initiated the re-enactment of the Incarnation in the Mass.

While the Burning Bush vividly signified the reality of the divine presence on the altar, the veil of the Temple in Mary's sewing basket represented the liturgical bread and wine which 'clothed' Christ's body during the Mass.[209] Alonso explained that these 'veils' were necessary because men on earth could not look upon the full divine essence. By placing the Burning Bush directly behind the sewing basket, El Greco illustrated the belief that the Host contained within it the full divine presence. The depiction of the veil in Mary's sewing basket emphasized her role in establishing and preserving the Eucharist.

El Greco must have worked closely with his patrons in order to produce an altarpiece that so well visualized Alonso's meditation on the Incarnation. However, it is important to realize, El Greco was not simply an executor of motifs given to him by others, but a full creative participant in a fruitful collaborative effort. While El Greco depended upon literary material which his patrons must have explained to him, he invented original visual devices to express their concerns. For instance, by creating the impression that Gabriel projected into the viewer's space, El Greco illustrated Alonso's belief that angels adored the Host on the altar. The pose of Gabriel, the rows of cherubim surrounding the light-filled space between Mary and the Dove, and the musical celebration all help to establish that the actual moment of the conception is represented. By placing the Virgin's sewing basket next to the Burning Bush, El Greco illustrated Alonso's discussions of the Eucharist. Moreover, El Greco's handling of forms conveyed the emotional intensity of Alonso's meditations.

'The Adoration of the Shepherds'

Like the *Incarnation*, the *Adoration of the Shepherds* (fig. 20) represents an event that Alonso discussed frequently. For Alonso, God's call to the shepherds demonstrated his love of the poor, indicated the necessity of a vow of poverty, and provided other lessons about the duties of ecclesiastics. Moreover, Alonso interpreted the adoration of Christ by the shepherds as one of the stages of the Mass.

In discussing the adoration of the shepherds, Alonso revealed some of the same concerns that appear to have influenced Don Diego's selection of this subject for the program at Santo Domingo. Like Don Diego, Alonso strongly opposed any

[208] Alonso, *Epistolario*, 79/r–v. [209] Alonso, *Epistolario*, 77/v–78/r.

requirement of noble lineage for benefits or offices of the Church.[210] Both these ecclesiastics were themselves descended from noble families, but their comprehension of the Gospel message led them to refuse any special privileges for their own class.

For Alonso, the shepherds who came to adore the Child exemplified the ideal type of prelate because of their poverty, humility, and deep love of God.[211] He claimed that Christ's decision to be born near the poor shepherds and to have his birth announced first to them proved that God esteemed the humble more than the proud and wanted them, rather than those with pretensions to noble status, to be the leaders of his Church.[212] Further, Alonso maintained, the circumstances of Christ's birth demonstrated that those who wanted to enter the services of the Church had to renounce material possessions and make a vow of poverty.[213] The shepherds typified the men of 'good will and desires' who were worthy to adore and hold Christ at the altar because their freedom from material concerns enabled them to love him fully.[214] According to Alonso, the rich, represented by the Magi, arrived at the manger after the shepherds because they were spiritually as well as physically further from God.[215] Because the wealthy could only hope to come near God through good works, Alonso encouraged them to devote their resources to alms-giving and to religious institutions, such as the seminary which he persuaded Doña María to endow.

Alonso believed that candidates for religious orders should stimulate their commitment to the vow of poverty by meditating upon the Nativity and the Adoration of the Shepherds.[216] First, he recommended, they should consider the poverty of Christ's birthplace and try to evoke all of its disagreeable aspects, including its smells and filth. In doing this, they would obtain a model for the circumstances in which they should live themselves.[217] Next, they should concentrate upon the exemplary devotion of the shepherds and realize that this depended on their poverty. Contemplation of the shepherds' lowly condition would inspire candidates to accept the burdens of a vow of poverty because it revealed the reward of directly seeing God that would be enjoyed by all who fulfilled it.[218] In accord with Alonso's writings on this theme, El Greco's painting of the Adoration of the Shepherds was probably intended to reaffirm the commitment of the religious to poverty, just as the *Incarnation* glorified chastity.

Following a long Christian tradition, Alonso maintained that the care of the shepherds for their animals exemplified the supervision of prelates for all the faith-

[210] Alonso, *Epistolario*, 35/r. [211] Alonso, *Epistolario*, 83/r.

[212] Alonso, *Epistolario*, 83/r–v.

[213] Alonso, *Epistolario*, 25/r; Alonso, *Crónica*, lxvii/r–v.

[214] Alonso, *Epistolario*, 111/r. [215] Alonso, *Epistolario*, 83/r; see also 84/v.

[216] Alonso, *Crónica*, lxviii/r; Alonso, *Epistolario*, 86/v.

[217] Alonso, *Crónica*, lxviii/r. [218] Alonso, *Epistolario*, 86/v.

ful under their jurisdiction.[219] In imitation of the shepherds who remained awake all night to watch their flocks, prelates must be vigilant in overseeing members of the Church. The circumstance that the shepherds received the angels' message only because they were caring for their flocks indicated the benefits to be derived from the meticulous fulfillment of duties. Alonso was particularly concerned that bishops make certain that Mass was being regularly and correctly performed in all the parishes under their rule. Furthermore, the friar maintained, Church officials must be especially zealous in caring for the poor because God's call to the shepherds demonstrated his love for those suffering material deprivations.[220]

Like the authors cited in conjunction with the program at Santo Domingo, Alonso interpreted the circumstances of the Nativity in Eucharistic terms. He imagined that the Child was again lying in the manger in the stable at Bethlehem during each celebration of the Máss. In the *Regla de la vida christiana*, Alonso explained that during the celebration of the Mass the church was transformed into Bethlehem and the altar became the Child's crib:

Here is the mystery of the Nativity. Thus, Bethlehem, the house of bread, is the church, and the crib is the holy altar where the Child is lying, wrapped in the humble cloths, which are the 'accidents' of bread and wine. Here come the angels singing 'Gloria,' just as they came there.

Aqui esta el misterio de la natividad pues Bethlehem casa de pan es la yglesia y el pesebre el sancto altar adonde el niño Jesus esta reclinado embuelto en pobres paños que son accidentes de pan y vino. Aqui vienen cantando Gloria los angeles tambien como vinieron alli.[221]

For Alonso, the description of the liturgical bread and wine as the swaddling clothes covering the Child was not simply an abstract theological concept, for after consecrating the Host he was privileged many times to view the Child contained therein.[222] Because of the recurrence of the scene in the Mass, the *Adoration of the Shepherds* continued the Eucharistic imagery of the *Incarnation*.

In creating the *Adoration of the Shepherds* for the retable of the seminary, El Greco retained many elements from his painting for Santo Domingo but eliminated the half-length figure of Jerome in the foreground, added new motifs, and made other changes. It seems likely that the two versions of the Adoration were partly intended to express ideas and concerns shared by the patrons, specifically the role of the poor in the Church and the repetition of the Nativity in the Mass. At the same time, the artist's modifications of his earlier painting were probably supposed to visualize

[219] Alonso de Orozco, *Declamationes in omnes solemnitates, quae in festivis sanctorum in ecclesia Romana celebrantur*, Salamanca, 1573, 36/v.

[220] Alonso, *Epistolario*, 43/v. [221] Alonso, 'Regla,' 1:ccxxiii/v.

[222] Cámara, *Vida*, 296.

concerns of special importance to his patrons at the seminary. In order to avoid unnecessary repetition of analysis, features unique to the painting now in Bucharest will be the primary focus of the present discussion.

Particularly striking in the *Adoration* for the seminary are the strong contrasts of light and shade. Although the painting at Santo Domingo shows the shepherds gathering at night, the illumination of the central group of figures surrounding the crib is comparatively even and consistent. In the Bucharest painting, the shadows are stronger and the darkness more pervasive, making the Child and the swaddling cloth stand out even more vividly than in the earlier version.

The strong contrasts in the Bucharest canvas serve to illustrate Alonso's vivid descriptions of the battle between light and darkness which occurred at the stable as the forces of evil tried to diminish the radiance of the Child.[223] Furthermore, certain details of the lighting correspond to Alonso's meditations. For example, Alonso maintained that the Virgin, who knelt before the manger, received more light from the Child than any other being, as is the case in El Greco's painting.[224] The less intense, but still bright illumination of the angel can be related to Alonso's assertion that the angels surrounding the crib glowed with the light radiating from it. The light bursting through the openings of the vaults seems to express the miracle of Christ's assumption of human form, which filled Alonso with awe.

In the *Adoration* for the seminary, El Greco, like many Italian artists of the second half of the sixteenth century, represented the Virgin lifting the swaddling cloth from the Child.[225] El Greco probably found this formula an excellent means of illustrating Alonso's statement that the Virgin displayed her Son to the shepherds.[226] By linking Mother and Son, Mary's gesture emphasized the Child's dependence upon her and thus visualized Alonso's belief that, without her, the shepherds would have had nothing to adore.[227]

Because of the Eucharistic meaning which Alonso assigned to the swaddling cloth,[228] Mary's handling of it affirms her role in the foundation of the Church and the preservation of its sacraments. The radiance of the cloth also expresses the miraculous character of the transformation that occurs during the Mass.

Through his subtle but eloquent language of gestures, El Greco represented the elderly man behind Mary fulfilling the role which Alonso assigned to Joseph. According to the friar, Joseph spoke of Christ with the shepherds and directed them to him.[229] On the far left, a shepherd salutes Joseph, who returns the man's gaze and indicates that Christ is the one who should be worshipped by pointing directly

[223] Alonso, *Crónica*, 371/v.
[224] Alonso, *Declamationes in omnes*, 39/r.
[225] Mâle, *L'art religieux*, 1953, 246.
[226] Alonso, *Declamationes in omnes*, 38/r.
[227] Alonso, *Epistolario*, 95/v.
[228] Alonso, 'Regla,' 1:ccxxiii/v.
[229] Alonso, *Declamationes in omnes*, 41/v.

at the crib with his left hand and by directing the frontal gesture of adoration of his left hand toward the Child. This exchange of glances and gestures both leads the shepherd to Christ and demonstrates the reverence with which the Child should be approached. The placement of Joseph directly behind Mary shows that his role is secondary to hers but, at the same time, expresses his function of protecting and caring for the other members of the Holy Family.

Throughout his writings, Alonso praised the shepherds' humble worship of the Child. He claimed that their adoration of the Child should inspire priests to adopt an appropriately reverent attitude at the altar.[230] The kneeling shepherd in the immediate foreground of the right side of the painting well exemplifies the attitude which servants of the Church were supposed to adopt. Next to him stands another shepherd, who extends his arms out and turns his palms toward the altar. El Greco may have devised this pose to illustrate Alonso's pronouncement that the priest must open both his hands toward the altar in order to show that he offers Christ his will and his works before he consecrates the Host.[231]

In the painting now in Bucharest, El Greco included an angel in the group around the crib; this figure does not recur in any of the many other versions which the artist and his workshop produced. The angel's bowed head and crossed arms, which convey his adoration of the Child, follow the pose of Gabriel in the *Incarnation*. It seems most probable that the artist included this figure to illustrate Alonso's belief that celestial beings knelt with the shepherds to worship the Child.[232] For Alonso, the descent of angels to earth to adore the Child in the company of men proved that Christ provides spiritual food for heavenly as well as earthly beings. By representing the shepherds directing their adoration entirely toward the Child and not to the angels, El Greco expressed the idea that men become 'brothers of angels' and enjoy complete equality with them through their mutual worship of God.[233]

In the left foreground, El Greco introduced elements that clarified some of the didactic intentions of the work. In accord with a long Christian tradition, the bound lamb before the crib visualizes the metaphoric description of Christ as the Lamb of God, crucified to atone for the sins of mankind and again sacrificed in every celebration of the Mass. By showing the lamb's legs already tied together, El Greco emphasized the inevitability of the sacrifice. Although the animal had long been a common symbol of Christ, it is nevertheless interesting to note that Manrique's funeral oration for Alonso described the sacrifice of the Lamb as the primary symbol of the Eucharist to which Alonso was dedicated.[234]

By placing the shepherd's staff along the back of the lamb, the artist visualized

[230] Alonso, *Declamationes in omnes*, 40/r; Alonso, *Epistolario*, 117/v.
[231] Alonso, *Declamationes in omnes*, 40/v. [232] Alonso, *Declamationes in omnes*, 40/r–41/v.
[233] Alonso, *Declamationes in omnes*, 40/r. [234] Manrique, *Sermon*, 114/v.

the special obligation of bishops to ensure that the sacrament was performed in an appropriate spirit in all churches under their jurisdiction. Because of its resemblance to a bishop's crozier, the staff in El Greco's painting also expressed Alonso's belief that shepherds typify the sort of men God wants to govern his Church. The prominent placement of this motif in the foreground on a diagonal to the picture plane may have been inspired by Northern versions of the Adoration of the Shepherds, such as Dürer's Paumgärtner Altarpiece (1503–04).

In the background of the Bucharest *Adoration*, El Greco depicted the ass, representative of the Gentiles, but surprisingly eliminated the ox, the symbol of the Hebrews, with which it was usually paired. The representation of only one of the animals may reflect the current political climate of Spain and Alonso's fanatic advocacy of the idea that the government should execute anyone suspected of being Jewish.[235]

The ruined structures in the Bucharest painting may have been intended to represent the actual site of Christ's birth and thus to illustrate Alonso's declaration that each church is transformed into Bethlehem during the celebration of the Mass. Because El Greco had not shown any architectural elements in his earlier version for Santo Domingo, it seems likely that he included them here at the specific request of the patrons.

That the artist tried to visualize Christ's birthplace accurately is suggested by the correspondence of the setting to the description of Bethlehem published by Aranda during the mid sixteenth century.[236] According to Aranda, the stable was no longer extant and the site was filled with the ruins of various monastic structures. El Greco represented the ruins described by Aranda, including remnants of high walls covered with dense vegetation and large arches supported on tall columns. Further, the artist suggested the impressive vistas which they were supposed to have created by showing arches and fragments of walls receding into the distance.

In the Bucharest *Adoration*, El Greco gave considerably more prominence to the angels who announce the birth of the Messiah than in any of his other paintings of this theme except that which he produced near the end of his life for his own tomb; in no other version was the angelic message so clearly transcribed. Although groups of singing angels were often shown in sixteenth-century representations of the Nativity, the rarity of them in El Greco's works suggests that they reflect special circumstances of the commission.

The large singing figures may have been conceived to evoke the memory of the angelic serenade offered to Alonso on the site of the seminary. One night when Alonso was praying in the primitive chapel, he heard the same angels who had appeared

[235] Cámara, *Vida*, 122.
[236] Antonio de Aranda, *Verdadera información sobre la Tierra Santa*, 2nd ed., Toledo, 1551, lxxxi/v–lxxxv/v.

to the shepherds singing the words of their announcement of Christ's birth.[237] The friar considered this to have been the greatest sign of divine favor that he had received, and his followers may well have wanted to commemorate such an important privilege.

Moreover, the prominent representation of the angelic celebration at the time of Christ's birth can be related to the function of the church as the burial place of Alonso and Doña María, two servants of God. According to the friar, the peace which the angels proclaimed is that which good Christians enjoy upon their death when they rest in the grace of God.[238] That El Greco understood this meaning of the heavenly message is indicated by the fact that he again represented large figures of angels only in the *Adoration of the Shepherds* which he created for his own tomb.

The *Adoration* served several purposes in its original context at the seminary, including the commemoration of the memory of Alonso, its founder and first Rector. El Greco vividly illustrated Alonso's meditations on this event and even incorporated some of the motifs which the friar emphasized in his writings. Although El Greco retained certain aspects of his earlier versions of the theme, his innovations attest to his awareness of the special purposes of this commission.

El Greco heightened the emotional tenor of the shepherds' adoration through the stylized but intense expressions and gestures, the elongation of the proportions of the figures, the strong contrasts of light and shade, and the dynamic and exciting application of paint. Thus, as in the *Incarnation*, El Greco succeeded in endowing his altarpiece with the spiritual intensity of Alonso's meditations.

'The Baptism of Christ'

The decision to balance the *Adoration of the Shepherds* with the *Baptism of Christ* (fig. 19) by placing them on the two sides of the lower storey may have been influenced by Alonso's description of the two events as clear representations of the extremes of glorification and sacrifice which constituted Christ's life on earth.[239] When he was born, Christ received the adoration which he deserved despite the humbleness of the stable. When he initiated his public ministry, he willingly knelt before a mere mortal and agreed to die for mankind, although he was simultaneously honored by the Father. Like the other paintings for the seminary, the *Baptism* presented lessons for persons in the service of the Church and glorified the Eucharist in accord with Alonso's meditations upon this event.

Alonso maintained that Christ's acceptance of Baptism by John ideally exemplified the absolute obedience which all candidates for religious orders must vow to give

[237] Alonso, *Confessiones*, 76/v–77/v. [238]. Alonso, *Epistolario*, 110/v–111/r.
[239] Alonso, *Declamationes in omnes*, 83/r–v.

their superiors.[240] Against his own desires, Christ submitted to the plan of the Father; in kneeling before John, he acknowledged the necessity of his death because he knew that Baptism was the first action that would lead inevitably to the Crucifixion.[241]

Because Christ was fully human as well as fully divine, he enjoyed free will and could have refused the sufferings demanded of him.[242] For Alonso, Christ's voluntary abasement before a mortal man provided an awesome example of obedience, which the professed religious must imitate by fulfilling unquestioningly the dictates of the superiors.[243] Furthermore, Alonso maintained, the circumstance that Christ did not appoint himself to the tasks which he received at Baptism demonstrated that one can be appointed to the service of the Church only by its established hierarchy.[244]

In accord with a long Christian tradition, Alonso interpreted John's Baptism of Christ as the initiation of that rite as a sacrament of the Church[245] and, following Paul and many Fathers of the Church, he described its effects in terms of the metaphor of removing old clothing and putting on new garments symbolic of the new status.[246] When men are baptized, they are stripped of their old clothing, contaminated by original sin and the evil customs of the world, and they are adorned with new garments radiant with Christian virtues.[247]

Alonso was especially concerned with the special meaning of Baptism for those who took religious vows. For one thing, he considered Baptism as the beginning of an ecclesiastical career.[248] Therefore, those who entered the service of the Church should preserve the 'garments' which they received in Baptism in an immaculate state. Additionally, he considered the acceptance of religious vows as having the same effects as Baptism. Therefore, he claimed, the receipt of a religious habit should be explained like Baptism through the analogy of removing garments tainted by life in the secular world and the putting-on of new ones which reflect the new life and customs of a member of an Order.[249] To emphasize this, he recommended that the Church revive the early Christian custom of stripping the candidate and displaying his ecclesiastical robes before putting them on him.[250]

Alonso also related Christ's Baptism to the Eucharist and maintained that it was re-enacted when the priest lowered the Host into the chalice.[251] Alonso emphasized that the action of immersing part of the Host explicitly imitated Baptism. Moreover,

[240] Alonso, *Declamationes in omnes*, 83/r–v; Alonso, *Epistolario*, 25/v–26/v.
[241] Alonso, *Declamationes in omnes*, 83/v–84/r.
[242] Alonso, *Epistolario*, 144/v. [243] Alonso, *Epistolario*, 26/v.
[244] Alonso, *Epistolario*, 26/r. [245] Alonso, *Confessiones*, 21/v.
[246] Alonso, *Epistolario*, 143/v–144/r. [247] Alonso, *Epistolario*, 145/r.
[248] Alonso, *Confessiones*, 19/v–20/r.
[249] Alonso, *Crónica*, lxi/r; Alonso, *Epistolario*, 144/v–145/r.
[250] Alonso, *Epistolario*, 108/r. [251] Alonso, 'Regla,' 1:ccxxxiiii/v.

the Host soaked in the Blood of Christ helped communicants suppress their own desires and inspired them to sacrifice their own lives as Christ had given up his. Thus, the specific part of the Mass in which Baptism was re-enacted also enabled the religious to adhere to obedience, the vow symbolized by Christ's abasement of himself before John. Clearly, Alonso perceived an intimate connection among the various meanings which he assigned to the sacrament of Baptism.

Like the *Incarnation*, El Greco's *Baptism* is an astonishingly original interpretation of one of the basic themes of Christian art. Many of its unusual elements visualize the specific concerns of the patrons.

The figures of John and Christ are probably the most conventional parts of this scene. The weathered skin of the Baptist, his emaciated figure, and his camel-hair garment – which accord with traditional iconography – attest to his years in the wilderness. According to Alonso, John's humble appearance at the Jordan demonstrated that every priest must confess before celebrating Mass and should continue to repent of his sins throughout his reiteration of the service.[252]

The virtually nude state of Christ's body, which is covered only by a loin cloth, and his kneeling pose are both basic parts of Counter-Reformation iconography.[253] Nevertheless, it is interesting to note, El Greco's presentation of the figure corresponds with Alonso's meditations. Alonso claimed that Christ appeared naked before John in prefigurement of the humiliations of the Passion, when he was again stripped of all clothing.[254] Alonso also argued that Christ's kneeling position expressed his obedience and his willing acceptance of the sacrifice of his own life.[255] In El Greco's representation of Christ, the sloped shoulders and strongly marked downward inclination of the head emphasize Christ's voluntary self-abasement.

The axe which appears before the kneeling angel between John and Christ is an emblem of the sermon which John delivered immediately before Christ's arrival at the Jordan. The Baptist proclaimed that God's axe was poised to destroy the Jews who had failed to live in a manner worthy of their status of God's chosen people:

Think not to say within yourselves, We have Abraham for our father: for I say unto you, that God is able of these stones to raise up children unto Abraham. And now also the axe is laid unto the root of the trees: therefore every tree which bringeth not forth good fruit is hewn down, and cast into the fire (Matthew 3:9–10).

This denunciation of the Israelites must have appealed to Alonso and his supporters because it could have been used to support his fervid stance and his proposal that all Jews should be executed.[256] The implication that the sinfulness of Jews provided

[252] Alonso, *Epistolario*, 234/r–237/r.
[253] Mâle, *L'art religieux*, 1953, 261–262.
[254] Alonso, *Declamationes in omnes*, 83/r.
[255] Alonso, *Declamationes in omnes*, 83/r.
[256] Cámara, *Vida*, 116–122, 272, and *passim*.

grounds for their destruction in the Christian era would also have warranted the elimination of the ox from the *Adoration* now in Bucharest.

In addition, the axe could have served to remind worshippers of the fate that would befall them if they did not live up to their obligations as Christians. According to Saint John Chrysostom, a Father of the Church frequently cited by Alonso, the axe in John's sermon referred to the punishment of members of the Church who committed mortal sins and thereby marred the purity of their souls after Baptism.[257] In the context of the seminary, this warning would have had special relevance because, as Alonso insisted, ecclesiastics had an obligation to preserve the effects of Baptism through righteous living.

While the Jordan has seldom been shown to be a large river, the artist's reduction of it at the immediate site of the Baptism to two very narrow streams forced to pass between rocks is unusual. An immediately available and obviously related prototype for El Greco's depiction of the river and for certain other aspects of his interpretation of the scene is the anonymous woodcut in the 1551 edition of Aranda's description of the Holy Land (fig. 26). In his text, Aranda emphasized that the Jordan suddenly diminished in width at the spot where the Baptism had occurred.[258] El Greco followed the accompanying woodcut by showing the Jordan narrowed between two rocky banks and by depicting Christ kneeling on a rock surrounded by water. Like the woodcut, the painting shows the water spreading out in front of the rocks, so that it occupies nearly the width of the bottom half of the image. Other details of El Greco's painting can be related to the woodcut, including the poses of both John and Christ and the irregular surfaces of the rocks. For El Greco's contemporaries, his incorporation of these motifs from a crudely executed work into an image of quite different character would have attested to his genius.

By showing the distinctive appearance of the river and rocks at the site of Christ's Baptism, El Greco probably intended to stress the reality of the re-enactment of the event in the Mass, in accord with Alonso's meditations.[259] Yet, he omitted any other details, such as trees, which would have helped to created a full landscape background. Further, the closely grouped angels behind Christ block any view into the distance. Both the angels who immediately attend Christ and the celestial vision above remove the painting from the level of ordinary earthly narrative and encourage the viewer to contemplate the symbolic and mystical meanings which Alonso assigned to the event.

El Greco has vividly illustrated Alonso's metaphoric conception of Baptism as

[257] El Greco owned a copy of Saint John Chrysostom's *Homilies* (see San Román, 'De la vida,' 196). On the image of the axe in the Baptist's sermon, see Saint John Chrysostom's *Homilies on Saint Matthew*, trans. George Provost and M. B. Riddle, London, 1888, 69–70, 73.

[258] Aranda, *Información*, lxxvi/r–lxxvii/r. [259] Alonso, 'Regla,' 1:ccxxxiiii/v.

the removal of old garments and the bestowal of new ones. Obviously, Christ's nudity follows from the idea that all his old robes have been stripped off. The cloth which the angels display above him must represent the new garments which will be put on after the completion of the ceremony. The brilliance and luminosity of the cloth correspond to Alonso's description of the robes of the newborn person.[260] Its vivid blood red color suggests the sacrifice which Christ agreed to make by accepting Baptism. Because the robes are held above Christ's head in the manner of a baldaquin over an altar, they emphasize the Eucharistic implications of the scene and express Alonso's interpretation of the Baptism as part of the Mass. The reverence with which the angel at the left regards the cloth emphasizes its sacramental importance.

Although attending angels were often included in medieval images of the Baptism, they were generally omitted from sixteenth-century ones. When they were included, as in Santo di Titi's painting now in the Galleria Corsini, Florence (c. 1570), they were not prominently featured. Only in a few images of the eleventh and twelfth centuries were angels with robes as prominently featured as they were in El Greco's painting.[261] For instance, in the illumination of the Baptism of the Gospels of Bernward (1011–14), angels hold up the robe like a curtain behind Christ. Obviously, El Greco cannot have been aware of this specific example, but it suggests the type of image upon which he may have drawn in visualizing his patrons' ideas.

El Greco demonstrated further iconographic originality by introducing the kneeling angel between the two human protagonists. Through his typically eloquent use of gestures, El Greco has shown that this creature served as the intermediary between the Son and the Father. El Greco's conception of the role of the Father in this Baptism differs profoundly from that of earlier artists because he showed the Father recognizing the Son only indirectly through the intermediation of this angel. The kneeling angel stretches out his left arm and turns his hand back so that the palm faces upward toward the Father. In accord with the meaning which El Greco seems to have typically assigned this gesture, the angel is shown to be acknowledging the divine and proclaiming to the Father that his will has been fulfilled.[262] In the heavens above, the Father inclines his head toward the angel and answers his message by forming with the thumb and finger of his right hand the Greek letter *Omega*, which signifies his recognition of Christ as his Son.

It has been suggested that the interchange between the angel and the Father was intended to illustrate the belief of Dionysius the Areopagite that Christ received the directions of the Father through the intermediation of angels. Because El Greco owned copies of Dionysius's writings, it has been assumed that the artist independently consulted them, realized the relevance of Dionysius's ideas to the scene, and

[260] Alonso, *Epistolario*, 143/v. [261] Schiller, *Iconography*, 1:138.
[262] Wittkower, 'El Greco,' 53.

devised this representation.[263] However, it seems more likely that the patrons requested El Greco to illustrate the functioning of the celestial hierarchy, although the artist was probably left to determine an appropriate visual expression for this concept. Alonso's commentary on the importance of the celestial hierarchy, which was based on the theories of Dionysius, probably constituted the immediate source of this theme.[264] In accord with Alonso's belief, the representation of the transmission of the divine will through an angel may have been intended to support by analogy the authority of the earthly ecclesiastical hierarchy, which was derived from and modelled upon that of the heavens.

El Greco devoted nearly the entire upper half of the canvas to the vision of the Father surrounded by angels. The prominent revelation further illustrates Alonso's interpretation of Christ's Baptism as the fulfillment of the divine will.[265] The representation of the celestial beings adoring the Father corresponds with the writings of Alonso, who described the angels praising God at the moment of the Baptism without mentioning a musical celebration such as he had specifically associated with the Incarnation.[266] The angel in the left foreground of the upper section folds his arms across his chest in the same gesture of adoration which El Greco employed for the figures of Gabriel in the *Incarnation* and the angel by the crib in the *Adoration*; the repetition of this pose establishes a formal link among the paintings.[267]

In collaboration with his patrons, El Greco illustrated many of the ideas of Alonso, including the metaphoric conception of Baptism as the putting-on of new garments, the intermediary role of angels, and the repetition of the Baptism of Christ in the Eucharist. El Greco utilized motifs from both medieval and contemporary images, but he transformed all his borrowings by integrating them into a coherent, original work in his distinctive mature style. The elongation of the figures, their rapt expressions, the elimination of a conventional background, the lively brushwork, and

263 Wittkower, 'El Greco,' 54.
264 See, e.g., Alonso, *Epistolario*, 104/r. Cf. Dionysius, *Hiérarchie céleste*, 202–203.
265 Alonso, *Declamationes in omnes*, 83/r–v; Alonso, *Epistolario*, 25/v–26/v.
266 Alonso, *Declamationes in omnes*, 83/r.
267 El Greco's representation of the celestial group is similar to Annibale Carracci's interpretation of the scene in his *Baptism of Christ* (San Gregorio, Bologna, 1585). (On this painting, see A. W. A. Boschloo, *Annibale Carracci in Bologna*, trans. R. R. Symonds, 2 vols., The Hague, 1974, 1:148.) Like El Greco, Annibale filled the upper half of his painting with the Father and the retinue of angels. It has been suggested that El Greco was influenced by Annibale's painting (Wethey, *El Greco and His School*, 2:35). However, this seems unlikely because Annibale executed his painting ten years after El Greco left Italy, and there is no evidence that a print was made of it. It is possible that El Greco saw a drawing of Annibale's *Baptism*, but this cannot be proven. Most likely, El Greco independently devised a similar composition in order to illustrate Alonso's writings, which may reflect a general tendency of the period to emphasize the role of the Father. El Greco's depiction of the angels without muscial instruments differs from Annibale's example and follows Alonso's meditations.

the strong white highlights all contribute to the intense, almost hallucinatory quality of the painting, which captures the deep emotion with which Alonso contemplated the Baptism of Christ. The angels holding brilliantly lit cloths and the celestial vision remove the scene from an ordinary earthly context and transform it into a vision.

The humility evident in Christ's bearing demonstrates his submission to the divine will and his acceptance of the burdens of the Passion which El Greco represented in the final painting of his series for the Seminary of the Incarnation.

'The Crucifixion'

It seems likely that the *Crucifixion* now in the Prado (fig. 21) was originally located in the central row of the retable above the *Incarnation*. The similarity in width of the two paintings supports the theory that they were placed in a single vertical row. Like the *Incarnation*, the *Crucifixion* is a visually stunning and exciting illustration of Alonso's meditations. In terms of iconography, both works are virtually unique – not only in El Greco's *oeuvre*, but also in the entire history of Western art. A pictorial program based upon the writings of Alonso would virtually have had to include an image of the Passion, which was the theme of many of his meditations.

Among his contemporaries, Alonso was famed for his devotion to the Passion, and his daily recitations of the Office of the Cross moved many to tears.[268] Alonso experienced the sufferings of the Passion on a deep personal level. He regarded his physical illnesses as answers to his prayers to be crucified upon the same cross as the Lord.[269] Alonso's vivid expression of gratitude for his physical suffering and his description of his bodily pains as 'nails of tormenting illnesses' reveal the extent to which he sought to make his own life conform to Christ's Passion.[270] After recovering from his second major illness, the Augustinian tried to retain the pain he had felt in his feet by wearing sandals with pieces of iron projecting into his soles, thereby causing severe wounds. Alonso's admirers believed that the resulting sores on his feet had miraculous powers and considered it a great privilege to touch them. Upon his death, the friars and others attendant upon him tried to impregnate various cloths with the pus and odor exuded by these sores, and the Augustinian community zealously guarded his dead body because they feared that his feet might be cut off and stolen.[271]

Christ miraculously recognized the friar's ardent worship of the Passion by appearing to him alive upon the crucifix on the altar of the church of San Felipe and gazing lovingly into his eyes. Alonso recorded this mercy with awe and humility

[268] Cámara, *Vida*, 305–308, discusses the various manifestations of Alonso's devotion to the Passion.
[269] Alonso, *Confessiones*, 60/r. [270] Alonso, *Confessiones*, 60/v.
[271] Cámara, *Vida*, 362–371.

in his *Confessiones* and claimed that the experience filled him with an overwhelming sensation of intense sweetness and warmth.[272]

The depth of Alonso's devotion to the Passion is suggested by the fact that the only works of art which he commissioned personally were associated with this cult.[273] He ordered several images of Christ on the Cross to be painted along the walls of the stairway leading to the friars' quarters in the Monastery of San Felipe in Madrid. As he climbed and descended the stairs, he kissed each of these paintings and encouraged others to do the same. Alonso also provided detailed instructions for the design and construction of a large silver memorial executed by López, a silverworker who had been freed from prison due to his intercession. This memorial incorporated two vials of animal blood, symbolizing that which Christ shed on the Cross, and five red stones, representing his wounds. Alonso kept this object in his room and used it to inspire his meditations upon the Passion. Unfortunately, no traces of these commissions, which could have provided insights into Alonso's taste, have been found. However, both commissions were probably conceived primarily to serve devotional and didactic purposes.

Alonso composed several books consisting primarily of meditations on the Passion – *Soliloquio de la passión* (1585), *Memorial de amor santo* (1575), and *Libro de la suavidad de Dios* (1576). However, in all of his writings, he developed such themes as the benefits conferred by the Passion, the intensity of Christ's love for mankind, the sorrows of Mary, and the re-creation of the sacrifice in the Mass.

Particularly interesting from an art historical point of view is a brief treatise, *Contemplación espiritual del crucifixo*, in which Alonso analyzed the meaning of each detail of the image of Christ on the Cross.[274] Although intended as a devotional manual, the *Contemplación* could also serve as a guide to artists because it indicated every element which a representation of Christ on the Cross must include. Because many of the details which distinguish the Prado *Crucifixion* from the many other versions of the theme produced by El Greco and his workshop follow the treatise, it is probable that the patrons referred to this guide when providing instructions to the artist. However, Alonso's other writings on the Passion have also proved to be useful in interpreting El Greco's *Crucifixion*.

According to Alonso, the Crucifixion constituted a perfect portrait of an ecclesiastic and exemplified absolute fulfillment of the three basic vows of the professed religious. Therefore, this subject would have provided an appropriate conclusion to the program by illustrating in a single image the vows which were represented in three distinct paintings on the lower level of the retable. In accord

[272] Alonso, *Confessiones*, 75/r–v. [273] Cámara, *Vida*, 306–307.

[274] Alonso, 'Contemplación espiritual del crucifixo,' in *Recopilación*, 1570, 1:cclxvi/r–cclxviii/v (henceforth cited as Alonso, 'Contemplación').

with a long Christian tradition, Alonso described Christ's willing sacrifice of his life as the supreme illustration of obedience.[275] Thus, he recommended, the religious should imitate Christ and obey all the directives of their superiors without protesting any pain that they might have to endure. In addition, Alonso claimed, Christ's nakedness on the Cross revealed disdain for all worldly goods and should encourage novices to accept the vow of poverty.[276] For Alonso, the Crucifixion even served as an inspiration to chastity because the denial of carnal desires causes great suffering and torments that, in effect, crucify the body.[277]

Like the other paintings for the seminary, the *Crucifixion* can also be interpreted as a symbol of the Mass. Placement of the *Crucifixion* and the *Incarnation* in the central vertical row of the original altarpiece would have followed Alonso's assertion that the Incarnation and Crucifixion constituted the two most important images of the Mass.[278] Alonso repeatedly identified the altar with the Mount of Calvary and described the Mass as a re-enactment of the Passion.[279] The fracture of the Host, which occurs shortly after the consecration, marks Christ's death through the separation of blood from his body and the departure of his soul.[280]

The Crucifixion, which had made it possible for the faithful to be forgiven and to obtain eternal life under the grace of God, was also related to the purpose of the foundation to work for the salvation of the souls of Doña María and members of her family. In his meditations, Alonso emphasized the victory over the forces of sin and death which Christ obtained for believers through the Crucifixion.[281] Because Alonso perceived this glorious result of the sacrifice, he claimed that contemplation of it filled him with joy and happiness, despite his intense awareness of Christ's pain. To appreciate the victorious meaning of the theme, Alonso recommended that worshippers looking at a crucifix first concentrate upon the *titulus*, a standard iconographic motif which recurs in all of El Greco's paintings of the Crucifixion. Alonso interpreted the *titulus* without irony as a literal and truthful declaration that Christ would become King of the World. Because, for Alonso, Christ's triumph was already implied in his Crucifixion, a program based upon the friar's writings might not have required an image of the Resurrection, the traditional symbol of divine victory over the forces of evil.

El Greco's handling of the figure of Christ, which differs in several respects from his usual manner, probably reflects close instructions from his patrons. Some of the unique elements of the Prado *Crucifixion*, such as the streams of blood and water pouring from the wound in Christ's side, are astonishing and immediately striking.

[275] Alonso, *Epistolario*, 138/r–141/v.
[276] Alonso, *Epistolario*, 133/r, 143/v; Alonso, *Crónica*, lxxii/r–lxxiii/v.
[277] Alonso, *Epistolario*, 130/r–131/v; Alonso, *Crónica*, lxx/r.
[278] Alonso, 'Regla,' ccxxiii/v. [279] Alonso, 'Regla,' ccxxiii/v.
[280] Alonso, 'Regla,' ccxxiii/v. [281] Alonso, 'Contemplación,' cclxvi/v–cclxvii/r.

But others, like the arrangement of Christ's feet, are apt to seem insignificant details today. However, for Alonso and his contemporaries, even such minor details of holy images had great significance.[282]

Indeed, the placement of Christ's feet helps to establish the relationship of the Prado *Crucifixion* to Alonso's short treatise, *Contemplación espiritual*. In all of his other paintings of the Crucifixion, El Greco showed Christ's left foot nailed on top of his right,[283] but in the Prado painting the right foot is placed on top of the left. This variation from El Greco's usual presentation reflects Alonso's assertion that Christ's right foot was nailed over his left because this would have caused him far more pain than would the opposite arrangement.[284]

The way in which Christ's body hangs on the Cross also differs from El Greco's typical formula and apparently follows Alonso's meditations. In his other paintings, El Greco enlivened the figure of Christ by bending the left leg and adapting the *contrapposto* pose to the exigencies of the Crucifixion.[285] However, in the Prado *Crucifixion*, El Greco showed the body of Christ hanging straight down vertically without any outward thrusting or curving movement, in accord with Alonso's description. The Augustinian emphasized that the way Christ's body fell straight down on the Cross permitted no freedom of movement and increased his suffering.[286] Candidates for religious orders were advised to imitate the placement of Christ's body by standing rigidly still while praying or listening to Mass.[287]

Such features of the Prado *Crucifixion* as the rigidity of Christ's body, his closed eyes, his downturned head, and the wound in his side – which was not made until after his last breath (John 19:33–34) – indicate that Christ has already died. This representation accords with Alonso's recommendation that the faithful should always imagine Christ dead on the Cross.[288]

[282] Cf. Jonathan M. Brown, *Images and Ideas in Seventeenth Century Spanish Painting*, Princeton, 1978, 60.

[283] In two works of poor quality, which have been associated with El Greco but should be assigned to a follower, Christ's right foot is shown covering his left – the *Crucifixion* in the parish church of Martín Muñoz de las Posadas (province of Segovia) and that in the National Gallery of Athens. (See Wethey, *El Greco and His School*, 2:181, nos. X–71 and X–72.) I presume that the follower utilized the Prado *Crucifixion* as a model and incorporated the arrangement of feet found in it without understanding its significance. The Mary and John in both the canvases of the follower and the Magdalene in the Athens painting confirm the anonymous artist's dependence upon the Prado *Crucifixion*. However, this artist eliminated some of the most unusual features of El Greco's painting, including the angels and the blood and water flowing from Christ's side, and added some elements which occur in other paintings by El Greco but not in the Prado *Crucifixion*, such as the prominently out-thrust knee and the landscape motifs.

[284] Alonso, 'Contemplación,' cclxvii/r.

[285] El Greco had first utilized this arrangement in the *Crucifixion* now in the Louvre (c. 1580) and generally adhered to it for the rest of this career, as did his seventeenth-century copyists.

[286] Alonso de Orozco, *Vergel de oración y monte de contemplación*, 2nd ed., Seville, 1548, iii/r.

[287] Alonso, 'Contemplación,' cclxvii/r; Alonso, *Epistolario*, 133/r, 143/v; Alonso, *Crónica*, lxxii/r–lxxiii/v.

[288] Alonso de Orozco, *Soliloquio de la passión de nuestro redemptor Jesu Cristo*, Madrid, 1585, 3/v, 26/v; Alonso, 'Regla,' xxlvi/r; Alonso, *Epistolario*, 101/v–103/v.

Undoubtedly, the long, thick red streams running from the nail holes in Christ's hands and feet were also inspired by the writings of Alonso, who often recommended the contemplation of the blood shed on the Cross.[289] According to the friar, the extraordinary amount of blood which flowed from Christ guaranteed the forgiveness of the sins of mankind.[290] Therefore, El Greco's vivid representation of blood may reflect the goal of the foundation to attain salvation for those buried in it. Among the artist's many representations of the Crucifixion, only the somewhat later painting now in Cleveland (c. 1605–10)[291] shows Christ bleeding so profusely. However, the wound in the side and the collection of the liquid give the theme of Christ's blood exceptional prominence in the *Crucifixion* for the seminary. Normally, El Greco very discreetly indicated the blood of the Savior, and none of his earlier paintings prepare us for the Prado painting.

The blood and water pouring from Christ's side in the Prado *Crucifixion* vividly illustrate Alonso's description of 'rivers' and 'fountains' flowing from the wound made by the lance.[292] The representation of both blood and water in the painting follows the Gospel account (John 19:34) and expresses the living connection between the Crucifixion and the Eucharist. This interpretation is based upon Alonso's assertion that the mixing of blood and water in the Mass proved that the Passion was completely and accurately re-enacted on the altar.[293]

El Greco's striking depiction of blood and water streaming from Christ's side exemplifies his creative adaptation of old iconographic motifs to illustrate the specific concerns of his patrons. Although the Bible mentions both liquids, the water was generally omitted from scenes of the Crucifixion during the Renaissance. Moreover, artists of the fifteenth and sixteenth centuries generally showed only a discreet amount of blood trickling from Christ's wound, as did Vasari in his *Crucifixion* in the Carmine, Florence (1560). In creating the Prado canvas, El Greco must have looked back to Byzantine and medieval Western images which include powerful streams of blood and water pouring out of Christ's side. El Greco's omission of the wound from all his other representations of Christ on the Cross was historically correct because, in these works, he showed the Savior as still alive, not yet pierced by the lance.[294]

[289] See, e.g., Alonso, 'Contemplación,' xxlxvii/r–v.
[290] Alonso, *Soliloquio*, 23/r.
[291] On this painting, see Wethey, *El Greco and His School*, 2:46–47.
[292] Alonso, *Siete palabras*, clxv/r.
[293] Alonso, 'Regla,' ccxxiiii/v.
[294] Jorge Manuel, El Greco's son, and other followers who lacked the master's doctrinal accuracy, sometimes showed a wound in the side of the still-living Christ, as can be noted in Jorge Manuel's *Crucifixion* in the collection of the Banco Urquijo, Madrid. In these school works, only a discreet amount of blood was shown near the wound, and there was no attempt to replicate the gushing water and blood shown in the Prado canvas.

Mary Magdalene and the angel working beside her are among the most astonishing and puzzling elements in the Prado canvas. None of Alonso's published writings specifically mention the saint and the angel wiping blood from the Cross. However, the action of these two figures accords so well with the spirit of Alonso's commentaries that it seems possible that he described it in an unpublished sermon.[295]

The image of the saint and the angel diligently wiping the Cross reflects Alonso's conviction that Christ's blood was so precious that his followers collected every drop of it.[296] The friar further maintained that only one drop of it would have sufficed to procure the salvation of mankind.[297] This belief was directly related to the requirement of the liturgy that all of the consecrated Host and wine be consumed before the end of the service.[298] The figures wiping the Cross provide models for the fulfillment of this obligation and affirm the interconnection between the Passion and its re-enactment in the Mass. The evident energy with which the angel and the Magdalene perform their task may surprise modern viewers, but it expresses the passion and the intense sensuous eagerness that characterize Alonso's meditations upon the privilege of contact with the consecrated wine and the blood flowing from Christ's wounds.

El Greco's portrayal of the Magdalene is an imaginative adaptation of iconography associated with her presence at the Crucifixion. Many artists had shown the weeping Magdalene passionately embracing the Cross. Moreover, some earlier painters, such as Rogier van der Weyden, had represented her rubbing her fingers in the rivulets. Others – including Vasari (in his *Crucifixion* in the Carmine, Florence) and Juan de Juanes (in a drawing in the Prado) – had shown her holding her handkerchief against the Cross. Works such as these could have influenced El Greco as he sought to develop a new and highly original image. But never before had the Magdalene been shown so eagerly and emphatically wiping the Cross with a cloth.

Alonso's assertion that an angel accompanied the Magdalene throughout the Crucifixion[299] would have justified the inclusion of the angel who assists her in cleaning the Cross. The depiction of both figures performing the task is also related to Alonso's belief that humble service to God, which the Magdalene exemplified, can make faithful Christians the spiritual equals of angels who also adore him.[300]

The flying angels who extend their palms so that Christ's blood can flow over

[295] Because Alonso habitually delivered several different sermons every Sunday, his published works probably constitute only a small part of his total writings.

[296] Alonso, *Suavidad*, 'Dedicatoria,' no pagination.

[297] Alonso, *Suavidad*, 93/v.

[298] Before drinking the contents of the chalice, the priest puts into it all of the small pieces of the Host which fall onto the paten during his division of it. After distributing the Host to the people, he pours unconsecrated wine into the chalice to disperse any drops of blood which may remain and drinks the resulting mixture.

[299] Alonso, *Vergel*, xix/v.

[300] Alonso, *Soliloquio*, 14/v–15/v.

them are among the other unusual and visually striking features of the Prado *Crucifixion*. None of El Greco's other pictures of Christ on the Cross include angelic attendants. Even though many earlier paintings by other artists depict angels mourning Christ upon the Cross and collecting his blood in chalices, blood was shown pouring directly onto the angels' hands in only a few late medieval works, such as Simone Martini's *Crucifixion* (a portable altarpiece painted in Avignon, 1338/9–1344, now in Antwerp, Musée des Beaux-Arts). El Greco may have drawn upon his memory of such an obscure Italian prototype when he devised the iconography of the Prado painting.

Alonso's writings probably directly inspired the inclusion of these angels. According to the friar, angels continued to attend and admire Christ throughout the Passion and attempted to gain some 'accidental glory' from it by washing themselves in his blood.[301] El Greco's representation of the angels without chalices follows from Alonso's assertions that celestial creatures do not share the power of priests to celebrate the Mass and do not even have the right to touch liturgical vessels.[302] If El Greco had placed chalices in the angels' hands in accord with the usual iconography of the scene, he would have denied the clear differences in the powers of God's celestial and earthly servants which Alonso noted throughout his writings. Although the friar metaphorically described priests as angels on earth, he emphasized the doctrine that angels are unable to create the Son miraculously or even to consume the elements of the Eucharist.

The actions of the flying angels also seem to illustrate Alonso's description of their behavior during the Mass. Although angels are not beneficiaries of the sacrament, they are supposed to 'delight themselves and receive accidental glory' in and from the celebration, and they beg the Father to have mercy upon sinners throughout the service.[303] The lively poses of El Greco's angels express their joy in the Mass. Moreover, because the angels are shown interrupting the stream of blood before it falls to earth, they literally fulfill an intermediary function between Christ and the human figures below them.

The Prado *Crucifixion* is the only authentic painting by El Greco which follows the common sixteenth-century Spanish practice of including standing figures of the Virgin Mary and John the Evangelist at the foot of the Cross.[304] Because they do

301 Alonso, *Epistolario*, 17/r; Alonso, *Siete palabras*, liiii/r.
302 Alonso, *Epistolario*, 191/v.
303 Alonso, *Epistolario*, 191/v; Alonso, *Reyna Saba*, 180/r and *passim.*; Alonso, *Confessiones*, 6/r–7/r.
304 The versions of the Crucifixion in Philadelphia and Sarasota (Ringling Museum), which have been associated with El Greco, show John and Mary both on the right side. Wethey found that both of these works were executed primarily by the workshop but suggested that El Greco invented the type. The mediocre quality of the execution of the figures and the lack of anatomical clarity confirm the theory that the paintings were primarily the work of others (see Wethey, *El Greco and His School*, 2:50–51). It seems doubtful that El Greco actually contributed anything to the works. The concentration of two figures on one side of the

not occur in any of the artist's other works, it seems possible that the patrons instructed him to include Mary and John, who played a prominent role in Alonso's meditations upon the Passion.

The Virgin's involvement in the Crucifixion was a major concern of Alonso, who repeatedly mentioned her presence at the base of the Cross. For the Augustinian, the Passion involved the martyrdom of Mary as well as of her Son, and her suffering was no less than his.[305] The dedication of the Virgin to Christ exceeded the love of any other mother for her son and caused her to experience personally and intensely every pain that he felt.[306] In contradiction to scriptural accounts, Alonso even claimed that Mary accompanied her Son every moment from the time of his entry into Jerusalem and witnessed each of his torments.[307] Because, for Alonso, the Passion was experienced as much by Mary as by Christ, a representation of the Crucifixion based upon his writings would be virtually unthinkable without her.

In fact, Alonso explicitly declared, the Virgin had to be included in images of the Crucifixion if they were to express the liberation of mankind from sin.[308] According to him, only the Virgin's presence at the foot of the cross and her prayers for mankind ensured that the Crucifixion led to salvation. Further, he maintained, it was during the Crucifixion that the Virgin resolved to act as the advocate of mankind and to care for all members of the Church.[309]

In El Greco's painting, Mary's anguished facial expression and her tightly gripped hands express the intensity of her sufferings. The artist may have depicted her looking fixedly at the wound in Christ's side in order to illustrate Alonso's assertion that Mary suffered her greatest anguish when she saw the hole made by the lance.[310] The Virgin's hands clasped together as though in prayer would also express her role as intercessor for mankind. This image of Mary would have been especially relevant to the seminarians because the pleas which Mary addressed to Christ from the foot of the Cross were supposed to serve as models for the prayers of priests during Mass.[311]

Alonso maintained that John, like the Virgin, remained with Christ throughout the events of the Passion.[312] Because of John's exemplary chastity, Christ loved him more than any other mortal except Mary and, therefore, sought to keep the disciple near him even at death. In his accounts of the Passion, Alonso emphasized that Christ's appointment of John as Mary's son intensified the sorrow of both the mother

foreground with a view into a distant space makes the composition seem strangely unbalanced. El Greco sometimes showed a suddenly recessed view of an apparently far-distant landscape of the sort shown on the right side of the canvases in question, but he did not do this in such a way as to destabilize the composition.

[305] Alonso, *Soliloquio*, 23/v.
[307] Alonso, *Soliloquio*, 15/v.
[309] Alonso, *Soliloquio*, 26/v.
[311] Alonso, *Siete palabras*, lxxix/r.

[306] Alonso, *Soliloquio*, 23/v–26/r.
[308] Alonso, *Siete palabras*, xxvii/v.
[310] Alonso, *Siete palabras*, clxv/r.
[312] Alonso, *Epistolario*, 125/v–129/r.

and the disciple because it clearly signified that he was dying.[313] If the Prado *Crucifixion* were placed above the *Incarnation*, the two primary mortal representatives of carnal purity would have stood directly above the event which was supposed to have instituted chastity as an important virtue.

The artist has effectively conveyed John's sorrow through the tragic expression on his upturned face, which is marked by the downturned mouth, the distended nostrils, and the large, tearfilled eyes. Like Mary in the *Incarnation*, John is shown raising his right hand in the frontal gesture of adoration. Except for the Prado *Crucifixion*, El Greco used this gesture only in scenes of the Incarnation. In the *Crucifixion*, John's use of this gesture may indicate that his devotion remained unaffected even though Christ was humiliated and scorned by others. This interpretation would accord with Alonso's perception of the Crucifixion as a victory. John's downturned left hand repeats the gesture which El Greco represented Christ making in several paintings of the Agony in the Garden. In accordance with its meaning in the latter scene, this gesture in the Prado *Crucifixion* would signify John's suppression of his own will and acquiescence to the divine plan, including the death of his beloved Master.

The 'flat' black sky and the sharp-edged, angular cloud shapes behind the figures evoke the terror of the darkness and storms which occurred at the moment of Christ's death (Matthew 27:51–53). However, because El Greco treated the clouds and the sky in an abstract, unnaturalistic manner, the background also removes the scene from the context of an earthly historical narrative and indicates that it should be regarded as a visionary re-enactment occurring in the present. Thus, the background served to affirm the belief that the Crucifixion recurs on the altar during every celebration of the Mass and would have encouraged the worshipper to contemplate the various meanings which Alonso assigned to the scene.

The unusual and striking iconography of the Prado *Crucifixion* can now be seen to have been inspired by Alonso's meditations, which El Greco's patrons could have explained to him. Through his direct response to the requirements of the commission, El Greco freed himself from the strict dependence on earlier images which had characterized his first works in Spain.

This iconographic originality may have fostered the liberation of his style from the confines of the normative classicizing manner which he had largely respected at Santo Domingo. Several stylistic devices in this painting evoke the intense anguish which characterized Alonso's meditations on the Passion. Particularly noteworthy is El Greco's use of strokes to convey the suffering of the Passion. In many parts of the canvas, roughly applied strokes intersect at acute angles which suggest the pain endured by the protagonists. This effect is most strongly pronounced in Mary's

[313] Alonso, *Soliloquio*, 26/r.

robe. Indeed, the artist appears to have devised an abstract visual equivalent of the swords sometimes shown piercing the grieving Mother. El Greco's application of strokes complements the sharp, angular contours which he used to define the heads and bodies of the attendant figures. The stylized but emotionally effective facial expressions and gestures, the emaciation of the proportions, and the strong contrasts of brilliantly lit areas against the dark background further contribute to the powerful mood of tension and pain.

The Side Altars

Juan Pantoja de la Cruz, the leading portraitist of the Spanish court, painted full-length images of Saints Augustine and Nicholas of Tolentino for the side altars of the church of the Seminary of the Incarnation in 1601 (Madrid: Prado; figs. 27 and 28).[314]

Rojas, who had already commissioned his own portrait from Pantoja (fig. 17), was probably responsible for giving him the commission for these altarpieces. If Chiriboga chose El Greco to execute the main retable, each of the principal administrators would thus have had a chance to select a painter to create major works for the church.

The style of the portrait of Rojas and the altarpieces of Augustine and Nicholas of Tolentino differ significantly from the manner which Pantoja utilized in his court portraits. Normally, Pantoja flattened figures and made faces passive masks. In the three paintings which Rojas commissioned, Pantoja stressed the full corporeality of the figures and created individualized, emotionally expressive countenances. He handled the many secondary details in the altarpieces with a precision unusual in his work. In these paintings, Pantoja apparently felt free to abandon the limitations which he imposed on himself in his work for the royal court.

Pantoja represented Augustine with an expression of profound spiritual and intellectual enlightenment on his upturned face. By placing the figure in the immediate foreground against a dark background, Pantoja emphasized its three-dimensionality. In accord with the typical sixteenth-century iconography of the saint, Pantoja showed Augustine with a quill pen in his right hand to allude to his theological works and with a model of a church building in his left to refer to the

[314] According to Pantoja's last will and testament, the seminary still owed him at the time of his death 800 *reales* for his paintings of the saints (Sánchez-Cantón, 'Pantoja,' 112). The full price of the altarpieces is uncertain, but the fact that he received 2,500 *reales* for painting the four coats-of-arms on the ceiling suggests that the original price was much higher (Arevalo, 'Cuentas,' 73/r, 175/v).

Chiriboga and Rojas selected Pantoja to evaluate the principal retable by El Greco (García Chico, 'Nuevo documento,' 235–236). The generosity of the assessment determined by the representatives of both sides indicates that Pantoja was not upset about not having received the commission for the main retable and that he admired El Greco's work, although it was quite different from his own.

importance of his doctrines to the authority of the Church. The bishop's mitre and staff, symbols of Augustine's highest office, were also typical elements of his iconography.

Pantoja's altarpiece of Augustine commemorated the affiliation of the seminary, which belonged to the Order founded by him. In addition, Rojas and Chiriboga may have hoped that this painting would remind worshippers of Alonso's enormous devotion to Augustine and of the derivation of his writings from those of this Doctor of the Church. Alonso frequently justified his ideas by claiming that he followed Augustine in all matters of doctrine, and Alonso's supporters unhesitatingly compared him to Augustine. Rojas even went so far as to claim that Alonso had lived in closer accord with divine law than had Augustine because he had committed no mortal sins.[315]

In representing Saint Nicholas of Tolentino, an Augustinian friar of the thirteenth century, Pantoja seems to have followed the woodcut of that saint which was included in Alonso's history of the Augustinian Order (fig. 29). Like the author of the woodcut, Pantoja represented the haloed saint wearing a garment covered with stars and holding a bird in his left hand and a crucifix in his right, toward which he looks. In both the woodcut and the painting, the saint stands on a narrow shelf in the foreground. Even the landscape backgrounds, including monastic buildings on the viewer's left and woods on the right, are related. The corporeality of Pantoja's figure and the intensity of emotional expression distinguish his painting from its apparent model. The face of Pantoja's Nicholas is filled with the ecstasy of a mystical experience.

Both the woodcut and the painting commemorate Nicholas's attainments as a miracle-worker and mystic. The stars on Nicholas's garments refer to those which often illuminated his path during his childhood and guided him to church at night. In both the woodcut and the painting, the saint looks at an image of Christ on the Cross, the subject of many of his meditations. The partridge which he holds on a plate in his left hand symbolizes the most famous of his many miracles.[316] A superior, who was worried about the friar's ascetic practices, ordered him to eat a partridge which the cook had prepared especially for him. Unwilling to eat one of God's creatures, Nicholas restored it to life on his plate. Pantoja specifically represented a red-legged partridge, which was called a *reclamo* in Spain and signified converts from heresy and paganism.[317] Pantoja's depiction of the saint holding the red-legged partridge was probably intended to inspire students to develop the skills of a

[315] Rojas, 'Alonso,' 91.
[316] Herbert Friedman, 'A Painting by Pantoja and the Legend of the Partridge of St. Nicholas of Tolentino,' *Art Quarterly*, 22 (1959), 46.
[317] Friedman, 'Pantoja,' 51.

preacher, for which Nicholas had been famed, and to adapt them to the special problems presented by Protestants and other heretics.

Alonso's deep veneration for Nicholas of Tolentino[318] could have inspired the patrons to decide to include an image of the saint in the program. Moreover, Nicholas could have exemplified some of the saintly qualities which Alonso's followers admired in him. Alonso himself compared the angelic serenade of Nicholas to his own privilege of hearing angels singing the *Gloria in excelsis* which had announced Christ's birth to the shepherds.[319] Alonso's fame as a preacher and miracle-worker could also be related to Nicholas's career. The red-legged partridge could have been intended to recall Alonso's commitment to fighting Protestantism.

Pantoja's pictures of the saints on the side altars would have helped introduce the worshipper to the spiritual realm vividly depicted on the main retable. If *Augustine* had been displayed on the side of the Gospel and *Nicholas of Tolentino* on the side of the Epistle, the two figures would have been shown looking towards the main altar, to which they would have directed the worshipper's attention. Because of the figures' real physical presence and decided personalities, they would have served as 'stepping stones' to the less naturalistic scenes on the main retable. Augustine's expression of intellectual and spiritual illumination and Nicholas's mystic swoon suggest that their thoughts occur on the same spiritual plane as the scenes conceived by El Greco and that they could even be perceiving inwardly the events which the Toledan artist had represented.

The altarpieces by Pantoja and El Greco were the two major parts of a carefully conceived program. The patrons chose each artist to execute the subjects for which his style was best suited. The manner which Pantoja developed for his portrait of Rojas was appropriate for the naturalistic but emotionally effective representations of the saints. El Greco's mature style provided the ideal means for visualizing Alonso's fervent meditations.

Conclusions

Historical, stylistic, and iconographic evidence suggests that El Greco painted four large altarpieces for the main retable of the church of the Seminary of the Incarnation: the *Incarnation*, the *Adoration of the Shepherds*, the *Baptism of Christ*, and the *Crucifixion*. The pictorial program formed by these works reflected the diverse purposes of the institution.

It seems likely that the paintings were intended to promote Alonso's canonization because they directly illustrate his visions and meditations. The actual proximity of the main retable to Alonso's body, preserved beneath the altar, would have

[318] Alonso, *Crónica*, xxxiii/r–v. [319] Alonso, *Confessiones*, 77/v.

emphasized the connection between El Greco's images and the friar's writings.

In illustrating Alonso's meditations, El Greco freed himself from the close dependence on earlier art which had characterized his work for Santo Domingo and created original, exciting paintings which directly responded to the needs and concerns of his patrons. The compositions of El Greco's altarpieces at Santo Domingo were based on works by earlier artists, whereas the overall conception of each of the scenes for the seminary was El Greco's own. In addition, El Greco incorporated into these paintings motifs which were virtually unprecedented in visual art.

Although it can be clearly established that El Greco's paintings for the seminary were intended to elucidate Alonso's mystical visions and meditations, it is more difficult to prove the connection between their style for purely aesthetic reasons. Yet, it cannot be denied that the style which El Greco employed in the altarpieces for the seminary well complemented the spirit of Alonso's meditations. El Greco's patrons must have at least encouraged the development of a style that so well met their needs, and it seems possible that the artist deliberately created forms that so well expressed the spirit of the commission.

El Greco endowed his altarpieces for the seminary with the passionately intense mood which characterizes Alonso's meditations. Many factors contribute to the impact of the paintings: stylized but vivid facial expressions and gestures, emaciated proportions, the intense illumination of limited areas against a black background, electrified colors, and the bold application of paint. The scenes are removed from ordinary earthly settings and thus from the realm of conventional narrative. These effects parallel Alonso's method of describing events without attempting to evoke naturalistically convincing, logically coherent settings and without respecting historical sequence.

The causes of the transformation of El Greco's style in the last years of the sixteenth century and of the development of his mature 'expressionistic' style need to be further explored. The possibility that he devised this style to suit the circumstances of his extremely prestigious commission for the seminary in Madrid should not be overlooked. Whatever his inspiration, El Greco retained this manner and fully exploited it in his final large-scale undertaking, which will be examined in the next chapter.

CHAPTER 3

THE HOSPITAL OF SAINT JOHN THE BAPTIST OUTSIDE THE WALLS, TOLEDO

El Greco's final large-scale undertaking involved the design and execution of altarpieces for the chapel of the Hospital of Saint John the Baptist Outside the Walls, Toledo. The artist first undertook work for the hospital in 1595, when he was commissioned to execute a wooden tabernacle for the main altar. Some years later, in 1608, he agreed to provide the architectural and sculptural elements for three retables. Although not mentioned in the preserved contracts, a series of paintings was also begun by the artist.

When he died in 1614, El Greco had not concluded his work for the hospital. The paintings – which include three of his most ambitious and visually exciting late works, the *Incarnation* (fig. 31), the *Baptism of Christ* (fig. 32), and the *Apocalyptic Vision* (fig. 37) – were either left unfinished or were later clumsily completed by his son. El Greco's original designs for the frames and sculptural decoration of the retables have been lost, and his intentions were obscured by the drastic alterations to his plans made at the request of the hospital by Jorge Manuel and other artists.

As a consequence of these circumstances, it has been hard to understand the meaning of the ambitious program. Yet, like so many of El Greco's projects, it was intended to speak eloquently of beliefs and concerns of special importance to the patron. Through the analysis of the writings of Pedro Salazar de Mendoza who commissioned these works on behalf of the hospital and through the reconstruction of the history of the institution, it is possible to come closer to understanding the meaning of this rich and subtle ensemble, the artist's final artistic statement.

In general terms, El Greco's paintings and sculpture for the hospital chapel form a carefully conceived iconographic program outlining the history and means of Christian salvation in accord with the summation of the doctrine of Justification presented in the Decrees of the Council of Trent. Each of the three extant paintings portrays a spiritual birth or rebirth which serves as a step toward final union with God. The program commemorated the special interests and privileges of the hospital

and also reflected the function of its chapel as the burial place of Cardinal Juan Tavera, founder of the institution.

In his paintings for the hospital, El Greco further developed the original and innovative handling of basic themes of Christian art which had characterized his work for the seminary. His elucidation of Salazar's ideas in the *Apocalyptic Vision* resulted in an astonishing and virtually unique work of art. Salazar believed that paintings were effective to the degree that they stirred the passions of the viewer. In response to this encouragement, El Greco intensified the emotional tenor of his style and created works which can still overwhelm us today.

Pedro Salazar de Mendoza and the Hospital of Saint John the Baptist Outside the Walls

Pedro Salazar de Mendoza (c. 1550–1629), the administrator of the Hospital of Saint John the Baptist, was responsible for giving El Greco the commissions for the tabernacle and the altarpieces and, most probably, also determined the program, which reflects ideas and concerns expressed in his writing. The contract which El Greco signed in 1608 with Salazar de Mendoza[1] indicates that the administrator was in charge of the decoration of the chapel and intended to supervise the project carefully. He obtained the right to inspect the work in progress at any time that he wished:

Further, the said distinguished administrator shall be able to see and visit and shall see and visit the said work [in order to verify] how work is progressing as many times as seems necessary to him so that if there shall seem to be slackness in it on the part of the said Dominico he may suspend, if he so desires, the payment of fees to the said Dominico on the account of the said work.

Iten que el dicho señor administrador pueda ber y visitar y vea y visite la dicha obra como se fuere haziendo todas las vezes que le pareciere para que si le pareciere aver remission en ella por parte del dicho dominico suspenda si quisiere el dar dineros al dicho dominico a cuenta de la dicha obra.[2]

Salazar was to represent the hospital in all matters concerning the completion of or payment for the retables, and the hospital was obligated to respect any decisions or commitments that he made.[3] Salazar included a lengthy account of the history and purposes of the hospital in his biography of Cardinal Tavera, who had founded it, and there explained the importance which he attached to its decoration by

[1] Manuel B. Cossío, *El Greco*, 2 vols., Madrid, 1908, appendice no. 13, 2:680–688. In preparing this chapter, I benefitted greatly from the comments of Professor Jonathan Brown (Institute of Fine Arts, New York), Professor Richard Kagan (The Johns Hopkins University, Baltimore), and Dr. Fernando Marías (Instituto Diego Velázquez, Madrid).

[2] Cossío, *El Greco*, 2:681. [3] Cossío, *El Greco*, 2:687.

claiming that sumptuous embellishment was needed to mark its special status and to inspire others to undertake charitable activities.[4]

Salazar was a well-educated ecclesiastical scholar, who had obtained a doctorate in canon law. Like other important patrons of El Greco, he held several administrative offices in the Church.[5] Salazar must have been well acquainted with Chiriboga, who was probably responsible for giving El Greco the commission for the main retable of the Seminary of the Incarnation. Both Salazar and Chiriboga belonged to the cabinet of Cardinal Quiroga, and Salazar was treasurer of the College of Talavera la Vieja, which Chiriboga represented as Canon. In his biography of Cardinal Mendoza, Salazar implied that Chiriboga did not have a generous and charitable disposition.[6] For this reason, it seems likely that the two men did not get along well. Nevertheless, Salazar strongly supported the efforts of Chiriboga and Rojas to promote the canonization of Alonso de Orozco.[7]

In many ways, Salazar de Mendoza was probably an ideal patron for El Greco. Salazar was greatly interested in art and assembled an impressive collection of paintings which included at least six works by El Greco.[8] In his numerous books, Salazar frequently expressed his admiration for painting. Although he was himself a tireless researcher and writer, Salazar maintained that paintings were the most effective means of impressing doctrines and history of the Church upon the mind and spirit because they re-created events before the eyes of the viewer:

Paintings provide very powerful persuasion, greater than that which is taken from writing, as long as they accord with tradition and historical accounts. Because painting stirs and elevates the spirit more than writing. The reason, as Saint Augustine explained, is that...What we know from writing, we know, as though by hearsay, and this is worth less than painting, which puts it before our eyes.

Las pinturas son un muy fuerte argumentacion y mayor, que el que se toma de la escritura, si van conformes con la tradicion, y con las historias. Porque la pintura mueve y levanta mas el espiritu que la escritura. La razon es, porque como dize san Agustin...Lo que sabemos por la escritura lo sabemos, como de oydas, y esto merece menos, que la pintura, que le pone delante de los ojos.[9]

In this brief passage, Salazar summarized his artistic philosophy. His forthright declaration that things seen are more vividly remembered than those heard or read about indicates his keen awareness of the potential of art to educate and convert.

[4] Pedro Salazar de Mendoza, *Chronico de el Cardenal don Juan Tavera*, Toledo, 1603, 310.

[5] Salazar briefly reviewed his achievements in *Tavera*, 305–306. Now see also Kagan, in Brown, *et al.*, *El Greco of Toledo*, 65.

[6] Salazar de Mendoza, *Mendoça*, 315. See above, p. 58.

[7] Cámara, *Vida*, 248.

[8] Wethey, *El Greco and His School*, 1:13, 15; 2:67, 85, 90, 117.

[9] Salazar de Mendoza, *Ildefonso*, 123–124.

He particularly admired the ability of painting to stir the spirit through the visual re-creation of events and apparently believed that a picture could educate viewers only if it affected their feelings. Salazar's concern for the emotional impact of paintings helps to explain his interest in the work of El Greco, who created intensely dramatic images.

According to Salazar, paintings were also to be judged in terms of their historical and doctrinal correctness. Only images that respected traditions and historical accuracy would be properly instructive. Salazar emphasized that paintings could illustrate a wide variety of doctrinal matters:

The Holy Catholic Church holds many things which are affirmed by painting. Among them is [the fact] that Saint Jerome was a Cardinal, [which is demonstrated] by painting him with the habit and insignia of a Cardinal. [That] Saint Christopher was of great stature, [by painting him] like a giant. [The fact that] the Magi were kings [is shown] by painting them with crowns: and in the same way many other things which could be cited.

La santa Yglesia Catolica tiene muchas cosas a que se da credito por la pintura. Entre ellas el haver sido cardenal san Geronimo, por pintalle con el habito, e insignias de Cardenal. Ser de grande estatura, como de Gigante, san Cristobal. El haver sido Reyes los Magcs por pintarse coronados: y asi otras muchas cosas que se pueden referir.[10]

El Greco's art certainly would have suited Salazar's requirement for doctrinal accuracy. We have already seen that El Greco created didactic ensembles which clearly and vividly elucidated the theological and philosophical ideas of his patrons. Because Salazar considered the truthfulness of images to be so important, we can suppose that he would have discussed the content of the altarpieces for the hospital with the artist in detail. The program which El Greco devised for the hospital certainly would have pleased Salazar if it had been assembled in the chapel as he and the artist originally intended, for it explained fundamental Christian beliefs through a series of impressive and stirring images.

Salazar de Mendoza was one of the most important Spanish chroniclers of his generation. His numerous books include a history of the Spanish monarchy, an account of the nobility of Spain, and biographies of ecclesiastics who made significant contributions to the grandeur of Toledo as center of the Church in Spain – Saint Ildefonsus, Cardinal Pedro González de Mendoza, Cardinal Juan Tavera, and Archbishop Bartolomé Carranza.[11] Because Salazar used nearly all of his large inheritance to finance his research for these books, Philip III ordered the royal treasury to underwrite the costs of the publication of most of his writings.[12]

[10] Salazar de Mendoza, *Ildefonso*, 124.
[11] Pedro Salazar de Mendoza, *Monarquía de España*, 2 vols., Madrid, 1770; *idem.*, *Dignidades* (1618); *idem.*, *Mendoça* (1625); *idem.*, *Tavera* (1603); and *idem.*, *Carranza* (1788).
[12] Salazar de Mendoza, *Monarquía*, 1:ix–xi.

The king claimed that he was greatly impressed by Salazar's diligence and commitment to scholarly ideals. Philip probably also supported Salazar's work because of the scholar's profound loyalty to the Spanish monarchy and his frequently expressed belief that Spain was the most virtuous and important nation in Christendom.

In all of his writings, Salazar was primarily concerned with a few major themes: the early history of Christianity in Spain and its relevance to the situation of the Church in the modern world, the status of Toledo as one of the leading centers of the Church from the Apostolic era to the present, the outstanding achievements of Toledan ecclesiastics, and the significance of noble lineage. Most frequently, he studied events as a careful, conscientious and objective historian. For example, he thoroughly analyzed various breviaries, documents, and accounts to determine the evolution of the ritual celebrated in Toledo in honor of the Virgin's investiture of Saint Ildefonsus with the chasuble.[13] However, Salazar also distorted facts and introduced legends and undefended – and sometimes indefensible – ideas in order to promote his polemical concerns as, for instance, when he maintained that the arms of the Mendoza family provided irrefutable proof of its descent from El Cid.[14]

Like Don Diego de Castilla, El Greco's first Spanish patron, and many other sixteenth-century Toledans, Salazar frequently asserted that his city was one of the most important cities in the world.[15] The passion with which Salazar, Pisa, and other writers defended Toledo probably reflects concern about the city's loss of political and social influence due to the appointment of Madrid as the permanent capital.[16] The loss of prestige in the secular realm may explain why Salazar and his contemporaries focused primarily upon Toledo's importance to the Church. As the Primacy of Spain, Toledo was still officially the head of most of the churches in the country.

Salazar described Toledo as the spiritual and cultural leader of Spain and argued that the city had been a center of faith and civilization from the time that the Church was established in Spain.[17] In terms of 'orthodoxy, customs, laws, courtesy, urbanity, and good language,' he claimed, Toledo surpassed other cities not only in Spain but even in the rest of the world.[18] He affirmed the tradition that the Gospel had been brought to Spain during the Apostolic era and maintained that Saint James the Greater had personally established Toledo as the Primacy of Spain.[19] Further,

[13] Salazar de Mendoza, *Ildefonso*, 89–121. [14] Salazar de Mendoza, *Mendoça*, 24–26.

[15] See, e.g., Salazar de Mendoza, *Mendoça*, 1–19.

[16] Kagan, in Brown, *et al.*, *El Greco of Toledo*, 35ff., provides an excellent analysis of Toledo in the late sixteenth century.

[17] Salazar de Mendoza, *Ildefonso*, Introduction, no pagination.

[18] Salazar de Mendoza, *Ildefonso*, Introduction, no pagination.

[19] Salazar de Mendoza, *Mendoça*, 5–6.

he insisted, many 'holy authors' – including Saints Paul, Dionysius the Areopagite, Justin the Martyr, Jerome, John Chrysostom, and Basil – had preached there.[20] According to Salazar, Toledo had always preserved the truth of the Catholic faith, even when Rome had been governed by misguided men.[21] For him, Toledo's status as the leading city of Christendom was demonstrated by the fact that no heretical bishop had ever governed it.[22] Like many of his contemporaries, Salazar obviously had ambiguous feelings about the authority of the Roman Church. Although he claimed to support the papacy, he was willing to challenge any of its decisions which threatened to diminish the prestige of Toledo.

Salazar claimed that the Virgin had recognized the special authority of Toledo by descending to the city and giving Saint Ildefonsus the chasuble.[23] His interpretation of this event as a sign of Toledo's importance as the center of Christianity may explain why El Greco represented the Virgin descending to earth in the *View of Toledo with a Map* (now in the Museo del Greco, Toledo; c. 1610–14), which the artist painted for him.[24]

Unlike Don Diego, Salazar proclaimed that the statute of pure lineage enhanced the power of the Toledan Church and claimed that those who opposed the measure wanted to damage ecclesiastical government by introducing into it undesirable (uneducated) persons from the lower classes.[25] Salazar's own right to hold ecclesiastical office was challenged under the statute, but he successfully defended himself against the charge that his ancestry was not 'old Christian.'[26] Perhaps this experience directly inspired his study of the origins of the Mendoza family. Salazar's approach to genealogy was much like that of Don Diego, and he freely utilized flimsy evidence and outright lies to establish the connection of his family with El Cid and other famous persons.[27] Obviously, Salazar's compelling need to establish the dignity of his ancestry overcame his commitment to scholarship in this case.

Salazar was also dedicated to rehabilitating the memory of Archbishop Carranza and wrote an important biography of the Archbishop which is still a major source for historians. In this book, Salazar praised all the writings of Carranza, including an unpublished, seven-volume revised version of the controversial *Catechismo* which he claimed to have read in manuscript form.[28] He maintained that Carranza's writings were entirely orthodox and fully in accord with the noble ideals of the early Church. Salazar explicitly compared the Inquisitorial process against Carranza to the false charges which had been levied against Saint Ildefonsus after his death.[29]

[20] Salazar de Mendoza, *Mendoça*, 'Dedicatoria,' no pagination. [21] Salazar de Mendoza, *Mendoça*, 17.

[22] Salazar de Mendoza, *Mendoça*, 17. [23] Salazar de Mendoza, *Mendoça*, 17.

[24] On this painting, see Wethey, *El Greco and His School*, 2:84–85.

[25] Salazar de Mendoza, *Mendoça*, 472. [26] Salazar de Mendoza, *Mendoça*, 473.

[27] Salazar de Mendoza, *Mendoça*, 24–26. [28] Salazar de Mendoza, *Carranza*, 198–200.

[29] Salazar de Mendoza, *Ildefonso*, 'Dedicatoria,' no pagination.

He thus verbalized the ideas which El Greco seems to have illustrated in the *Resurrection* for Santo Domingo.

Because he claimed that Toledo had always been governed by orthodox bishops, Salazar may have felt compelled to prove Carranza's innocence. Nevertheless, it seems likely that Salazar sincerely believed in the integrity of the Archbishop. Throughout his writings, Salazar depended upon the same scriptural and patristic sources that had inspired Carranza. Moreover, Salazar's dedication to the charitable activities of the hospital and his zealous commitment to the fulfillment of all ecclesiastical responsibilities reflected Carranza's concern with reforming the Church so that it would be responsive to the needs of all of its members.

The close connection between the program of El Greco's altarpieces for the hospital chapel and beliefs explained in Carranza's *Catechismo christiano* suggests the importance of the Archbishop's work in the formulation of Salazar's ideas. Indeed, passages of the *Catechismo* elucidate many aspects of the pictorial program, and Carranza's book could have served as the ideal spiritual guide for the literate worshipper in the chapel. Given the likelihood of the influence of Carranza's writings upon the iconographic program of the chapel, it is especially relevant that the Archbishop had vowed to build a hospital for the poor at the termination of his trial.[30] Salazar, who recorded this pledge, maintained that only the Archbishop's death shortly after his release from prison prevented its realization.

Salazar was very proud of his position as chief administrator of the Hospital of Saint John the Baptist Outside the Walls in Toledo, and he considered it to be one of the most important religious foundations of the city.[31] Cardinal Juan Tavera (1472–1545) had founded the hospital in 1541 and intended it to offer physical care and spiritual consolation to men and woman of all classes.[32] Salazar's biography of Tavera is still the basic source on his life and career.

After holding important offices including the archbishopric of Santiago (1524–34), the bishopric of Osma (1523–24), and that of Ciudad Rodrigo (1514–23), Tavera was appointed Cardinal-Archbishop of Toledo in 1534. Although Tavera expressed the desire to devote himself solely to religious duties, Charles V also required his services as an advisor; and for many years, the Cardinal acted as President of the Royal Council. In 1539, he resigned the latter position and became the Inquisitor-General of Spain. Although these obligations prevented Tavera from residing in Toledo, he showed his concern for the welfare of the city by founding the hospital.[33]

[30] Salazar de Mendoza, *Carranza*, 97–98.
[31] Salazar de Mendoza, *Ildefonso*, 'Dedicatoria,' no pagination.
[32] Salazar de Mendoza, *Tavera*, 230–306. Catherine Wilkinson, *The Hospital of Cardinal Tavera in Toledo*, Ph.D. dissertation, Yale University, 1968 (published in the Garland series, Outstanding Dissertations in the Fine Arts, New York, 1977), briefly reviews the purposes of the institution and analyzes the design and construction of the building. [33] Salazar de Mendoza, *Tavera*, 230.

Salazar's passionate interest in demonstrating the preservation of early Christian practices in Toledo led him to justify the establishment and activities of the Hospital of Saint John the Baptist by citing biblical and patristic sources of inspiration.[34] Even though, in reality, the hospital provided care for the wealthy as well as the poor and had special, lavishly furnished suites for nobles, Salazar explained its foundation as a specific response to Christ's injunction to care for the poor.[35] In his discussion, Salazar strongly affirmed the beliefs that the poor are the special objects of Christ's compassion and, in fact, represent his presence on earth.

Like Alonso de Orozco, Salazar claimed that the wealthy were obligated to perform charitable actions and could avoid damnation only by doing so.[36] From Salazar's account, it is clear that the hospital was intended not only to meet specific needs of the community but also to promote the salvation of Tavera's soul.[37]

By the mid sixteenth century, hospitals were widely considered to be one of the best expressions of charitable ideas, and many had already been founded in Toledo to treat specific illnesses and to provide accommodation to certain classes of pilgrims.[38] Tavera's foundation differed from the older hospitals because it tried to deal with illnesses of all sorts and welcomed both men and women from all classes.[39] To ensure that the hospital could fulfill its many responsibilities, the administrators established very elaborate, well-organized systems of care which were well in advance of contemporary practice.[40]

As was customary at this time, great attention was also devoted to the patients' spiritual well-being. This concern was founded on the traditional Christian belief that illness resulted from sin.[41] Each patient at the Hospital of Saint John the Baptist was required to confess before seeing a doctor and was expected to receive Holy Communion at least once a week.[42]

Although the hospital evidently devoted much energy and ingenuity to curing the

[34] Salazar de Mendoza, *Tavera*, 310.
[35] Salazar de Mendoza, *Tavera*, 307–309.
[36] Salazar de Mendoza, *Tavera*, 307–309.
[37] Salazar de Mendoza, *Tavera*, 230, 309–310.
[38] Salazar de Mendoza, *Tavera*, 230–231.
[39] Salazar de Mendoza, *Tavera*, 230–231, 287–290; Wilkinson, *Tavera*, 5.
[40] Salazar de Mendoza, *Tavera*, 287–290, 294–297.
[41] According to the Gospel accounts, Jesus frequently described illness as a consequence of sin and cured the sick by forgiving their sins. This can be exemplified by the account of Jesus's cure of the paralytic in Matthew 9:2–8.

Behold, they brought to him a man sick of the palsy, lying on a bed: and Jesus seeing their faith said unto the sick of the palsy; Son, be of good cheer, thy sins be forgiven thee. And, behold, certain of the scribes said within themselves, This man blasphemeth. And Jesus knowing their thoughts said, Wherefore think ye evil in your hearts? For whether is easier, to say, Thy sins be forgiven thee; or to say, Arise, and walk? But that ye may know that the Son of man hath power on earth to forgive sins, (then saith he to the sick of the palsy,) Arise, take up thy bed, and go unto thine house. And he arose, and departed to his house. But when the multitudes saw it, they marvelled, and glorified God, which had given such power unto men.

[42] Salazar de Mendoza, *Tavera*, 287–290, 294–297.

ill, Salazar claimed that nothing was more important to its officials than helping its patients to die well.[43] To promote this goal, Tavera obtained from the papacy the right for his institution to grant an exceptional number of privileges and indulgences.

Throughout his career, Tavera promoted indulgences as a means to stimulate faith by rewarding devotion and piety. During his tenure as Archbishop of Santiago, Tavera revived the custom of granting the indulgences which the Cathedral and other institutions of the city had been empowered to distribute in earlier centuries.[44] For the hospital, Tavera obtained all the privileges and indulgences which the Holy See had previously extended only to the Hospitals of Santo Spirito in Sassia and San Giacomo degli Incurabili, both in Rome. These extraordinary benefits included the right to grant complete absolution of sins and remission from all punishment to patients who died there.[45]

It should be emphasized that indulgences did not replace the sacraments of Communion, Penance, and Extreme Unction. To receive a plenary indulgence, the patient had to adopt a genuinely penitent attitude and sincerely consign his soul to the care of the Church.[46] A priest remained continuously with each dying patient, confessing him and encouraging him to repent. In order for the indulgences to be effective, Mass had to be celebrated in the hospital chapel immediately after the death of a patient. Because of the special benefits which the hospital enjoyed, even those whom the officials felt unable to absolve completely departed in greater grace and would endure Purgatory for a shorter time than if they had died elsewhere. The hospital's indulgences also directly benefited Tavera and Salazar because they were applicable to the patrons and officials of the institution as well as to its inmates.[47] The importance which Salazar attached to the privileges is indicated by the detail with which he recorded them in his account of the hospital.

Tavera had not intended to be buried at the hospital, but early in 1546 his relatives decided to construct his tomb in the middle of the hospital chapel.[48] The tomb, executed by Alonso de Berruguete, is surmounted by a recumbent effigy of the Cardinal. Tavera's remains are actually preserved in the crypt beneath the chapel, where many later officials and patrons of the hospital are also buried. To promote

[43] Salazar de Mendoza, *Tavera*, 290. [44] Salazar de Mendoza, *Tavera*, 83–85.

[45] Salazar de Mendoza, *Tavera*, 265–293. The privileges and indulgences granted to Santo Spirito and San Giacomo are transcribed in full in *Compendio delli privilleggi essention' e indulgente concesse all' archihospitale di S. Spirito in Sassia in Roma* (Viterbo, 1584) (henceforth cited as *Compendio di S. Spirito*). An excellent modern study of S. Spirito, which includes a comprehensive discussion of the philosophical and theological concerns reflected in the foundation of hospitals in the sixteenth century, is Pietro d'Angelis, *L'Archiconfra-ternità ospitaliera di S.to Spirito in Saxia* (Rome, 1954). For a brief but very useful history of papal indulgences, see Serafino De Angelis, 'Indulgenze,' in *Enciclopedia cattolica* (Vatican City, 1951), 1:1901–1909.

[46] *Compendio di S. Spirito*, cap. 12, clearly explains this.

[47] Salazar de Mendoza, *Tavera*, 264–276. [48] Wilkinson, *Tavera*, 103ff.

the salvation of all these individuals, masses were offered on their behalf several times a day.[49]

Salazar certainly would have sought to ensure that all the appropriate and required masses were celebrated because he strongly believed in the efficacy of services conducted on behalf of the dead. In discussing the achievements of the Canons of Toledo Cathedral, he particularly praised their commitment to performing all the masses requested by the founders of benefices, even though many of the older obligations no longer had to be honored.[50]

In addition to being administrator of the hospital, Salazar served as Penitential Canon (*canónigo penitenciario*) of Toledo Cathedral, and the sacrament of Penance was one of the doctrinal matters with which he was most concerned. Salazar followed Saint John Chrysostom in arguing that Christ had allowed Peter to reject him so that Peter's inevitable sorrow for this action would provide an Apostolic model for the renunciation of sin.[51] Moreover, Salazar affirmed, God appointed men, rather than angels, as his priests because only creatures who were themselves subject to sin could understand and deal with human weakness.[52] Salazar also emphasized the importance of penitence to both the physical care and the spiritual well-being of the patients of the hospital.[53] Only willing repentance could bring about the rebirth into eternal life which El Greco illustrated in his paintings for the hospital.

There is every reason to suppose that El Greco enjoyed an amicable relationship with Salazar. The two apparently shared some of the same philosophical and theological interests. The artist's library contained writings by many of the Church Fathers whom Salazar had praised and associated with Toledo.[54] No dispute about the program seems to have occurred during the artist's lifetime. In fact, disagreements with the artist's son about the completion of the project are not recorded until 1622, long after Salazar's resignation (1614) and replacement by Alonso Biedma y Rojas.

In the paintings which he undertook for the Hospital of Saint John the Baptist, El Greco vividly and accurately illustrated beliefs and ideas explicated by Salazar and theologians whom he revered. The boldness of El Greco's style endows the altarpieces with an emotional force that would have served to impress the meaning of the program upon the minds and spirits of worshippers in the hospital chapel.

El Greco's Commissions for the Hospital

Over a long period, Salazar and El Greco worked together to elaborate a program that glorified the character and mission of the Hospital of Saint John the Baptist.

[49] Salazar de Mendoza, *Tavera*, 276.
[50] Salazar de Mendoza, *Ildefonso*, 'Dedicatoria,' no pagination.
[51] Salazar de Mendoza, *Mendoça*, 418. [52] Salazar de Mendoza, *Mendoça*, 419.
[53] Salazar de Mendoza, *Tavera*, 290–293. [54] San Román, *El Greco*, 195–197.

The collaboration began in 1595, when Salazar commissioned from the artist a wooden tabernacle for the main altar of the hospital chapel. The tabernacle was to be decorated with four statues of the Fathers of the Latin Church on the upper corners and a statue of the Resurrected Christ on the top.[55] Although this tabernacle was ordered before the three altarpieces, there are reasons to suppose that the statue of the Resurrected Christ was conceived as part of the over-all program.

In a contract of 1608, Salazar de Mendoza, again on behalf of the hospital, commissioned the design and execution of the architectural elements and sculpture for three altars from El Greco.[56] The contract specifically mentioned a sculptural group of angels adoring the Lamb, which was to occupy the tympanum above the main retable. In addition, twelve statuettes of the Apostles were commissioned to adorn the tabernacle ordered in 1595, as well as the painting of its five statues, which had been finished in 1598.

No paintings were mentioned in this contract, nor has a separate contract for them been found. But the inventory of El Greco's estate indicates that, by the time of his death (1614), he had begun paintings for the hospital chapel. This inventory refers to 'paintings for the hospital, begun' ('los quadros del ospital empezados').[57] The inventory made in 1621 of the possessions of El Greco's son Jorge Manuel refers to 'the principal Baptism for the hospital' ('el bautismo prinzipal del ospital')[58] and also mentions 'two large paintings sketched in for the side altars of the hospital' ('dos quadros bosqueados para los colaterales del ospital grandes') without specifying their subjects.[59] Only the *Baptism of Christ*, still located in the hospital, can be identified by references to paintings for its chapel in the inventories of El Greco's estate or of his son's possessions.

The subjects of the other paintings commissioned for the program have been deduced from a contract of 1635 in which Félix Casteló agreed to paint for the hospital chapel large versions of the Incarnation, Baptism, and Apocalyptic Vision, as well as smaller canvases of the Preaching of John the Baptist and the Beheading of John the Baptist.[60] There is no evidence that Casteló actually began any of these paintings. Because he was the official painter of the king, Casteló undoubtedly had many other obligations which might have prevented him from working on this project.

San Román and later authorities have logically assumed that the hospital would have required El Greco to represent the same subjects that they later assigned to Casteló. The *Incarnation*, now in the collection of the Banco Urquijo, Madrid, and

[55] Wethey, *El Greco and His School*, 2:19–20, 158, 160.
[56] Cossío, *El Greco*, appendice no. 13, 2:680–688, transcribes this contract.
[57] San Román, *El Greco*, 195. [58] San Román, 'De la vida,' 303, no. 184.
[59] San Román, 'De la vida,' 302, no. 183.
[60] This contract is transcribed by San Román, 'De la vida,' 337–338.

the *Apocalyptic Vision*, now in the Metropolitan Museum of Art, New York, have been identified as the principal paintings for the lateral altars.[61] The fragment known as the *Angel Concert* (Athens: National Gallery) is now recognized as having formed the upper section of the *Incarnation*.[62] The Metropolitan painting is the only late work by El Greco which could be described as an Apocalyptic Vision. No paintings by El Greco of the Preaching of John the Baptist or of the Beheading of John the Baptist, for the smaller upper storeys, have been found. However, the inventory of 1614 lists 'two canvases prepared for the attics of the side altars' ('dos lienzos aparezados para los remates de los colaterales').[63] Because representations of the ministry and martyrdom of John the Baptist would have reflected both the dedication of the chapel and the iconographic scheme elucidated by the larger paintings, it is likely that the hospital would have also commissioned paintings of these subjects from El Greco.

The *Baptism of Christ* appears to be the only one of the three paintings identified with the commission to have been delivered. The *Resurrected Christ* is the only statue in the possession of the hospital which can certainly be ascribed to El Greco. Neither the *Incarnation* nor the *Apocalyptic Vision* by El Greco was included in the inventories of the hospital's paintings made in 1624, 1631, and 1762.[64]

Probably because of the infirmities of old age, El Greco was unable to complete the commission for the hospital chapel before his death, but Jorge Manuel continued work on the various parts. The extensive changes in the main altar which Biedma y Rojas required and the apparent slowness of Jorge Manuel retarded completion of the project and resulted in an exceptionally bitter legal dispute.[65] The hospital seized the completed parts of the retables and other goods in 1623 and again in 1624. In 1630, the hospital entrusted another artist with the completion of the project.

Despite the fact that the commission was never completed by El Greco, it is clear that the various parts were intended to form a unified whole. Analysis of the purpose and meaning of this ensemble will show that long-held assumptions about the arrangement of the elements of the commission must also be examined.

'The Resurrected Christ'

The tabernacle with the statue of the *Resurrected Christ* (Hospital of Saint John the Baptist Outside the Walls, Toledo; 45 cm. tall; fig. 30) was the first part of the chapel

61 San Román, 'De la vida,' 302, no. 183; and 338, f.n. 1. See also Soehner, 'Greco,' 9–10, 210; Theodore Rousseau, 'El Greco's Vision of St. John,' *Metropolitan Museum Bulletin*, 1959, 254; Wethey, *El Greco and His School*, 2:22–23; José Gudiol, *El Greco*, trans. K. Lyons, New York, 1973, 258–268.
62 The shapes of the *Angel Concert* are continued down into the *Incarnation*. The colors and the style of execution of both parts are intimately related (Wethey, *El Greco and His School*, 2:34–35).
63 San Román, *El Greco*, 195. 64 San Román, 'De la vida,' 339.
65 San Román, *El Greco*, 58–59, 209–210; *idem.*, 'De la vida,' 310–336.

decoration to have been commissioned from El Greco. The choice of this statue may reflect the ceremonies of the hospital and ideas expressed by Carranza in his *Catechismo*.

A priest at the hospital always placed before the bed of a dying patient a crucifix and altar candles.[66] When a patient approached death, he was removed to a special room where the sacrament of Extreme Unction was administered. The crucifix and candles were brought from the infirmary to this room and remained before the patient's eyes until he died, as a means for stimulating him to repent his sins.

The practice accorded with Carranza's interpretation of the Crucifixion as an extreme act of penance for the sins of mankind, which provided the model for the milder forms of penance required of Christians.[67] Carranza believed that contemplation of the crucifix would inspire people to repent, especially if they imagined the weight of all the sins of the world upon Christ's body. Christ's death had made salvation possible because it freed all people from the condemnation which they deserved because of their sins. The Council of Trent had therefore described the Crucifixion as the 'meritorious cause' of the Christian's justification:

The meritorious cause is His most beloved only-begotten, our Lord Jesus Christ, who, when we were enemies, *for the exceeding charity wherewith he loved us*, merited Justification for us by His most holy Passion on the wood of the cross, and made satisfaction for us unto God the Father.[68]

Because of Christ's sacrifice, Penance and the other sacraments are effective in restoring the faithful to the grace of God.

As soon as possible after a patient's death, his body was removed to the chapel, where the Mass for the Dead was celebrated. According to the papal decrees, the benefits which the hospital was able to confer upon those who died within its walls were effective only if the Mass for the Dead was said in its chapel.[69] Thus, the image of the Resurrected Christ at the main altar in this chapel would have complemented the image of the Crucifixion put before the patient as he lay dying.

The Resurrection of Christ signified his victory over death, to which he had succumbed while on the Cross, and also represented the triumph of the faithful over death because it had made possible the Christian's restoration to full life (I Corinthians 15:22). Following Paul and numerous Church Fathers, Carranza had described the Resurrection as both the exemplary and efficient cause of mankind's Justification, for it demonstrated the way in which bodies will be fully revived at the time of the Last Judgment.[70] More significantly, Carranza had declared, Christ's Resurrection guaranteed the future resurrection of his followers. As parts of his

[66] Salazar de Mendoza, *Tavera*, 292. On the treatment of the dying, see 291–293.
[67] Carranza, *Comentarios*, 1:285–286. [68] Trent, Session 6, 34.
[69] Salazar de Mendoza, *Tavera*, 292–293. [70] Carranza, *Comentarios*, 1:290–291.

mystical body, Christians will necessarily be resurrected with him who alone constitutes the head of that body.

The statues of the Four Fathers of the Latin Church on the tabernacle beneath the statue of Christ would have indicated the centrality of Christ's Resurrection to the Christian faith and hope of salvation. The doctrine that Christ's Resurrection provided the basis for all the activities of the Church was formulated by Paul, who declared that the Church would have no consolation to offer mankind if it had not occurred (I Corinthians 15:14, 17–18).

Because it inspired faith and hope, the image of the Resurrected Christ was described by Carranza as the most joyful and important of Christian images.[71] This belief may have influenced the choice of this theme for the initial decoration of the altar.

As the crowning element of the tabernacle in which the Host was venerated, the statue of the Resurrected Christ also would have helped to affirm the fundamental doctrine of his bodily presence in the Eucharist. This was a doctrine strongly reiterated by the Council of Trent in opposition to Protestants who denied it.[72] The Council specifically related the Resurrection to the Eucharist by declaring that the reunion of the three parts of Christ's being – body, blood, and soul – through his restoration to life made it possible for him to be fully present in both the consecrated Host and wine.[73] The nudity and realistic muscular structure of El Greco's statue would have served to express the beliefs that Christ regained the full corporeality of his earthly state through the Resurrection and that he was physically present in the Eucharist.

El Greco underlined the doctrine of the Real Presence by showing Christ making the gesture used to signify offering and libation in ancient Roman and later art.[74] In this way, Christ was seen to offer himself in the Host contained within the tabernacle below and to pour out his blood into the chalice. This elucidation of the content of the Eucharist would have served a didactic function in accord with the Decrees of the Council of Trent, which asserted that a communicant who failed to recognize the Host as Christ's body and blood would be damned.[75]

Finally, the statue of the Resurrected Christ on top of the tabernacle expressed the importance of Communion to salvation, a belief that also was reflected in the hospital's frequent administration of this sacrament to its patients.[76] The Council of Trent emphasized the consolation which the veneration or the Host and the receipt of the sacrament provided to the sick and directed that Communion should

[71] Carranza, *Comentarios*, 1:287–288.
[73] Trent, Session 13, 78.
[75] Trent, Session 13, 82.
[76] Salazar de Mendoza, *Tavera*, 390.
[72] Trent, Session 13, 76.
[74] Brilliant, *Gesture*, 28–29.

be brought to those too sick to go to church to receive it, insisting that they be given the opportunity to benefit from it.[77]

'The Incarnation'

The *Incarnation* (Madrid, Fundación del Banco Urquijo; 2.94 × 2.09 m.; fig. 31) was probably intended for the altar on the side of the Gospel.[78] Most authorities agree that El Greco laid out the composition but that Jorge Manuel was responsible for the present state of execution.[79] The insubstantial body of Mary, the distinctive physiognomies of the two protagonists, and the detailed rendering of the floor tiles, which are shown rapidly receding into depth, are all characteristic of Jorge Manuel's style.[80]

The *Incarnation* records the conception of the Son by the Father acting through the agency of the Holy Spirit (Luke 1:35) and initiates the history of Christian salvation, which will be fulfilled at the time of the Last Judgment, an event alluded to in the *Apocalyptic Vision*, which brings El Greco's program to a close. The decree of the Council of Trent on justification, issued January 13, 1547, devoted a chapter to the 'dispensation and mystery of Christ's advent' which emphasized that the Incarnation provided the basis for the expiation of the sins and the justification of mankind.[81] Christ's birth made possible the salvation of mankind through faith and gave men the opportunity to become the adopted sons of God (Galatians 4:4–5). Following the Gospel accounts and Paul's Epistles, the Church Fathers had frequently reiterated the doctrine that the purpose of Christ's coming was to remit the sins of the world.[82]

Carranza was among those who emphasized that Christ's Resurrection, which prefigured and guaranteed that of the faithful, was implied in his conception.[83] According to Carranza, Christ entered and left the womb of his mother without leaving any mark upon it, just as he later passed through the stones of the tomb without moving them. In his version of the scene, El Greco may have intended to allude to the Resurrection by posing the figure of the Angel Gabriel to resemble the statue of Christ on the tabernacle. In the context of the painting, the upraised

[77] Trent, Session 13, 80.

[78] Soehner, 'Greco,' 11, 202–204.

[79] Wethey, *El Greco and His School*, 2:34, with previous bibliography.

[80] Elizabeth du Gué Trapier, 'The Son of El Greco,' in *Notes Hispanic*, 3 (1943), 1–46, analyzes Jorge Manuel's career and works.

[81] Trent, Session 6, 31.

[82] For example, Saint John Chrysostom, as stated in his *Homilies*, a book included in El Greco's library (San Román, *El Greco*, 196). See Saint John Chrysostom, *Homilies on Saint John the Apostle and Evangelist*, 2 vols., trans. Sister Thomas Aquinas Gogger (Washington, D.C., 1957), 1:269.

[83] Carranza, *Comentarios*, 1:201.

right hand, which corresponds to that of the statue, could signify the offering of God's love through the descent of the Spirit to Mary.

The Church Fathers found that the miraculous and awesome character of the spiritual birth of the Incarnation inspired faith. In his *Homilies on Saint John*, Chrysostom described the Incarnation as the most awesome spiritual birth and stated that, in comparison with it, even baptism seemed earthly.[84] Carranza wrote that the Incarnation was demonstrated miraculous by the fact that in one instant a soul was joined to a body and divinity was united to body and soul.[85] For the first and only time, a man's soul was attached to his body before forty-six days had elapsed after conception. Following Saint Thomas Aquinas, Carranza also insisted that the inseparable, dual divine and human nature of Christ was fully developed at the moment of conception.[86] Carranza's tone of genuine excitement and his interpretation of the miraculous aspect of the Incarnation as a major inducement to belief indicate the importance which he attached to this point.

El Greco depicted these ideas in the *Incarnation* by showing in the upper left the Christ Child seated in the lap of the Virgin and adored by John the Baptist. This motif represents the doctrine that Christ's human and divine nature was fully formed at the moment of his conception, for Christ had to be already divine to receive adoration.

In the upper right section of the painting are four figures which have generally been described as angels but which clearly represent Virtues attendant upon the Virgin. On the far right sits Temperance, who pours water from a pitcher into a basin. Faith, the second figure from the right, holds the Cross, her usual attribute; to her left is Prudence, who holds up a mirror. At the far left of the group sits Charity, who suckles a baby. This combination of Virtues is unusual and must respond to the specific requirements of the program.

The inclusion of these figures is explained by reference to the writings of the medieval theologian Saint Bernard of Clairvaux and of leading sixteenth-century Marian authors, such as Saint Thomas of Villanueva, who maintained that these four virtues particularly attracted God to Mary and inspired him to select her as the Mother of Christ.[87]

Temperance signifies the virginity of Mary because only the renunciation (or literal tempering) of carnal desires enabled her to achieve chastity.[88] To guard her

[84] John Chrysostom, *Homilies on...John*, 1:290. [85] Carranza, *Comentarios*, 1:195ff.

[86] Carranza, *Comentarios*, 1:195–196. Saint Thomas Aquinas, *Summa Theologica*, Blackfriars Edition, vol. 52, *The Childhood of Christ*, trans. Ronald Potter (New York, 1972), part 3, questions 32–34, 41–82.

[87] The four specific Virtues represented by El Greco were inspired directly by Marian literature, which emphasized their importance. See Saint Bernard of Clairvaux, 'In Laudibus Virginis Matris,' in *Sermones*, ed. by J. Leclercq and H. Rochas, Opera 4, Rome, 1966, 22, 36–37, 42, and *passim.*; and Saint Thomas of Villanueva, *Sermones*, 234–313. [88] Alonso, *Epistolario*, 126/v.

purity, the Virgin secluded herself from others and was, therefore, in an isolated chamber when Gabriel visited her, as she was traditionally shown in paintings.

The Virgin's faith was also especially gratifying to God, and she expressed great devotion to him through the continuous study of the Scriptures and prayers.[89] The prayer stand and book, basic parts of the iconography of this scene, indicate that Mary was engaged in her devotions when Gabriel arrived.

The Virgin demonstrated her prudence by ascertaining that Gabriel was an angel and not a demon and by considering his message carefully.[90] The Virgin enjoyed free will like all other mortals, and she reflected upon the consequences of her decision before giving her assent. Her pensive and wondering attitude in the painting now in Madrid suggests her careful consideration of the Archangel's announcement.

The Church associates charity with the Virgin, who is venerated as the chief advocate of mankind before God.[91] Mary's willingness to become the Mother of God demonstrated her charity because at the same time she accepted for herself the anguish of the Passion.[92]

As well as glorifying Mary, the four Virtues in El Greco's painting represented the qualities which Tavera displayed in his service to the Church. This interpretation follows from the declarations of the Council of Trent that the Incarnation should inspire Christians to live in a virtuous manner and that the benefits of the Incarnation particularly obligate ecclesiastical leaders to demonstrate the virtues which had attracted God to Mary.[93]

In his biography of Tavera, Salazar de Mendoza emphasized that the Cardinal's actions revealed the four virtues shown by El Greco. According to Salazar, the Cardinal was particularly zealous in charity, appropriately represented nearest to the center of the painting. Obviously, the foundation of the Hospital well exemplified this virtue, but Tavera also showed his kindness and generosity by feeding the hungry during famines, arranging dowries for women from poor families, and attending to many of the other needs of the poor.[94]

In fulfilling his duties, Tavera displayed great prudence.[95] The thoroughness with which he provided for the financial support of the Hospital typified his cautious and meticulous handling of administrative matters, which enabled him to realize his charitable intentions and to strengthen the actual presence of the Church in the world.[96]

[89] Saint Bernard, 'In Laudibus,' 36–40; Saint Thomas of Villanueva, *Sermones*, 241–243 and *passim*.

[90] See Saint Bernard, 'In Laudibus,' 42; and Saint Thomas of Villanueva, *Sermones*, 236–237.

[91] See, e.g., Saint Thomas of Villanueva, *Sermones*, 275, 297.

[92] Saint Bernard, 'In Laudibus,' 40–41.

[93] Trent, Session 6, 36, 38. I am grateful to Fernando Marías for encouraging me to investigate the ways in which the paintings commemorated Tavera's memory (letter of October 7, 1982).

[94] Salazar de Mendoza, *Tavera*, 84–85, 90–92, 230–232, and 307–310.

[95] Salazar de Mendoza, *Tavera*, 51–52, 60, and 73. [96] Salazar de Mendoza, *Tavera*, 285–287.

First as an ordinary member of the Inquisition and later as Inquisitor-General of Spain, Tavera attested to his faith by investigating and prosecuting diligently instances of laxness, heretical attitudes and practices, and immoral behavior which could weaken the Church.[97] At the same time, he stimulated devotion by promoting indulgences, which rewarded those truly committed to the Church.[98] The foundation of the hospital also demonstrated his faith because it was inspired ultimately by the love of Christ, who identified himself with the poor.[99]

In order to devote most of his financial resources to the hospital and other charitable projects, Tavera also required great temperance, which enabled him to renounce material things.[100]

El Greco's depiction of Prudence and Temperance as the immediate attendants of Faith may be related to the title page of Salazar's biography of Tavera, which showed these two Virtues holding the Cardinal's hat above the coat of arms of his family (fig. 33). These two Virtues exemplify the qualities which Paul demanded of anyone appointed as bishop (Titus 1:7–9). In the second session, the Council of Trent affirmed the importance of temperance to bishops, exhorting them:

That, above all, each observe sobriety at the table, and moderation in diet; further, that whereas idle conversations are often wont to arise there, the reading of the divine Scriptures be introduced, even at the tables of bishops; and let each charge his servants not to be quarrelsome, given to wine,...and lovers of pleasures; in fine, let them shun vice and follow after virtue, and in dress, demeanour, and in all their actions show forth modesty, as becomes the servants of God.[101]

The decrees of the thirteenth session of the Council emphasized that attempts by bishops to reform their flocks should be undertaken with prudence.[102]

The composition of the *Incarnation* was originally completed by a representation of an angelic concert which, however, was detached from the canvas and is now in Athens (1.12 × 2.05 m.). This motif celebrates God's love, which led to Christ's birth, and indicates the new life which it enabled mankind to obtain. Angelic choirs are not mentioned in the biblical accounts of the Annunciation to Mary, but Angel Concerts in this and other paintings of Gabriel in Mary's room by El Greco and sixteenth-century Italian artists were probably inspired by their appearance at the later Annunciation to the Shepherds where, as Carranza maintained, they joyously commemorated God's infinite love.[103] It was also appropriate that a scene of celestial glory be shown at the top of the painting because Carranza described the new state

[97] Salazar de Mendoza, *Tavera*, 55–65, 82, and *passim*.
[98] Salazar de Mendoza, *Tavera*, 85–88, 265–271, 291–294.
[99] Salazar de Mendoza, *Tavera*, 230–309.
[100] Salazar de Mendoza, *Tavera*, 45, 73, 85, 231, 286, and 308–309.
[101] Trent, Session 2, 14. [102] Trent, Session 13, 84–85.
[103] Carranza, *Comentarios*, 1:208.

of being which the Incarnation made possible in terms of celebrations in the heavens.[104]

Because John the Baptist prepared the way for Christ by proclaiming his coming and by recognizing him as the Savior, it is probable that a scene of John the Baptist preaching, which was mentioned in the contract of 1635 with Félix Castelo, was intended for the attic storey of the altar of the Gospel. John's prediction that light was coming into the world (John 1:6–8, 15) is realized in the *Incarnation*, where the arrival of the shining Dove illuminates the dark room. The presence of Saint John would also have emphasized his love of poverty, his modesty, and humility before God and demonstrated that his commitment to the Word should be emulated.[105] Thus, the scene of the preaching would have served not only as a historical record but also as a demonstration of the virtues seated above the Annunciatory Angel. Finally, the scene of John's ministry would have been related to the dedication of the hospital to the Baptist and to its mission of caring for the poor and inspiring their faith, making them worthy to receive the outpouring of God's grace.

'The Baptism of Christ'

The *Incarnation* records Christ's conception as the Son of God, human and divine in one being. But mankind cannot receive the grace of God at the time of conception because of original sin. Only through Baptism are men spiritually reborn as adopted sons of God. The Decrees of the Council of Trent and Carranza's *Catechismo* define Baptism as the means by which mankind obtains the benefits made available by Christ's Incarnation.[106] This definition illustrates the intimate link between El Greco's paintings of these two events for the hospital chapel.

El Greco's *Baptism of Christ* for the hospital (still at the Hospital of Saint John the Baptist Outside the Walls, Toledo; 3.30 × 2.11 m.; fig. 32) is a variant of his painting of the same subject for the Seminary of the Incarnation, Madrid. Many of the common elements illustrate ideas and beliefs which the patrons of the two projects shared. However, El Greco made important changes in the composition to adapt it to the circumstances of the later commission and to express the special concerns of the hospital program.

The intervention of Jorge Manuel, who apparently tried to finish the picture after his father's death, did not conceal the boldness of El Greco's conception. Jorge

[104] Carranza, *Comentarios*, 1:197.

[105] Dionisio Vázquez, Sermon for the fourth Sunday of Advent, extant fragment transcribed in Vázquez, *Sermones*, ed. Félix G. Olmeido, S.I., Clásicos Castellanos 123, Madrid, 1956, lxii.

[106] Trent, Session 6, 32, 34; Carranza, *Comentarios*, 1:201.

Manuel's hand is most evident in the lower section – especially in the hard faceting of the bodies of Christ and John and in their stylized and sharply pointed physiognomies. The free painterly technique of the upper section is much more characteristic of El Greco. The faces and limbs of the angels gathered about the Father are in El Greco's mature style and well convey the adoration of these beings for God. The black background employed for the whole canvas makes the brilliantly lit areas stand out with extraordinary intensity and helps to give the whole scene a haunting, mysterious quality.

In general terms, this depiction of the major event in the earthly life of one of Tavera's principal name saints would have helped to commemorate his memory and marked the dedication of his foundation. Because of his humility and love of poverty, the Baptist was an ideal patron for a charitable institution.

In devising his second version of the Baptism, El Greco strengthened his visualization of the belief that God's will is realized through the cooperative action of his agents. In the painting for the hospital, God the Father directs his benediction to the angel at the far left, whose upturned hand signals that the divine will has been fulfilled and also marks the receipt of grace.[107] By showing the Father in a profile view with his body turned toward the angel at the left, El Greco clearly indicated that God did not respond directly to the Baptism and acted only through the appointed intermediaries. In the *Baptism* for the seminary, the downward gaze of the Father could have encompassed John pouring water over Christ. In the *Baptism* for the hospital, the Father looks only toward the angel at the left and cannot personally see the Baptism taking place.

El Greco stressed the importance of the intermediary angel at the left of the hospital *Baptism* by greatly elongating his proportions so that he extends far above the figure of Christ below him. The greatly increased number of cherubim surrounding the Father in the later version may also have been intended to reinforce the importance of the celestial hierarchy to the fulfillment of the divine will. Cherubim were responsible for conveying the Lord's instructions to those of lower ranks, the only celestial beings that could appear in visible form on earth.[108]

Because the celestial hierarchy provided the model for ecclesiastical government, this theme would have been especially appropriate for the burial place of Tavera, who as Cardinal-Archbishop of Toledo and Inquisitor-General had been the most powerful Church official in Spain. The globe held by the Father in the hospital *Baptism* may signify the divine authority exercised on earth by the Cardinal and other officials of the Church. Christ's voluntary submission to the celestial hierarchy

107 Wittkower, 'El Greco,' 53.
108 Dionysius, *Hiérarchie céleste*, 206–212, 217–221.

provided a model for the obedience which the faithful owed to cardinals and other leaders of the Church.[109]

The Baptism of Christ by John instituted the rite as a sacrament of the Church. The nature of this sacrament, especially as explained by Carranza, is of primary importance to understanding the significance of the painting for the hospital.[110] Carranza held that Baptism, after the Incarnation, opened the gates of heaven to mankind. In a discussion that could be applied to El Greco's canvas, Carranza maintained that the scene of Christ's Baptism in the Jordan illustrated all the benefits which Christians derived from the sacrament. The Archbishop maintained that accurate pictorial representations of John's Baptism of Christ helped the faithful to understand these beliefs and combatted Protestantism.

El Greco visualized the effects of Baptism in several ways. Like most earlier Western artists, he showed John pouring water over Christ's head in spite of the fact that Christ did not need to be cleansed of sin. For when a priest applies water to a mortal who is entering the Church, it serves as the means by which the Spirit washes sin from the soul.[111] The gifts of the Holy Spirit received in Baptism are almost invariably symbolized by the descent of the Dove. It is because of the presence of the Holy Spirit in the sacramental water that Baptism has miraculous effects and conveys to its recipients the grace of God.[112] In the version of the *Baptism* for the hospital, the exceptional proximity of the Dove to the shell and the twisting of its head toward the water are used to emphasize the participation of the Spirit. Against the dark background, the light radiating from the Dove, which illuminates the stream of water poured over Christ's head, vivifies the doctrine that Baptism is birth both 'of water and of the spirit' (John 3:5).

Through Baptism, man dies to the earthly life of sin and is reborn through participation in Christ's Crucifixion and Resurrection. Saint John Chrysostom had emphasized the wondrousness of man's rebirth in Baptism and described it as the fulfillment of the divine covenant: 'Burial and death and resurrection and life, and all these take place at once.'[113] In like manner, Carranza explained that the benefits of Christ's sacrifice and the assurance of participation in the general resurrection are conveyed through Baptism.[114]

The infant descending upon the wing of the Holy Spirit in the hospital *Baptism* is a child-soul, which represents the new being which man becomes through rebirth

[109] Dionysius the Areopagite, *pseud.*, *La Hiérarchie ecclésiastique*, in *Oeuvres*, trans. by Gandillac, 245–251.
[110] Carranza, *Comentarios*, 2:170, 174, 182–186.
[111] Carranza, *Comentarios*, 2:169; Saint Basil the Great, *Ascetical Works*, trans. Sister M. Monica, Washington, D.C., 1950, 386. A Greek copy of Basil's *Ascetical Works* was included in El Greco's library; see San Román, *El Greco*, 196.
[112] Carranza, *Comentarios*, 2:184–185. [113] Saint John Chrysostom, *Homilies on...John*, 1:24.
[114] Carranza, *Comentarios*, 2:183–184.

by grace in Baptism. The motif of the child-soul was employed frequently in Early Christian and medieval representations of the departure of the souls of saints at their martyrdoms and of the weighing of souls at the Last Judgment.[115] This symbol continued to be employed in popular art and appeared in many prints in the 1584 edition of the *Flos Sanctorum*, including the *Martyrdom of Saint Cecilia* (fig. 34) and *Saint Michael Weighing Souls* (fig. 35). El Greco may have been directly influenced by prints such as the *Martyrdom of Saint Cecilia* when he represented an angel carrying the soul of the Count to heaven in his earlier painting, *Burial of the Count of Orgaz* (1586, fig. 36). In the hospital *Baptism*, El Greco utilized the motif of the child-soul in an entirely new way and associated it with birth instead of death.

The adaptation of the child-soul to the *Baptism* visualizes in an exceptionally concise and accurate manner the doctrine that the sacrament produces a spiritual rebirth. This image of the soul, closely linked to the Dove, may have been inspired directly by Saint John Chrysostom's description of the water of Baptism shaping and forming the Christian into a 'rational soul bearing the Holy Spirit.'[116] The arrival of the soul at the moment of Christ's Baptism demonstrates that the institution of this rite made possible the birth of men to a level of spiritual life that had previously been inaccessible to them. It cannot refer directly to Christ because he did not need to be reborn.

As in the *Baptism* for the Seminary of the Incarnation, El Greco vividly illustrated the conception of Baptism as the casting-off of old garments and the putting-on of new ones. Like Alonso, Carranza discussed this metaphor at length, describing the new garments as representing the cleansing of the soul in Baptism, the morally pure life which should follow Baptism, and the certainty of the resurrection of all worthy Christians.[117] The Archbishop strongly recommended that the Church incorporate this metaphor into the rite of Baptism by removing the clothes of recipients and by replacing them with new robes.

The celestial vision at the top half of the painting is essential to the historical account of the life of Christ but may also illustrate Carranza's claim that the sacrament of Baptism provides the means by which the possibility of entering heaven is given to mankind.[118] The presence of all three Persons of the Trinity in every sacrament and divine action is a fundamental doctrine of the Church which was strongly defended by Carranza throughout his *Catechismo*.[119] According to Carranza, it is only because of the tripartite divine presence in the baptismal water that the rite can confer new life upon the recipient. The representation of the Trinity would

[115] Cf. Adolphe Napoléon Didron, *Christian Iconography*, 2 vols., trans. and ed. E. J. Millington and M. Stokes (1886), reprint ed., New York, 1965, 2:174–181.
[116] Saint John Chrysostom, *Homilies on...John*, 1:251.
[117] Carranza, *Comentarios*, 2:180. [118] Carranza, *Comentarios*, 2:174.
[119] Carranza, *Comentarios*, 1:195.

also have helped the worshipper to remember the intervention of the three Persons of the Trinity in all divine actions, including the Incarnation and the Apocalyptic Vision, represented on the other altars.

In addition to its universal significance, the *Baptism* would have had specific relevance to the hospital's concern with encouraging its patients to repent their sins. Following numerous Church Fathers, the Council of Trent had defined the sacrament of Penance as 'a laborious kind of Baptism.'[120] The Council emphatically reiterated the tradition that Baptism could be administered only once – in opposition to certain heretical sects which maintained that it could be performed as often as needed to purify a man's soul – and that Penance was necessary to revive its effects. Baptism provided the necessary basis for Penance, as for the other sacraments, but Penance alone could not save a man. The fruits of Penance were available only to those who had entered into the community of believers through Baptism. In its decrees on Penance, the Council of Trent declared that contrition was 'even a gift of God, and an impulse of the Holy Ghost, whereby the penitent being assisted prepares a way for himself into justice.'[121] The image of the *Baptism* might have been intended to stimulate the patients to undertake Penance in order to regain the purity and grace that had been freely given to them in the first sacrament, with a view to restoring their temporal and spiritual health.

As in the earliest version of the subject, El Greco represented the River Jordan widening and spreading out into the viewer's space. This was an excellent means of visualizing the necessity of Baptism to salvation. The water flowing out of the picture represents the Spirit encompassing all baptized Christians. Carranza described water as an ideal symbol of the action of the Spirit and compared water's power to relieve thirst with the consolation which the Spirit offers Christians to help them deal with the adversities of life.[122] The pouring out of the Spirit to people in times of trial would have been of special relevance to the patients who were preparing for death because the grace of the Spirit was needed to help them renounce their sins and genuinely repent.

The child-soul and other details of El Greco's *Baptism* for the hospital, such as the treatment of the River Jordan, visualize the spiritual rebirth of Christians through the sacrament. By alluding to Penance, the painting shows the means by which Christians can revive the effects of the first sacrament. Both Baptism and Penance prepare the faithful for rebirth into eternal life at the time of the Last Judgment, which is the subject of the final painting of the series.

[120] Trent, Session 14, 92–104.
[121] Trent, Session 14, 96.
[122] Carranza, *Comentarios*, 1:349.

'The Apocalyptic Vision'[123]

The *Apocalyptic Vision* (New York: Metropolitan Museum of Art; 2.25 × 1.93 m.; fig. 37) completes the history of Christian salvation initiated by the Incarnation. Although no document specifies the scene in Revelation which is depicted in this picture, it evidently refers to the final birth of Christians – their resurrection to eternal life at the time of the Last Judgment.

The enormous figure of Saint John the Evangelist in the foreground of this painting would have helped to commemorate Tavera's memory. The Evangelist was one of the Cardinal's two major name saints, and this figure would have thus complemented the representation of the Baptist in the previously discussed altarpiece. Tavera was additionally linked to the Evangelist because he was a Cardinal of the Basilica of Saint John the Evangelist in Rome. In his biography of Tavera, Salazar noted that the Cardinal had been very proud of this appointment.[124]

The vivid portrayal of John's intense amazement, combining fear and ecstasy, is responsible for much of the immediate impact of this great painting upon the viewer. While the scene draws upon earlier representations of John's visions of events recorded in Revelation, El Greco has transformed them with great originality. The location of John in a lower corner of the composition and the upward direction of his gaze follow most previous representations of John's vision of events recorded in Revelation. The highly charged interpretation of the Evangelist can be related to Dürer's treatment of him in some of the scenes of the Apocalypse series, although the frontal view of the Evangelist distinguishes El Greco's presentation of the saint from that of Dürer and most earlier artists.

Titian's *Vision of Saint John the Evangelist* painted in the 1540s for the ceiling

[123] One of the paintings commissioned from Félix Casteló in the contract of 1635 was designated as the *Apocalyptic Vision*. Because of the uncertainty concerning the scene represented in the painting now in the Metropolitan, which is frequently called the *Opening of the Fifth Seal*, I have chosen to use the title employed in this document.

I wish to thank the staff of the Department of European Paintings at the Metropolitan Museum for allowing me to examine the file which contains the results of the extensive scientific examination undertaken in 1956–1959 and includes the series of X-ray photographs made at that time.

The Metropolitan painting has been cut on both the top and left side. X-ray photographs reveal widespread damage. The fingers of John's left hand, the face of the middle nude figure, and the major part of the face of the third figure from the right have been completely lost. The red bole ground to the right of John's robe was never covered.

The provenance of the painting before the nineteenth century is uncertain. During that century, it was successively in the collections of J. Nuñez del Prado, Madrid, and of Antonio Cánovas del Castillo, Madrid (Cossío, no. 327). In 1880, it was restored and relined at the Prado (Cossío, 1:357). Rafael Vázquez de la Playa, Córdoba, may have acquired it before or sometime after the death of Cánovas in 1893. He owned it in 1902 when it was exhibited at the Prado (no. 21). Ignacio Zuloaga (Paris and Zumaya, Spain) acquired it in Córdoba from Vázquez de la Playa in 1905 (E. Lafuente Ferrari, *La vida y el arte de Ignacio Zuloaga* [Madrid, 1950], 55). The Metropolitan Museum purchased it in 1956 from the estate of Zuloaga.

[124] Salazar de Mendoza, *Tavera*, 97.

of the Albergo Nuovo of the Scuola di San Giovanni Evangelista (now in Washington, D.C.: National Gallery of Art) provides a precedent for the frontal view of El Greco's figure. Like Titian, El Greco has projected the saint from a low viewpoint, so that his knees extend out into the viewer's space and his arms extend far upwards. Through his handling of the figure, Titian had intended to create the illusion that the saint was actually in the heavens above the viewer. In El Greco's work, the related presentation of the figure enhances the hallucinatory character of the scene because the picture was meant to be displayed in a retable against the wall, not on the ceiling. By greatly elongating the proportions which Titian had employed, El Greco transformed the Apostle into a towering, gigantic figure.[125]

El Greco's presentation of Saint John is so overwhelming that the Evangelist has become a vision presented to the viewer. In effect, the painting contains two visions: the Evangelist on the first plane and the event miraculously seen by him in the background. The identification of the background scene is not immediately apparent, but the upward movement of the nude bodies suggests that it concerns their resurrection from the dead.

In 1908, Cossío identified the painting as Saint John's Vision of the Opening of the Fifth Seal (Revelation 6:9–11):

When he had opened the fifth seal, I saw under the altar the souls of them that were slain for the word of God, and for the testimony which they held: And they cried with a loud voice, saying, How long, O Lord, holy and true, dost thou not judge and avenge our blood on them that dwell on the earth? And white robes were given unto every one of them and it was said unto them, that they should rest yet for a little season, until their fellowservants also and their brethren, that should be killed as they were, should be fulfilled.

Most authorities have concurred with Cossío's identification of the subject as the Opening of the Fifth Seal.[126]

Yet, El Greco's painting does not closely represent the biblical account. El Greco did not show the altar under which the souls were said to lie in repose, and this omission of the altar distinguishes the Metropolitan painting from all known

[125] El Greco's painting differs in a number of other respects from Titian's. El Greco showed the Evangelist as a young man, rather than an old one, as had Titian. El Greco omitted the eagle which Titian included. The visions perceived by the two saints are entirely different.

[126] Cossío, El Greco, 1:356. See also San Román, 'De la vida,' 302, f.n. 183, and 338, f.n. 1; Hugo Kehrer, Die Kunst des Greco, Munich, 1914, 83–84; Mayer, Greco, 1926, no. 122; Goldscheider, El Greco, no. 237; Rousseau, 'El Greco,' 252; Wethey, El Greco and His School, 2:77; Gudiol, El Greco, 267–268 and 355 (no. 226). In an earlier study of this painting, I accepted the theory that the Metropolitan painting represents the Opening of the Fifth Seal. See my article, 'The Altarpieces for the Hospital of Saint John the Baptist, Outside the Walls, Toledo,' in J. Brown, ed., Figures of Thought: El Greco as Interpreter of History, Tradition, and Ideas, Studies in the History of Art 11, Washington, D.C., 1982, 65–68. I now think El Greco did not intend to depict the Opening of the Fifth Seal.

representations of the Opening of the Fifth Seal.[127] In consolation of their long wait, the martyrs were clad in white robes, but the largest and most prominent draperies in the background scene are yellow and green. Although the biblical account does not specify how the white robes were distributed, earlier artists had always shown angels clothing the martyrs.[128] In El Greco's painting, the children flying above the draperies are wingless and cannot be identified as angels; furthermore, they do not actually seem to be distributing the cloth. Because El Greco's work is usually characterized by doctrinal accuracy, it seems unlikely that he would have ignored the fundamental textual sources, although he might have diverged from some aspects of earlier visualizations.

I propose that the Metropolitan painting represents the final resurrection of the Elect. The struggle of the kneeling figures to lift themselves and of the standing figures to stretch upwards indicates that the resurrection is in progress. Other aspects of the background scene, including El Greco's handling of the bodies, the children floating in the air, and the shimmering cloths, reflect discussion in sixteenth-century Toledo about the resurrection.

The theme of the resurrection of the Elect would have been especially relevant to the mission and purpose of the hospital. Salazar emphasized that those who died within its walls departed in grace, enjoying the special care of God.[129] The special indulgences which the hospital was empowered to grant enabled worthy patients to join the ranks of the Elect. Furthermore, the poor – whom Salazar claimed that the hospital was especially dedicated to serving[130] – were esteemed as martyrs because of the physical deprivations which they endured and were therefore considered especially worthy of salvation.[131] Works of charity provided the most secure means for the rich to be included among the Just. According to Salazar, Tavera helped to ensure his own salvation through the foundation of the hospital and other actions on behalf of the poor.[132]

Arias Montano's commentaries enable us to understand how the Evangelist's description of the Elect as beheaded martyrs throughout Revelation (see, e.g., 7:13–14, 20:4) can encompass all Christians. Arias wittily explained that the term 'beheaded,' as used in Revelation, applied to all the faithful because baptized

[127] An examination of the representations of Revelation 6:9–11 recorded in the Index of Christian Art (Princeton), in the photographic archives of the Frick Art Reference Library (New York), and in all available published sources has revealed no other representation of this passage without an altar. I wish to thank the librarians of the Index and the Frick for their gracious assistance. For basic, though dated, bibliography, consult Louis Réau, *Iconographie de l'art chrétien*, 3 vols., Paris, 1955–1956, vol. 2, part 2, 724–726.

[128] This is true of all representations of Revelation 6:9–11 available at the Index of Christian Art and the Frick Art Reference Library, as well as in published sources.

[129] Salazar de Mendoza, *Tavera*, 293. [130] Salazar de Mendoza, *Tavera*, 230, 307–309.

[131] Carranza, *Comentarios*, 1:335, 338.

[132] Salazar de Mendoza, *Tavera*, 293–294.

Christians become part of the body of Christ and find in him their sole head.[133] Through participation in the Crucifixion, all who have remained loyal to the Christian faith and have received Baptism and Communion are martyrs and will be clad in shining garments.[134]

The theme of the vindication of the Just would have had special significance for the admirers of Carranza, who certainly included Salazar. Because the final decision of Carranza's case was ambiguous,[135] his supporters sought consolation in the thought that he would be vindicated at the time of the Last Judgment. In his preface to his biography of Carranza, Salazar quoted the Franciscan Visitador-General of Andalusia as saying, 'How I long for the Day of Judgment in order to know the truth of this case' ('Que desea el día del juicio por saber la verdad de esta causa').[136] Salazar commented that he was certain that Carranza's innocence would be established at that time.[137] Salazar's praise of Carranza for the modesty and strength with which he bore the suffering inflicted by misguided men indicates that he considered the Archbishop a martyr awaiting vindication.[138] From his deathbed, Carranza had declared that he was innocent of any heresy, that the charges against him and the final settlement of his case were unjust, and that he expected to be fully justified by Christ.[139]

El Greco's portrayal of the bodies of the resurrected reflects Carranza's description of the four graces which will characterize the Just in heaven: spirituality, lightness, radiance, and freedom from any form of pain.[140] Although still fully corporeal, resurrected bodies will be spiritualized to the point of extreme delicacy and slight weight, so that they can freely penetrate one another and live on the level of angelic spirits. This description of the resurrected bodies of the Elect is accurately expressed in the figures in El Greco's painting. The extremely elongated proportions, the shimmering effect of light on the skin, and the loose definition of the contours of the figures all contribute to the effect of spiritualization. The apparent ease with which the standing figures seem to float upward illustrates the quality of lightness which will enable bodies to go anywhere without difficulty.

El Greco followed Carranza in showing figures of varying degrees of whiteness and radiance, ranging from the extremely bright, white woman with her arms crossed over her chest to the brown-skinned kneeling man. According to Carranza, who was inspired by I Corinthians 15:41, those who were most just and loyal to Christ on

[133] Benito Arias Montano, *Elucidationes in omnia scriptorum Apostolorum eiusdem in S. Ioannes Apostali*, Antwerp, 1583, 473.

[134] Arias Montano, *S. Ioannes*, 115.

[135] Tellechea Idigoras, 'El libro,' 1:43–45; Salazar de Mendoza, *Carranza*, 164–170.

[136] Salazar de Mendoza, *Carranza*, 'Al lector,' no pagination.

[137] Salazar de Mendoza, *Carranza*, 'Al lector,' no pagination.

[138] Salazar de Mendoza, *Carranza*, 79–98, 193–198.

[139] Salazar de Mendoza, *Carranza*, 175–180. [140] Carranza, *Comentarios*, 1:410–415.

earth will shine as brilliantly as had he at the Transfiguration. Others, having been less righteous on earth, will be less bright. The dark-skinned man may also have been included to refer to the doctrine that men of all nations will be resurrected.

El Greco only vaguely suggested the sex of the figures. The three figures on the right and the kneeling figure on the far left seem to be male, while the figure with crossed arms and her companion can be identified as female because of the shape of their breasts and hips. However, the sex of the second figure from the left, who lifts up the yellow cloth, is uncertain. El Greco may have tended towards an asexual definition of the figures to illustrate Christ's pronouncement, 'When they shall rise from the dead, they neither marry nor are given in marriage; but are as the angels which are in heaven' (Mark 12:25).

The wingless children who float down towards the nude figures were intended as representations of souls being reunited with bodies. The writings of Salazar himself provide the basis for this interpretation.[141] Salazar did not write about many theological matters, but he did concern himself with the resurrection from the dead and its proper representation in visual arts. Salazar carefully differentiated the properties of bodies, which are subject to death, and souls, which exist eternally. The soul, he explained, will not need to be resurrected because it is not subject to corruption and always retains its natural immortality.[142] Just as the soul had to enter the body during gestation, the soul will have to return to the body at the moment of birth to eternal life.[143] Salazar criticized most pictures of the resurrection because they did not show the reunion of souls and bodies. Thus, it seems most likely that he instructed El Greco to create an image of the final resurrection which would correctly distinguish between bodies and souls.

In using the motif of the child-soul, El Greco here continued the use of a visual metaphor which he had introduced in the *Baptism*, where he had portrayed the birth of the 'rational soul bearing the Holy Spirit.' The depiction of the child-soul also corresponded with his previous use of this motif in the *Burial of the Count of Orgaz*, where he showed the soul of the Count being consigned to the protection of the grace of God. In the *Apocalyptic Vision*, he represented the reunion of Christian souls with transformed bodies that conform to the life of the Spirit. This event is a necessary consequence of the separation of the soul from the body at death, which El Greco depicted in *Orgaz*.

The symbolism of the clothing is also important to understanding El Greco's picture. The Christian insistence upon the resurrection of the body was necessarily linked to a radical change undergone by the body as it was raised to eternal life. In I Corinthians and in other writings, notably Romans 7, Paul recognized that the

[141] Salazar de Mendoza, *Ildefonso*, 135–138. [142] Cf. Carranza, *Comentarios*, 1:397–399.
[143] Carranza, *Comentarios*, 1:398, 403–404; Salazar de Mendoza, *Ildefonso*, 135–139.

body, in its present earthly state, was unworthy of eternal life and an inadequate vessel for divine grace, and he described the change wrought in the bodies in terms of putting new clothes on them. Carranza, drawing as usual upon Early Christian sources, endorsed Paul's analogy of putting on new, imperishable garments of immortality as the most adequate means of representing the change needed by our mortal bodies.[144] Carranza developed this analogy and, following John's vision of the Apocalypse, stated that the Just will wear shining garments in heaven as a symbol of their immortality.[145]

In El Greco's painting, the brilliantly lit yellow and green draperies held behind the figures were probably intended to represent heavenly clothing. Obviously, the vivid colors depart from the tradition that white best symbolized purity. However, the radiance certainly corresponds with Carranza's description. The idea that these draperies constitute the garments of persons who have been reborn spiritually is supported by their striking resemblance to the robes which angels hold behind Christ in the *Baptism*. In particular, the piece of cloth which extends over the arms of the two kneeling figures at the right of the *Apocalyptic Vision* looks very much like the drapery held by the kneeling angel in the right foreground of the *Baptism*. By adapting the brilliant robes of the *Baptism* to the scene of the resurrection, El Greco emphasized the belief that these events involved closely related spiritual births.

The distribution of raiment was frequently shown as part of the resurrection, as it was in the anonymous early sixteenth-century altarpiece of the parish church of Canet lo Roig, which represents both the Mass of Saint Gregory and the Last Judgment (fig. 38).[146] In the lower left section of the central panel, the Just are shown receiving their new clothes. It is interesting to note that a standing figure of John the Evangelist is located in the lower section of the left wing of the altarpiece, although not integrated with it as in the *Apocalyptic Vision*.

El Greco may not have been familiar with this specific altarpiece, but he probably drew upon an image of this type in formulating his own distinctive painting. However, El Greco did not follow earlier artists in showing the Just wearing or putting on their new robes. In his painting, the yellow and green draperies are simply displayed behind the nude figures. This presentation accords with Carranza's discussions. Following Paul, Carranza had emphasized that heavenly clothing would not be needed to cover the nude body or to protect it against the elements and that its only function was to mark the glorious state of the Elect.[147]

Thus, El Greco's handling of the draperies probably reflects his concern for

[144] Carranza, *Comentarios*, 1:398.
[145] Carranza, *Comentarios*, 1:417.
[146] Enrique Bagué and Juan Petit, 'Repertorio iconográfico,' in L. Font, E. Bagué and Juan Petit, *La Eucaristía, el tema eucarístico en el arte de España*, Barcelona, 1952, 135, no. 102.
[147] Carranza, *Comentarios*, 1:417.

theological accuracy. El Greco also introduced into the painting other themes, such as the reunion of souls with bodies, which were not treated by other artists. Ironically, the close correspondence between the *Apocalyptic Vision* and sixteenth-century theological discussions of the final resurrection may account for the modern failure to understand El Greco's intentions.

The last motif in the painting that needs to be considered is the largest: the mammoth figure of John. The endowment of the Evangelist with superhuman size attests to his role in the promulgation of the doctrine of the resurrection. John's vision of the institution of the Holy Kingdom constituted God's solemn promise of the Second Coming (Revelation 22:20). The end of the world was revealed to him before any other mortal, and his record of the event is the ultimate source of later discussions and representations. The prominence accorded by El Greco to Saint John demonstrates once again the artist's concern for accurate, and at times surprisingly literal, depiction of dogma which characterized the commission as a whole.

The upward-reaching pose of Saint John and his heavenward gaze suggest that he is looking at a vision of God the Father or Christ. Passages of Revelation which describe the Saint as kneeling (19:10 and 22:8–9) are complemented by other descriptions of motions of obeisance (4:9–11, 5:8–14, 7:9–11, 11:16, and 19:4) in the presence of God. Otherwise, John is described as standing (13:1) or walking. The biblical account was respected by artists, who only showed John kneeling before visions of God or the angel sent by God.[148] This suggests that the *Apocalyptic Vision* originally was surmounted by a manifestation of the divine.

Unlike the other altarpieces for the hospital, the *Apocalyptic Vision* was untouched by Jorge Manuel and other artists. I imagine that Salazar would have particularly liked this painting because of its intense emotional power and its unusual, doctrinally accurate iconography. However, he was forced to resign his position at the hospital in the year of El Greco's death (1614). Those aspects of the painting which most appealed to Salazar might have discouraged the officials from seeking its completion. The later selection of Casteló to execute the altarpieces suggests that the hospital administration would have preferred a more conventional and 'up-to-date' painting – i.e., one in a more naturalistic style and with more conventional iconography.

Of course, Jorge Manuel might not have worked on the *Apocalyptic Vision* simply because he was too lazy to finish it. The protracted legal dispute between Jorge Manuel and the hospital reveals ill will and distortions on both sides. Nevertheless, the evidence presented by the hospital seems to prove that Jorge Manuel was extremely lax in fulfilling his obligations.

It is also possible that Jorge Manuel felt unequal to completing the painting now

148 See n. 127 above for sources of images.

in New York. He was certainly incapable of matching the emotional power and iconographic originality which his father demonstrated in the *Apocalyptic Vision*. The other two major paintings which El Greco had begun for the hospital would have presented his son with far fewer problems. El Greco seems to have substantially completed the *Baptism* before his death. Jorge Manuel might have felt comfortable working on the *Incarnation* because he was able to introduce into it such typical details of his personal style as the carefully depicted recession of floor tiles.

Because it was left unfinished, the *Apocalyptic Vision* provides the best indication of El Greco's latest manner. In this final painting, the artist pushed to an extreme the iconographic originality and the stylistic boldness which had characterized his work for the seminary in Madrid. His representation of the final resurrection is virtually unique in visual art, although strictly in accord with orthodox belief. Contributing to the dramatic force of the work are the projection of John's figure as though seen from far below, the startling shift in scale between the Evangelist and the nude figures, and the forceful application of paint, especially notable in the white highlights slashed on John's robes.

The Intended Arrangement of the Altarpieces

Records of the hospital indicate that the *Baptism of Christ* was the only one of El Greco's three large altarpieces to have been displayed in the chapel. Nevertheless, because the paintings were conceived as part of a tightly knit iconographic program, it would be interesting to know where El Greco and Salazar de Mendoza intended to place them. Because the contract with El Greco has been lost, we have to depend on other evidence to determine the various possibilities for the original arrangement.

The major problem confronting all of the proposals is the difficulty in reconciling the present dimensions of the paintings with the frames of the retables. The dimensions of the paintings themselves have unquestionably been altered, and the problem is further complicated by the fact that there is no way to be certain about the original dimensions of the frames.

El Greco did not live to finish the pictures or to supervise the construction of the retables. Therefore, as Cossío suggested in 1908, it is likely that none of the retables corresponds to the artist's original designs.[149] The inventory of 1614 implies that the side altars were finished at the artist's death except for sculptural and decorative work: 'the side altars of wood less the ornament and sculpture' ('los colaterales de madera menos la talla y escultura').[150] However, these altarpieces were not set up before 1635,[151] and changes could have been made before this date, either

[149] Cossío, *El Greco*, 1:338. [150] San Román, *El Greco*, 195.
[151] Wethey, *El Greco and His School*, 2:21.

by Jorge Manuel or another of the artists in the employ of the hospital. Furthermore, the records of the legal disputes between Jorge Manuel and the hospital prove that the principal retable differs greatly from El Greco's plans.[152] The removal of the *Baptism* from the altar of the Epistle to the infirmary in about 1631,[153] the year of Jorge Manuel's death, may indicate that the administrators found it necessary to reconsider their plans for the retables in that year.

As for the paintings, pending technical examinations, it is impossible to be certain of the full extent to which the existing canvases for the side altars were cut down in size or otherwise represent modifications of El Greco's designs by his son or others. But even with the naked eye, it can be seen that changes were made in the pictures. The *Apocalyptic Vision* has been cut on the top and the left side. The upper zone of the *Incarnation* – the Athens *Angel Concert* – was separated from the rest of the canvas. The figures in the *Angel Concert* appear to have been conceived entirely by Jorge Manuel.

Perhaps the *Baptism*, now about 75 cm. shorter than the *Incarnation* including the *Angel Concert*, was also modified. A comparison with the version of the Baptism executed for the Seminary of the Incarnation suggests that the canvas at the hospital was reduced in size at some point. In the earlier work, the artist showed much more of the river at the bottom of the canvas. Considering the iconographic importance of water to the meaning of the hospital *Baptism* in particular, it seems probable that more of the Jordan was originally shown. The river landscape by an anonymous seventeenth-century artist which was used to extend the *Baptism* on the altar of the Epistle may have been intended to replace a missing section of El Greco's canvas. It is also unlikely that El Greco would have cut off the wings of the angels at the top.

The earliest documentary reference to the placement of the paintings occurs in 1621 – thirteen years after the altarpieces were commissioned and seven years after El Greco's death. The inventory of Jorge Manuel's possessions made in that year includes the following item: 'the principal Baptism for the hospital' ('el bautismo prinzipal del ospital').[154] This entry has been construed to mean that El Greco created the *Baptism* for the main altar. This theory is supported by the contract of 1635 with Félix Casteló, who was commissioned to paint an Incarnation and an Apocalyptic Vision for the side altars and a Baptism of Christ for the main altar.[155] This evidence is extremely important, but it should be kept in mind that the organization of the program could have been changed before 1621 by the hospital's

[152] San Román, 'De la vida,' 310–336. The extensive modifications in the original plans for the main altarpieces are detailed in the contract with Jorge Manuel signed on February 18, 1625 (San Román, 'De la vida,' 335–336).

[153] San Román, 'De la vida,' 339. [154] San Román, 'De la vida,' 303.

[155] San Román, 'De la vida,' 337–338.

administrators, who may not have understood or liked the original plans devised by Salazar de Mendoza and El Greco.

Interestingly, the paintings actually used in the chapel were never arranged according to the indications provided by the available documents. Despite the fact that El Greco's *Baptism* has been in the hospital's possession for over three hundred years, it has never been installed on the main altar. When the hospital obtained the *Baptism* in 1624, it was placed above the altar of the Epistle and remained there until 1936, except for a brief period when it was removed to an infirmary. It seems possible that the *Baptism* was conceived for the altar on which it was displayed for so long. Similarly, it is probable that the *Incarnation* was intended for the altar of the Gospel, where a representation of the subject by Gabriel de Ulloa (active 1630/33) was located until 1936.[156] As for the main retable, it is known only that two separate paintings by El Greco of Saints John the Evangelist and John the Baptist were displayed on it after 1631.[157] Despite the late date, the representation of the Evangelist above the main altar might indicate that a painting with a large figure of the Evangelist was planned for this space.

There is some evidence to suggest that El Greco created the *Apocalyptic Vision* for the main retable. According to the contract of 1608, the tympanum above the main altar was to be filled with a sculptural group of angels adoring the Lamb,[158] which would have formally and iconographically completed the painting now in New York. The new plans commissioned by the hospital from Jorge Manuel in 1625 did not include the sculptural representation of the Adoration of the Lamb,[159] and the exclusion of this element may have necessitated the rearrangement of the original program.

This hypothesis is admittedly controversial. Upon first consideration, the *Baptism* would seem to be the most logical subject for the main altar because it commemorates the titular saint of the hospital. However, there are reasons to believe that Salazar diverged from the frequent practice of showing an incident in the life of the titular saint above the main altar in order to emphasize the special privileges of the hospital. As his published comments show, Salazar placed great value upon these privileges and regarded them as establishing the extraordinary status of the institution and of Toledo. The significance of these benefits would have been most strongly asserted by referring to them in the main retable. This arrangement would have also glorified

[156] In 1630, Gabriel de Ulloa was commissioned to complete the sculptural and architectural work of the altarpieces and to make paintings for them. Of the paintings, only the *Incarnation* was finished at the time of his death in 1633. See San Román, *El Greco*, 216. A settlement with his widow was made in 1635 as payment for the *Incarnation*. See San Román, 'De la vida,' 337–338, for the relevant document. See also Wethey, *El Greco and His School*, 2:22–23. None of the documents which have thus far been discovered indicates the other subjects which Ulloa was commissioned to paint.

[157] San Román, 'De la vida,' 335–336. [158] Cossío, *El Greco*, 2:680.

[159] San Román, 'De la vida,' 335–336.

the faith and charity that Tavera demonstrated in obtaining the indulgences for the patients and officials of the hospital. This theme would have been especially appropriate for the main altar of Tavera's funerary chapel because, as Salazar indicated, the Cardinal's efforts to console poor patients and to procure salvation for them provided the primary hope for his own glorification.[160] In addition, the large figure of John would have commemorated Tavera's memory by recalling his appointment as cardinal of the Basilica of Saint John the Evangelist in Rome.

The sculptural group mentioned in the contract of 1608 would have logically completed the *Apocalyptic Vision*. Angels worshipping the Lamb constitute an important part of the vision known as the Adoration of the Lamb (Revelation 7:9–15). The representation of this event in terms of a few angels adoring the symbolic animal would correspond to El Greco's concise treatment of John's vision in the Metropolitan painting. Carranza interpreted the Adoration of the Lamb as a vision of the arrival of the Just into the eternal kingdom of God and claimed that it ensured the bliss and lack of suffering which will characterize eternal life.[161] According to Arias Montano, the angels' adoration of the Lamb expressed their joy at the arrival of the Elect into their realm.[162] With the sculptural group of the angels adoring the Lamb above and the painting of the final resurrection below, the main retable would have shown the reign of saints in the process of its creation. In effect, the dead for whom the hospital offered Mass at the altar would have been shown rising to meet the angels above.

From an artistic point of view, the representation of the Apocalyptic vision in both painting and sculpture would have constituted a logical development of the ideas of design already evident in the Chapel of Saint Joseph (1597–99), where El Greco broke down the clear separation of different images and media characteristic of Spanish retables and enlivened the space near the altar in a theatrical manner.[163] For instance, in the segments of the attic of the principal altarpiece, he put sculpted putti who look down toward Joseph and the Child Jesus in the canvas below and join the painted angels in scattering flowers above the earthly pair. However, in the Chapel of Saint Joseph, the sculpture was still subordinated to the painting, whereas in the chapel of the hospital, El Greco seems to have intended to advance the integration of artistic media by creating an essential part of the principal subject of the altarpiece in sculpture. In the Chapel of Saint Joseph, the painting contained the essential elements of the subject but, without the sculptural scene above and the altar below, the *Apocalyptic Vision* was both formally and iconographically incomplete.

[160] Salazar de Mendoza, *Tavera*, 266, 270–271, 293–294.
[161] Carranza, *Comentarios*, 1:330, 416. [162] Arias Montano, *S. Ioannes*, 445–446.
[163] Halldor Soehner, *Una obra maestra del Greco, la Capilla de San José en Toledo*, trans., Madrid, 1961, 20–33.

2 Luis Carvajal, Portrait of Archbishop Carranza, Chapter House, Toledo Cathedral, 1578

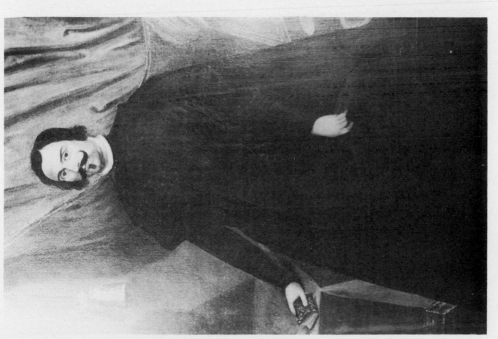

1 Portrait of Don Diego de Castilla, Convent of Santo Domingo el Antiguo, Toledo

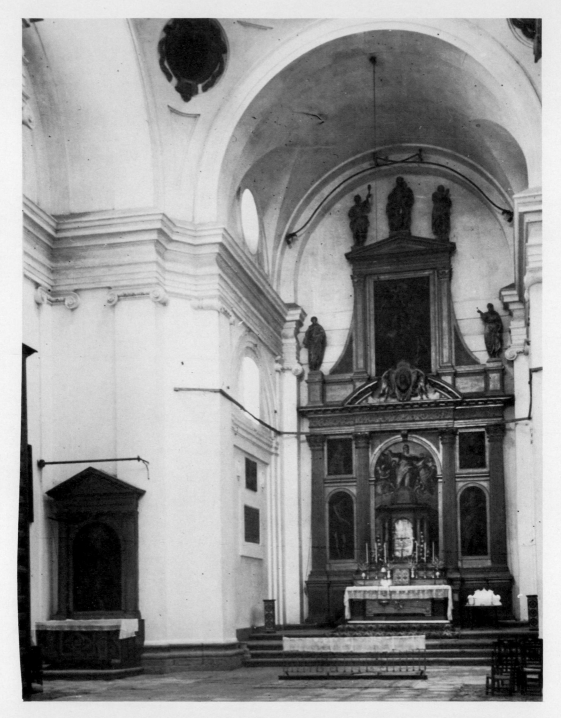

3 El Greco and J. B. Monegro, main altarpiece, Santo
Domingo el Antiguo, Toledo, 1577–79

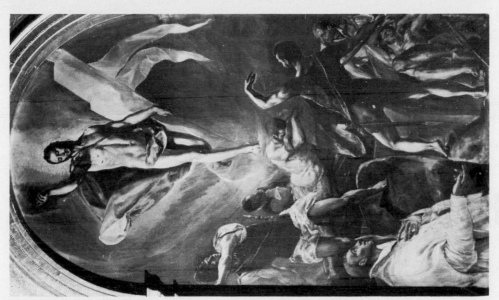

5 El Greco, *Resurrection of Christ*, Santo
Domingo el Antiguo, Toledo, 1577–79

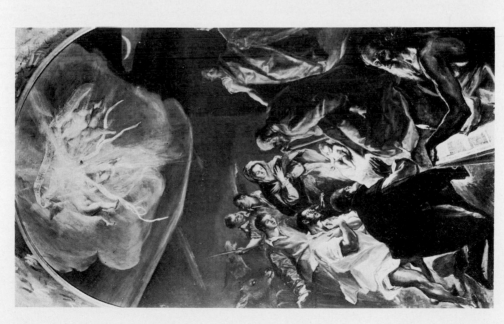

4 El Greco, *Adoration of the Shepherds*, private
collection, Santander, 1577–79

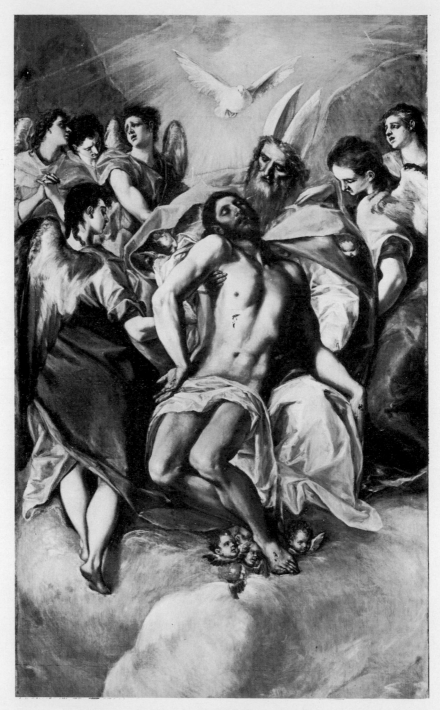

6 El Greco, *Trinity*, Museo del Prado, Madrid, 1577–79

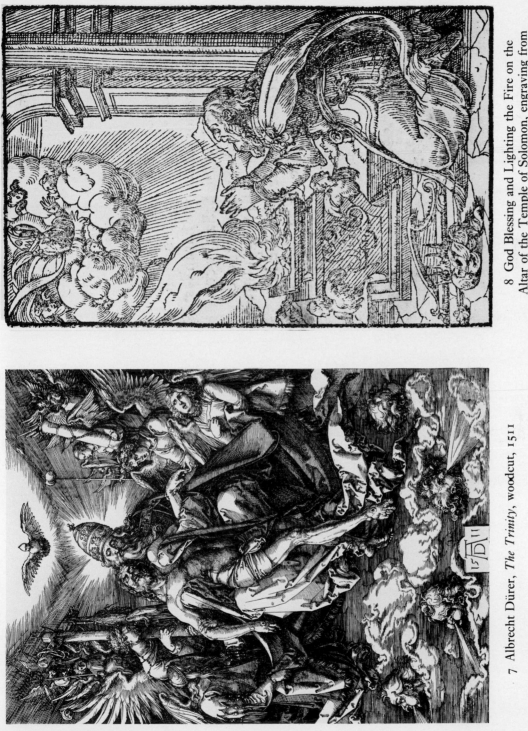

8 God Blessing and Lighting the Fire on the Altar of the Temple of Solomon, engraving from Blessed Alonso de Orozco, *Libro de la suavidad de Dios*, Salamanca, 1576

7 Albrecht Dürer, *The Trinity*, woodcut, 1511

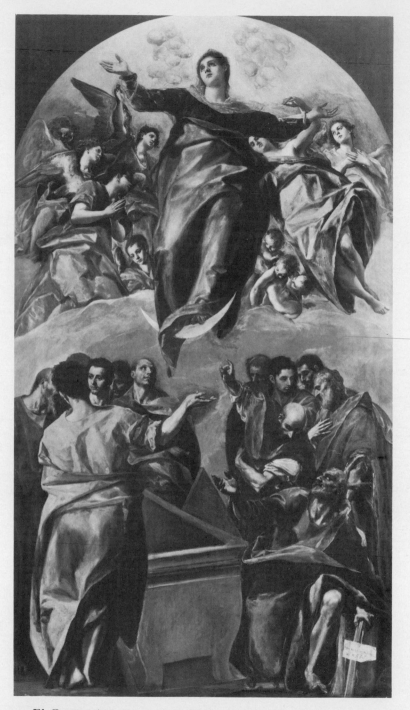

9 El Greco, *Assumption of the Virgin*, Art Institute, Chicago, 1577

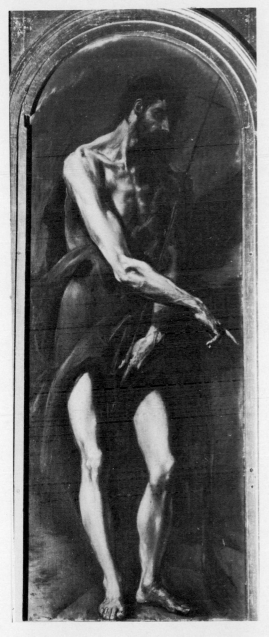

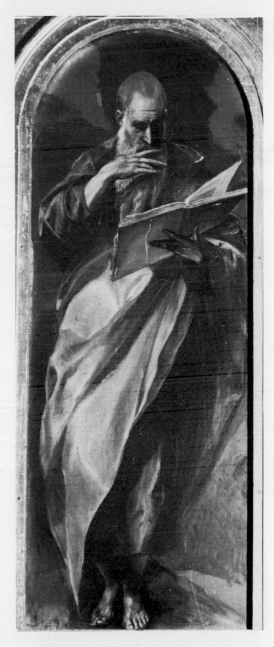

10 El Greco, *Saint John the Baptist*, Santo Domingo el Antiguo, Toledo, 1577–79

11 El Greco, *Apostle*, Santo Domingo el Antiguo, Toledo, 1577–79

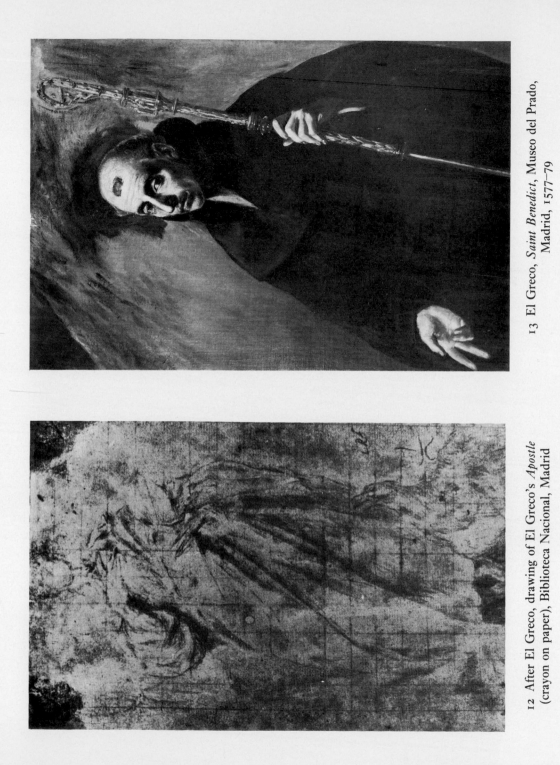

13 El Greco, *Saint Benedict*, Museo del Prado, Madrid, 1577–79

12 After El Greco, drawing of El Greco's *Apostle* (crayon on paper), Biblioteca Nacional, Madrid

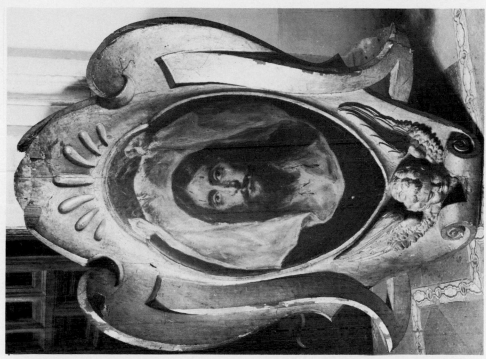

15 El Greco, *Veronica's Veil*, Santo Domingo el Antiguo, Toledo, 1577–79

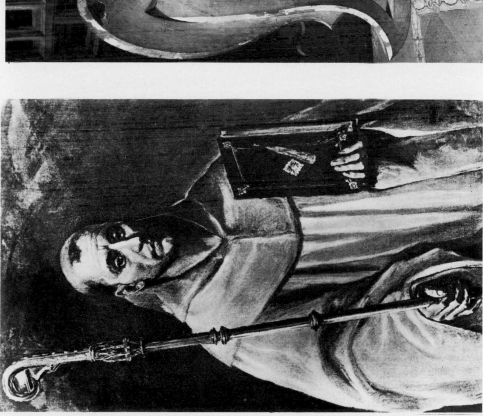

14 El Greco, *Saint Bernard of Clairvaux*, whereabouts unknown, 1577–79

16 Portrait of the Blessed Alonso de Orozco, engraving (after a lost painting by Juan Pantoja de la Cruz?)

17 Juan Pantoja de la Cruz, Portrait of Fray Hernando de Rojas, collection of Duquesa de Valencia, Madrid, 1595

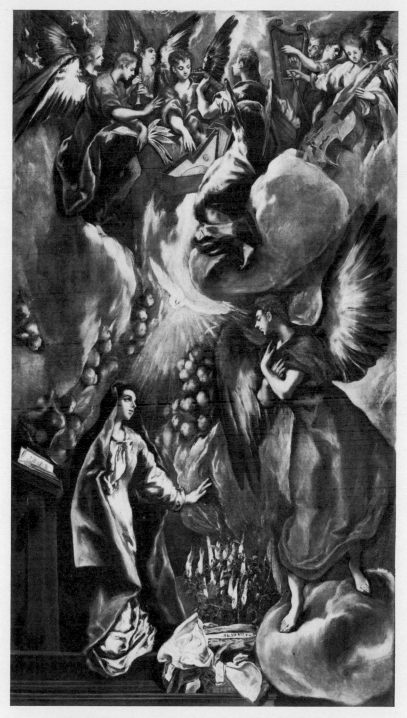

18 El Greco, *Incarnation*, Museo Balaguer, Villanueva y
Geltrú, on permanent loan from the Museo del Prado,
Madrid, 1596–1600

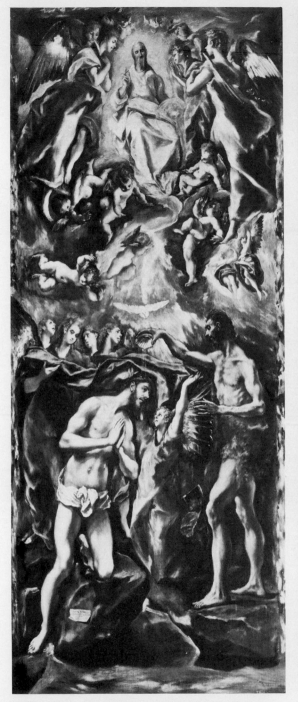

19 El Greco, *Baptism of Christ*, Museo del Prado, Madrid, 1596–1600

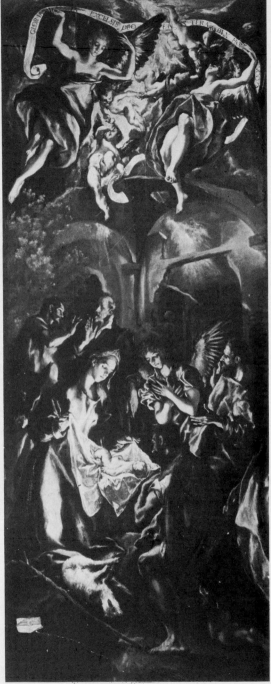

20 El Greco, *Adoration of the Shepherds*, National Museum of Art, Bucharest, 1596–1600

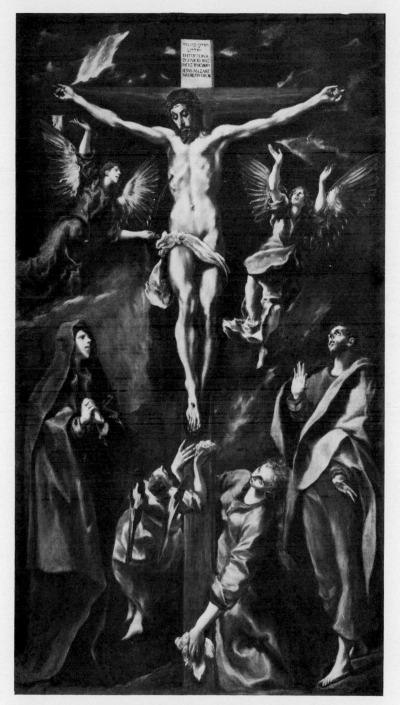

21 El Greco, *Crucifixion of Christ*, Museo del
Prado, Madrid, 1596–1600

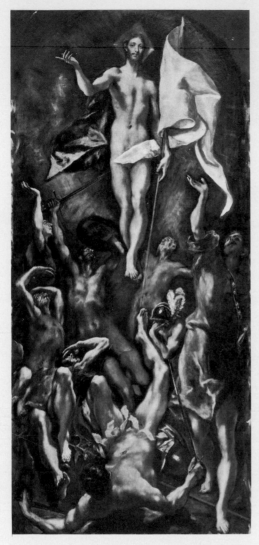

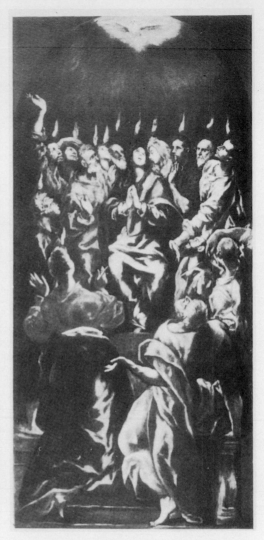

22 El Greco, *Resurrection*, Museo del Prado, Madrid

23 El Greco, *Pentecost*, Museo del Prado, Madrid

24 El Greco and workshop, altarpiece
for Nuestra Señora del Remedio,
Talavera la Vieja, 1591–92
(photographed before 1936, year of
extensive damage)

25 Proposed original form of El
Greco's altarpiece at Talavera la Vieja

26 Baptism of Christ, woodcut from
Antonio de Aranda, *Verdadera información
sobre la Tierra Santa*, Toledo, 1551

27 Juan Pantoja de la Cruz, *Saint
Augustine*, Museo del Prado, Madrid, 1601

28 Juan Pantoja de la Cruz, *Saint Nicholas
of Tolentino*, Museo del Prado, Madrid,
1601

29 Saint Nicholas of Tolentino,
woodcut from Blessed Alonso
de Orozco, *Crónica del glorioso
padre y doctor de la Yglesia
Sant Agustin*, Seville, 1551

30 El Greco, *Resurrected Christ* (polychrome
statue), Hospital of Saint John the Baptist
Outside the Walls, Toledo, c. 1595–1605

31 El Greco and Jorge Manuel, *Incarnation*, Banco Urquijo, Madrid, c. 1608–22

32 El Greco and Jorge Manuel, *Baptism of Christ*, Hospital
of Saint John the Baptist Outside the Walls, Toledo,
c. 1608–22

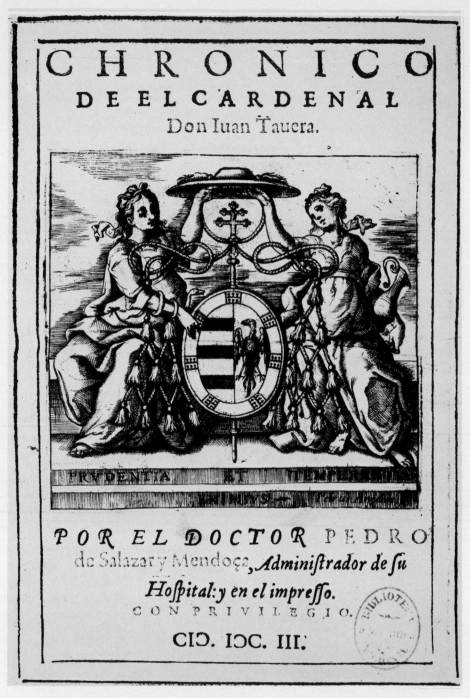

33 Pedro Angelo, *Prudence and Temperance*, engraving from the title page of
Pedro Salazar de Mendoza, *Chronico de el Cardenal don Juan Tavera*, 1603

34 P.A. (Pedro Angelo?), Martyrdom of Saint Cecilia, from A. Villegas, *Flos Sanctorum*, *secunda parte*, Toledo, 1584

35 P.A. (Pedro Angelo?), Saint Michael Weighing Souls, from A. Villegas, *Flos Sanctorum*, *secunda parte*, Toledo, 1584

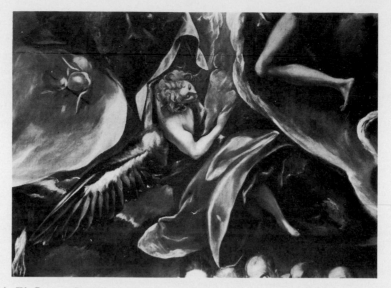

36 A El Greco, *Burial of the Count of Orgaz*, detail showing an angel carrying the soul of the count to Heaven, Santo Tomé, Toledo, 1586

36 B El Greco, *Burial of the Count of Orgaz*, Santo Tomé, Toledo, 1586

37 El Greco, *Apocalyptic Vision*, Metropolitan Museum of Art, New York, 1608–14

38 *The Mass of Saint Gregory with the Last Judgment*, altarpiece, parish church of Canet lo Roig (Castellón), sixteenth century

The representation of the Adoration of the Lamb in sculpture would have endowed the celestial vision with an illusionistic force greater than that of John witnessing it from below. The Heavenly Church would have been shown to be more substantial than the scene of the earthly world which will be destroyed at the time of the Last Judgment, immediately after the resurrection of the dead (Revelation 20:11–15, 21:1–8). The impermanence of this world would have been strongly contrasted with the palpable reality of the divine.

The iconographic scheme of the principal altar would also have encompassed the statue of the *Resurrected Christ* on the tabernacle in front of the *Apocalyptic Vision* and served to emphasize the doctrine that Christ's Resurrection ensured the resurrection of the bodies on the day of the Last Judgment. Visual linking of the body of the Resurrected Christ with the Last Judgment would have been related to certain earlier Spanish altarpieces of the Mass of Saint Gregory. These included the *Mass of Saint Gregory with the Last Judgment* in Canet lo Roig, cited previously, and the altar of the *Mass of Saint Gregory with the Liberation of Souls and the Entry to the Holy Jerusalem* in the Archpriest's Church at San Mateo (Castellón).[164]

Together, the various elements of the main altar in the hospital chapel would have represented the miracles that occur during the Mass. The statue represented the body of Christ, which the priest brought into existence and offered as nourishment to prepare communicants for eternal life. In celebrating the Mass for the Dead, the priest helped to ensure the salvation of the Just, depicted in the painting. The reliance of this conception upon the role of the priest would have emphasized the doctrine that the Christian's hope of salvation was in the process of realization. The Eucharist and God's blessing upon the souls contributed to the fulfillment of the history of redemption.

It must be admitted that the iconographic evidence for the placement of the *Apocalyptic Vision* on the main altar is inconclusive. Whether the *Baptism* or *Apocalyptic Vision* was originally intended for the main altar, the basic iconographic program of the chapel would be the same, although the focus would have been somewhat different. If the *Baptism* were located on the main altar, the greatest emphasis would have been placed on the doctrine that salvation was reserved for those who had been reborn into the life of the Church through the administration of this sacrament. A declaration of this belief would reflect Carranza's assertion that baptism was absolutely necessary for salvation under all circumstances.[165] The statue of the *Resurrected Christ* would illustrate the doctrine that men are reborn by participating in Christ's death and resurrection. Above the *Baptism*, the Adoration of the Lamb would have referred to the Baptist's proclamation of Jesus as the Son who will be sacrificed (John 1:29).

[164] Bagué and Petit, 'Repertorio,' 127–128, no. 64. [165] Carranza, *Comentarios*, 2:174.

Whatever the arrangement, the three paintings and the statue which El Greco created for the Hospital would have outlined the history of Christian salvation. The Incarnation, which must have been displayed on the altar of the Gospel, made it possible for the Elect to be justified at the time of the Last Judgment. Before the Incarnation, men had no hope of resurrection to eternal life with God. Through baptism, men are reborn spiritually by the action of the Holy Spirit, as Christ was acknowledged Son of God at his Baptism. The Resurrection of Christ provides the basis for men's hope of final birth through bodily resurrection whereby they will enter the life of the heavens. The *Apocalyptic Vision* would have completed the history of Christian salvation and commemorated the way in which the Hospital prepared its patients for death. The image of the fulfillment of Christian history would have inspired hope in those preparing for their death and subsequent birth to eternal life.

Conclusions

Before his death in 1614, El Greco began three large and exciting altarpieces for the Hospital of Saint John the Baptist Outside the Walls: the *Incarnation*, the *Baptism of Christ*, and the *Apocalyptic Vision*. Although poor health prevented El Greco from completing this project, it is clear that he and Salazar de Mendoza carefully devised a pictorial program that reflected the functions of the hospital and its chapel. The altarpieces and the statue of the Resurrected Christ elucidated the history and means of Christian salvation, a theme especially appropriate to the chapel, where the Mass for the Dead was recited daily. In each of the paintings, El Greco included symbols of the achievements and virtues of Cardinal Tavera, whose tomb was located in the middle of the chapel.

As might be expected, the paintings for the hospital exemplify the ideas of Salazar, the only one of El Greco's patrons who has left us a theory of art. El Greco devised unusual motifs in order to illustrate correctly points of doctrine with which artists did not usually concern themselves. In the *Baptism* and the *Apocalyptic Vision*, El Greco pushed the emotional intensity of his mature style to an extreme and thereby created paintings that are still capable of stirring the emotions of viewers.

Because El Greco's paintings so well illustrate Salazar's principles, it seems possible that the painter influenced his patron's artistic philosophy. Whether or not this is true, Salazar must have appreciated fully the distinctive characteristics of El Greco's art and encouraged his iconographic inventiveness and stylistic boldness. The poor condition of the extant canvases cannot hide their originality and dramatic power, which Salazar must have admired as much as we do today.

AFTERWORD

The patrons of El Greco who have been studied here all belonged to a distinct class. All obtained advanced university degrees and dedicated themselves to careers in the Church, in which they held various types of administrative posts. It can be presumed that these men shared a common intellectual and philosophical framework. All must have supported the hierarchy of the Church, accepted the basic tenets of orthodox Catholic doctrine, and fully understood the complexities of Tridentine theology.

Nevertheless, the differences among the artist's patrons should not be overlooked. Don Diego de Castilla, El Greco's first Spanish patron, was a dynamic and forceful politician. His large collection of books attested to his extensive learning, but he was not dedicated to scholarly pursuits as an end in themselves. Instead, he used his knowledge to defend himself in the disputes which he seems to have relished. Because of Don Diego's constant involvement in heated political debates, it is not surprising that all of his preserved writings are polemical tracts. His longest treatise explains the supposed descent of his family from Peter the Cruel, a medieval Spanish king. As Dean of Toledo Cathedral, Don Diego was by far the highest-ranking of El Greco's patrons.

Rojas and Chiriboga, who supervised the decoration of the Seminary of the Incarnation, held less important offices. Rojas was the second Rector of the seminary. Chiriboga, a member of the cabinet of Cardinal Quiroga, participated in the affairs of the seminary as executor of the estate of Doña María de Aragón, the wealthy court lady who financed it. Rojas and Chiriboga promoted the canonization of Alonso de Orozco, the first Rector of the seminary, whom many Spaniards of the late sixteenth and early seventeenth centuries revered as a saint. Although no important writings can be attributed to either Rojas or Chiriboga, their involvement with the intellectually distinguished seminary presupposes a sophisticated understanding of Catholic theology.

Among the patrons discussed here, Pedro Salazar de Mendoza is the only one

who was a published scholar. Salazar was particularly interested in the careers of leading Toledan ecclesiastics, but he also studied the history of the Church in Spain and the origins of noble titles. Most of his books were based on meticulous research, but in trying to promote causes of special importance to himself, he sometimes introduced flimsy evidence and lies. Salazar was very proud of his appointment as chief administrator of the Hospital of Saint John the Baptist Outside the Walls, for which he commissioned El Greco's last major pictorial ensemble.

For these patrons, El Greco devised programs that elucidated their concerns and beliefs and expressed the purposes of the institutions which they supervised. In order to do this, the artist and his patrons must have carefully discussed each project. El Greco succeeded in making his altarpieces both rich in meaning and visually stunning. The immediately perceptible beauty and power of El Greco's illustrations of Catholic belief distinguish them from most contemporary theological and devotional writings, which tend to be rambling and diffuse.

Not surprisingly, El Greco's first major project, which involved the design and execution of the altarpieces for Santo Domingo, was his most conventional. In these works, El Greco largely retained the normative classicizing style which he had developed in Italy. In the *Trinity*, in particular, he even increased the sculptural solidity of his figures. However, he introduced some modifications of his earlier manner, such as the compression of space in the large narrative scenes.

Don Diego probably encouraged El Greco to employ a basically Italianate style. It seems likely that Don Diego wanted to imitate royal patronage by employing a painter associated with the Italian school. Don Diego's straightforward and powerful approach to ecclesiastical politics seems to be reflected in the forceful, monumental paintings which El Greco created for Santo Domingo.

In iconography as well as in style, the paintings for Santo Domingo are less unusual than El Greco's later altarpieces. In conceiving the four large narrative paintings, El Greco closely followed the compositions of earlier artists, perhaps because he felt insecure about working on a large scale. However, by introducing original details into the scenes, he subtly enriched their meaning. Because Don Diego was not as involved with scholarly pursuits as El Greco's later patrons, he may not have encouraged the artist to invent the highly distinctive interpretations of Christian themes which characterize later altarpieces.

A dramatic change is evident in the altarpieces which El Greco created for the Seminary of the Incarnation in Madrid. El Greco filled these canvases with motifs which are rare – and, in some cases, unprecedented – in Western art. All of the unique elements in these paintings illustrate the visions and meditations of Alonso de Orozco, who was buried underneath the altar for which El Greco created these works. Rojas and Chiriboga probably explained to El Greco the ideas which he was

supposed to represent and even pointed out to him the motifs which he was to transfer from Alonso's writings to canvas. The results of their collaboration reveal El Greco's extraordinary ability to give convincing and dramatic visual expression to concepts seldom treated by earlier artists. Many of the images in these altarpieces, such as the Burning Bush and the figures wiping up blood in the *Crucifixion*, still startle and amaze viewers. El Greco developed original compositions for these altarpieces and no longer relied on the formulations of earlier artists. The goal of responding directly to the needs of his patrons apparently inspired El Greco to realize his inventive powers.

It is possible to establish that El Greco intended to visualize Alonso's mystical visions and meditations in the altarpieces for the seminary. It is more difficult to prove the connection between the content and style of the paintings. Yet, the style which El Greco utilized for these altarpieces well complemented and expressed the spirit of Alonso's meditations. El Greco employed such means as stylized but dramatic gestures, expressions and poses, intense contrasts of light and shade, and electrified colors to evoke the moods described by Alonso. He also made notable use of purely formal elements of painting for expressive purposes, conveying the torments of the Passion in the *Crucifixion* by slashing strokes roughly on the canvas and making them intersect at sharp angles. The elimination of realistic backgrounds, the unnaturalistic and strange lighting, and the elongation of proportions help to remove the scenes from the realm of conventional narrative. This effect can be related to Alonso's method of recounting events without a sense of chronological sequence and without logically and fully described settings.

It is not necessary to suppose that El Greco shared the beliefs or convictions of his patrons. Certainly, there is no reason to posit that El Greco had mystical visions of the sort described by Alonso. As a creative artist, El Greco would have been concerned primarily with the problem of devising images and forms which were faithful to the content and spirit of Alonso's meditations. The challenge of illustrating Alonso's fervent texts seems to have promoted the evolution of the artist's style and stimulated him to exploit fully his powers of visual expression.

Salazar de Mendoza's comments on art suggest that he, like Rojas and Chiriboga, would have fostered El Greco's iconographic and stylistic originality. As a scholar of Church history, Salazar was ideally suited to help El Greco devise images that represented fine points of Christian belief and liturgical practice, and Salazar must have been glad to encounter an artist who could perform this task so well. El Greco depicted the instantaneous conception of Christ's full being and the virtues inspired by this event in the *Incarnation*, the process of spiritual birth in the *Baptism*, and the reunion of souls and bodies at the time of the final resurrection in the *Apocalyptic Vision*. Although modern viewers often have difficulty in understanding these

paintings, Salazar and his well-educated contemporaries would have easily recognized all the motifs employed by El Greco. For these individuals, El Greco's altarpieces would have clearly and directly elucidated the history of redemption.

Salazar was also deeply concerned with the power of pictures to appeal to the feelings of viewers, and he must have encouraged the artist to make the *Apocalyptic Vision* so overwhelming. The intervention of Jorge Manuel has dimmed, but not entirely destroyed, the impact of the other two large canvases for the hospital.

Today, it may seem paradoxical that El Greco utilized such a moving and intense style to visualize aspects of an intellectually complex theological system. However, the obvious expressive force of El Greco's altarpieces accurately reflected the spiritual commitment of the people who commissioned them. El Greco's patrons and other contemporary ecclesiastics were passionately devoted to all aspects of Catholic theology and doctrines which explained the means of human salvation through the Church.

This study demonstrates that El Greco enjoyed a productive and mutually beneficial relationship with his patrons. The artist must have worked closely with these men to create pictorial ensembles that – both in content and appearance – expressed their convictions. El Greco demonstrated an extraordinary talent to create unusual images that accurately and concisely illustrate often very complex theological issues. He employed striking formal devices to endow his works with great emotional power.

The Toledan ecclesiastics must have encouraged and challenged El Greco to realize and develop his powers of invention and expression. The results of their collaboration can still amaze, excite, and delight us.

BIBLIOGRAPHY

Alcocer, Pedro de, *Hystoria o descripcion de la imperial ciudad de Toledo*, Toledo, 1554.

Alonso de Orozco, Blessed, 'Cartas del Beato Alonso de Orozco a Doña María de Córdoba y Aragón,' ed. T. Cámara, *Revista Agustiniana*, 4 (1889), 31–34, 164–171, 262–266.

Confessiones (1601), reprint ed., Madrid, 1620.

Crónica del glorioso padre y doctor de la yglesia, Sant Agustín: y de los sanctos y beatos y de los doctores y su orden. Una muy provechosa instrución de religiosos, Seville, 1551

Declamationes decem et septem pro Adventu nostri Iesu Christi, Madrid, 1594.

Declamationes in omnes solemnitates, quae in festivis sanctorum in ecclesia Romana celebrantur, Salamanca, 1573.

Epistolario cristiano, Alcalá de Henares, 1567.

Historia de la Reyna Saba, Salamanca, 1565.

Liber orthodoxis, omnibus per utilis, et maximé Monachis, qui Bonum certmen appellatur, Salamanca, 1562.

Libro de la suavidad de Dios, Salamanca 1576,

Obra nueva y muy provechosa, que trata de las siete palabras que la Virgen sacratissima nuestra Señora hablo, Medina del Campo, 1568.

Recopilación de todas las obras, 2 vols., Alcalá de Henares, 1570.

Soliloquio de la passión de nuestro redemptor Jesu Cristo, Madrid, 1585.

Vergel de oración y monte de contemplación, 2nd ed., Seville, 1548.

Ancona, Mireille Levi d', *The Iconography of the Immaculate Conception in the Middle Ages and Early Renaissance*, New York, 1957.

Andrés, Melquiades, *La teología española en el siglo XVI*, Biblioteca de Autores Cristianos Maiores 13–14, 2 vols., Madrid, 1976–1977.

Angelis, Pietro d', *L'Archiconfraternità ospitaliera de S.to Spirito in Saxia*, Rome, 1954.

Angelis, Serafino de, 'Indulgenze,' in *Enciclopedia cattolica*, Vatican City, 1951, 1:1901–1909.

Angulo Iñiguez, Diego, *Pintura del Renascimiento*, Ars Hispaniae 12, Madrid, 1954.

and Alfonso E. Pérez-Sánchez, *Spanish Drawings, 1400–1600*, A Corpus of Spanish Drawings 1, London, 1975.

Antonio, Nicholas, *Biblioteca Hispana Nova*, 2 vols., Madrid, 1788.

Aragón, Doña María de, 'Constitucion que el monesterio de la encarnación ha de guardar,'
 ed. T. Cámara, *Revista Agustiniana*, 4 (1889), 266–268.

Aranda, Antonio de, *Verdadera información sobre la Tierra Santa*, 2nd ed., Toledo, 1551.

Arias Montano, Benito, *Elucidationes in omnia scriptorum Apostolorum eiusdem in S. Joannes
 Apostali*, Antwerp, 1588.

 Elucidationes in Quator Evangelia, Antwerp, 1575.

Augustine, Saint, *The Confessions*, trans. Edward B. Pusey, The Modern Library, New
 York, 1949.

Aviles, Angel, *Catálogo de las obras existentes en el palacio del Senado*, 2nd ed., Madrid, 1917.

Azcárate, José María, 'La iconografía de "El Espolio", del Greco,' *Archivo español del arte*,
 28 (1955), 189–197.

Barasch, Mosche, *Gestures of Despair in Medieval and Early Renaissance Art*, New York,
 1976.

Barocchi, Paola, *Trattati d'arte del Cinquecento fra Manierismo e Contrariforma*, 3 vols., Bari,
 1960–1962.

Barrès, Maurice, *Greco ou le secret de Tolède*, new ed., Paris, 1966.

Basil the Great, Saint, *Ascetical Works*, trans. Sister M. Monica, Washington, D.C., 1950.

Bayon, Damien, 'El Greco, creador de conjuntos plásticos,' *Colóquio* (Fundación
 C. Gabenkian, Lisbon), no. 5, 1971, 14–23.

Bernard of Clairvaux, Saint, *Sermones*, ed. J. Leclercq and H. Rochas, Opera 4, Rome, 1966.

Bishop, Edmund, *Liturgica Historica*, Oxford, 1962.

Blunt, Anthony, 'El Greco's *Dream of Philip II*: an Allegory of the Holy League,' *Journal
 of the Warburg and Courtauld Institutes*, 3 (1939–1940), 58–69.

Bonet Correa, A., *Iglesias madrileñas del siglo XVII*, Madrid, 1961.

Boschloo, A. W. A., *Annibale Carracci in Bologna*, trans. R. R. Symonds, The Hague, 1974.

Brilliant, Richard, *Gesture and Rank in Roman Arts*, Memoirs of the Connecticut State
 Academy of Arts and Sciences 14, New Haven, 1963.

Bronstein, Leo, *El Greco*, Library of Great Painters, New York, [1967].

Brown, Jonathan M., *Images and Ideas in Seventeenth Century Spanish Painting*, Princeton,
 1978.

 'Painting in Seville from Pacheco to Murillo: a Study of Artistic Transition,' Ph.D.
 dissertation, Princeton University, 1964.

 William B. Jordan, Richard L. Kagan, and Alfonso E. Pérez-Sánchez, *El Greco of Toledo*,
 Boston, 1982.

 ed., *Figures of Thought: El Greco as Interpreter of History, Tradition, and Ideas*, Studies
 in the History of Arts 11, Washington, D.C., 1982.

Bulovas, Ana Julia, *El amor divino en la obra del Beato Alonso de Orozco*, Ph.D. dissertation,
 Universidad de Madrid, 1973 (published Madrid, 1975).

Bustamante García, Agustín, 'El Colegio de doña María de Aragón, en Madrid,' *Boletín
 del Seminario de Estudios de Arte y Arqueología*, 38 (1972), 427–438.

Busuioceanu, A., 'Les tableaux du Greco dans la collection royale de Roumanie,' offprint
 from *Gazette des Beaux Arts*, 1924.

Cámara, Tomás, *Vida y escritos del Beato Alonso de Orozco*, Valladolid, 1882.

Camón-Aznar, José, *Dominico Greco*, 2 vols., 2nd ed., Madrid, 1970.

 La Pasión de Cristo en el arte español, Biblioteca de Autores Cristianos 47, Madrid, 1949.

Carranza de Miranda, Bartholomé, *Comentarios sobre el Catechismo christiano*, ed. José Ignacio Tellechea Idigoras, Biblioteca de Autores Cristianos Maior 1–2, 2 vols., Madrid, 1972.

Castilla, Diego de, *Historia del Rey Don Pedro, y su descendencia, que es el linaje de los Castillas*, ed. Antonio Valladares, in *Seminario erudito*, 28, 1790, 222–288; 29, 1791, 3–61. For manuscript versions, see Madrid, Biblioteca Nacional, Sala de Investigadores.

Castilla, Francisco de, *Pratica de las virtudes de los buenos reyes de España y otras obras*, Murcia, 1518.

Castre, Victor, *Le mythe Greco*, Geneva, 1961.

Ceán Bermúdez, Juan Agustín, *Diccionario de los más ilustres professores de las bellas artes en España*, 6 vols. (Madrid, 1800), reprint ed., Madrid, 1965.

Cedillo, Conde de, *Toledo en el siglo XVI*, Madrid, 1901.
 Toledo, guía artístico-práctica, Toledo, 1890.

Chastel, André, 'La Véronique,' *Revue de l'art*, no. 40–41 (1978), 71–82.

Compendio delli privilleggi essention' e indulgente concesse all' archihospitale de S. Spirito in Sassia in Roma, Viterbo, 1584.

Cossío, Manuel B., *El Greco*, 2 vols., Madrid, 1908.
 Lo que se sabe de la vida del Greco, Madrid, 1914.

Cruzada Villaamil, Gregorio, *Catálogo provisional historial y razonada del Museo Nacional de Pinturas*, Madrid, 1865.

Davies, David, *El Greco*, London, 1976.

De Tolnay, Charles, *The Medici Chapel*, Michelangelo 3, 2nd ed., Princeton, 1970.

Didron, Adolphe Napoléon, *Christian Iconography*, 2 vols., trans. and ed. E. J. Millington and M. Stokes (1886), reprint ed., New York, 1965.

Diéz Ramoz, Gregorio, 'San Bernardo: doctrina teológica-dogmática,' in *Obras completas de San Bernardo*, Biblioteca de Autores Cristianos, Madrid, 1953, 1:1–73.

Dionysius the Areopagite, *pseud.*, *Oeuvres complètes du Pseudo-Denys l'Aréopagite*, trans. and ed. Maurice de Gandillac, rev. ed., Paris, 1972.

Elliott, John, *Imperial Spain, 1469–1711*, Cambridge, 1963.

Estrada, Luis de, *Rosario della Madonna e sommario della vita di Cristi*, trans., Rome, 1588.

Evans, Joan, *Monastic Iconography in France from the Renaissance to the Revolution*, Cambridge, 1970.

Floranes, Rafael de, *Vida literaria del canciller mayor de Castilla, Don Pedro Lopez de Ayala*, Colección de documentos inéditos para la historia de España, vol. 19, Madrid, 1851.

Font, Lamberto, Enrique Bagué, and Juan Petit, *La Eucaristía, el tema eucarístico en el arte de España*, Barcelona, 1952.

Frankfort, Enriquetta Harris, 'A Decorative Scheme by El Greco,' *Burlington Magazine*, 72 (1938), 154–164.
 'El Greco's *Holy Family with the Sleeping Christ Child and the Infant Baptist*: an Image of Silence and Mystery,' *Hortus Imaginum*, ed. R. Enggass and M. Stokstad, Lawrence, Kansas, 1974, 103–111.
 'Moses and the Burning Bush,' in *Journal of the Warburg and Courtauld Institutes*, 1 (1937–1938), 281–286.

Friedman, Herbert, 'A Painting by Pantoja and the Legend of the Partridge of St. Nicholas of Tolentino,' *Art Quarterly*, 22 (1959), 45–55.

Gallego, Julian, *Vision et symboles dans la peinture espagnole du siècle d'or*, Paris, 1968.

García Chico, Esteban, 'Nuevo documento sobre El Greco,' *Boletín del Seminario de Estudios de Arte y Arqueología*, Universidad de Valladolid, 22–24 (1939–1940), 235–236.

García-Rey, Verardo (Comandante), 'Datos relativos a la vida del famoso Greco,' *Arte español*, 8 (1926), 74–75.

 El Deán de la Santa Iglesia de Toledo, don Diego de Castilla, y la reconstrucción e historia del Monasterio de Santo Domingo el Antiguo, Toledo, 1927.

 'Juan Bautista de Monegro, escultor y arquitecto,' *Boletín de la Sociedad Española de Excursiones*, 39 (1931), 109–125, 183–189; 40 (1932), 22–38, 129–145, 236–244; 41 (1933), 148–152, 204–225; 42 (1934), 202–234; 43 (1935), 53–72.

Garibay y Zamolloa, Esteban de, *Memorias*, Memorial histórico español, no. 7, Madrid, 1854.

Gaya Nuño, Juan Antonio, 'El Museo Nacional de la Trinidad,' *Boletín de la Sociedad Española de Excursiones*, 51 (1947), 19–77.

 La pintura española fuera de España, Madrid, 1958.

Goldscheider, Ludwig, *El Greco*, London, 1938.

Gómez de la Serna, Ramón, 'El Greco y Toledo,' *Ars*, 1957, 61–85.

Gómez-Menor, José, 'Un documento desconocido del Greco,' *Boletín de arte toledano*, 1 (1965–1968), 127–128.

 'En torno a algunos retratos del Greco,' *Boletín de arte toledano*, 1 (1965–1968), 77–88.

 'El tema de San Ildefonso en el arte español,' *Boletín de arte toledano*, 1 (1965–1968), 25–31.

Gómez-Moreno, Manuel, *El Greco*, Barcelona, 1943.

González Dávila, Gil, *Teatro de las grandezas de la villa de Madrid*, Madrid, 1623.

Gracia-Dei, *Genealogía universal*, Seville, 1515.

Gudiol, José, *El Greco*, trans. K. Lyons, New York, 1973.

Guerrero Lovillo, José, 'Lo que España dio a El Greco,' *España en la crisis del arte europeo*, Madrid, 1968, 159–165.

Guinard, Paul, *El Greco*, trans. J. Emmons, New York, 1956.

Gutiérrez, David, *Los Agustinos desde el protestantismo hasta la restauración católica, 1548–1648*, Historia de la Orden de San Agustín 2, Rome, 1971.

Harris, Enriquetta: see Frankfort, Enriquetta Harris.

Herrera, Tomás de, *Alphabetum Augustinianum*, 2 vols., Madrid, 1644.

 Historia del Convento de S. Agustín de Salamanca, Salamanca, 1652.

Illescas, Gonzalo de, *Historia pontifical y catolica*, 2nd ed., 2 vols., Burgos, 1578.

Jacobus de Voragine, *The Golden Legend*, trans. Granger Ryan and Helmut Ripperger (1941), reprint ed., New York, 1969.

Jameson, Mrs. [Anna Murphy], *Sacred and Legendary Art*, 2 vols., 4th ed., London, 1863.

Jerome, Saint, *The Homilies of Saint Jerome*, 2 vols., trans. Sister Marie Liguori Ewald, The Fathers of the Church 48 and 57, Washington, D.C., 1964–1966.

 Letters and Selected Works, trans., A Select Library of Nicene and Post Nicene Fathers, 2nd series, vol. 6, Grand Rapids, MI, 1890.

John Chrysostom, Saint, *Homilies on St. John the Apostle and Evangelist*, trans. Sister Thomas Aquinas Gogger, 2 vols., Washington, D.C., 1957.

Homilies on St. Matthew, trans. George Provost and M. B. Riddle, London, 1888.

Kagan, Richard L.: see Brown, Jonathan M., William B. Jordan, Richard L. Kagan, and Alfonso E. Pérez-Sánchez.

Kirschbaum, Engelbert, *Lexikon der Christlichen Ikonographie*, 2 vols., Rome, 1970.

Knipping, John B., *Iconography of the Counter Reformation in the Netherlands: Heaven on Earth*, trans., 2 vols., Leiden, 1974.

Kusche, María, *Juan Pantoja de la Cruz*, Madrid, 1964.

Lafond, Paul, 'La chapelle de l'Hospital de Afuera,' *Gazette des Beaux-Arts*, ser. 3, vol. 38 (1907), 482ff.

'Le Christ en Croix de Prades,' *Gazette des Beaux-Arts*, ser. 3, vol. 39 (1908), 177–182.

Lafuente Ferrari, L., *La vida y arte de Ignacio Zuloaga*, Madrid, 1950.

López-Rey, José, 'Spanish Baroque: a Baroque Vision of Repentance in El Greco's St. Peter,' *Art in America*, 35 (1947), 313–318.

Madoz, Pascual, *Diccionario geográfico-estadístico-histórico de España*, 16 vols., Madrid, 1846–1850.

Madrazo, Mariano de, *Historia del Museo de Prado*, Madrid, 1945.

Madrazo, Pedro de, *Catálogo de los cuadros del Museo del Prado*, Madrid, 1893.

Madrid, Archivo Histórico Nacional. Sección de Cleros, Libro no. 6820.

Sección de Consejos, Legajo no. 27.831.

Madrid. Archivo Histórico de Protocolos, Protocolo no. 904.

Protocolo no. 1578.

Protocolo no. 1579.

Protocolo no. 1601.

Madrid. Biblioteca Nacional, Sala de Investigadores. Don Diego de Castilla, 'Historia del Rey don Pedro y su descendencia que es el linaje de los Castillas,' MS. 628, MS. 18.732(27), MS. 10.640, MS. 10.419, MS. 1.652.

Luis de Castilla, 'Sobre el estado ecclesiastico' (1604), MS. 945.

Geronimo de la Higuera, 'Historia ecclesiastica de Toledo,' 7 vols., MS. 8192–8198.

'Memoria de algunas cosas insignas y de las virtudes del Cardenal d. Gaspar de Quiroga de Toledo,' MS. 13.044.

'Relación de lo que pasó al hacer el estatuto de limpieza, Toledo, 1547,' MS. 13.038.

Mâle, Emile, *L'art religieux de la fin du XVIe siècle, du XVIIe siècle, et du XVIIIe siècle, étude sur l'iconographie après le Concile de Trente* (Paris, 1953), reprint ed., Paris, 1972.

Manrique, Pedro, 'Sermon que Predicò el dia del entierro del Venerable Padre Fr. Alonso de Orozco, el Illustrissimo señor D. Fr. Pedro Manrique, Arçobispo y Virrey de Zaragoça,' in Alonso de Orozco, *Confessiones* (q.v.), 112/r–128/r.

Marañon y Posadillo, Gregorio, *El Greco y Toledo*, 4th ed., Madrid, 1963.

Marías, Fernando, 'De nuevo el colegio madrileño de doña María de Aragón,' *Boletín del Seminario de Estudios de Arte y Arqueología*, Universidad de Valladolid, 45 (1979), 449–451.

and Agustín Bustamante García, *Las ideas artísticas de El Greco*, Madrid, 1981.

Márquez, Juan, *Vida del venerable P. Fr. Alonso de Orozco*, ed. Tomás de Herrera, Madrid, 1648.

Martín, E., *Los Bernardos españoles*, Palencia, 1953.

Martín-González, Juan José, *Juan de Juní*, Madrid, 1974.

'Tipología e iconografía del retablo español renacimiento,' *Boletín del Seminario de Estudios de Arte y Arqueología*, Universidad de Valladolid, 30 (1964), 5–60.

Martyrriço, Juan Pablo, *Historia de la muy noble y leal ciudad de Cuenca*, Cuenca, 1629.

Mayer, August L., *Dominico Theotocopuli, El Greco*, Munich, 1926.

El Greco, Berlin, 1931.

Melida y Alinari, José Ramón, *El arte antiguo y el Greco*, Madrid, 1915.

Memorial del Rector y Colegio de la Encarnación de la villa de Madrid, en favor de su sitio, Madrid, [1622?].

Missale secundum ordinem Primatis ecclesię Toletanę, Toledo, 1550.

Moreno Nieto, Luis, *Guía de la Iglesia de Toledo*, Toledo, 1975.

Morichini, Carlo Luigi, *Degli instituti de pubblica carità ed istruzione primaria e delle prigioni*, Rome, 1842.

Nieto, Benedicto, *La asunción de la Virgen en el arte; vida de un tema iconográfico*, Madrid, 1950.

Palm, Erwin, 'Zu zwei späten Werken Grecos,' *Pantheon*, 28 (1970), 294–299.

Palomino de Castro y Velasco, Antonio, *El museo pictórico y escala óptica* (1715 and 1724), reprint ed., Madrid, 1947.

Pamplona, German de, *Iconografía de la Santíssima Trinidad en el arte medieval español*, Madrid, 1970.

Pérez Pastor, Cristobal, 'Noticias y documentos relativos a la historia y literatura española,' *Memorias de la Real Academia Española*, 11 (1914), entire issue.

Pérez-Sánchez, Alfonso E.: see Brown, Jonathan M., William B. Jordan, Richard L. Kagan, and Alfonso E. Pérez-Sanchez.

and Xavier de Salas, *The Golden Age of Spanish Painting*, trans. Philip Deacon, with a forword by Nigel Glendinning, Catalogue of the exhibition at the Royal Academy of Arts, London, 1976.

Pisa, Francisco de, *Apuntamientos para la segunda parte de la 'Descripción de la imperial ciudad de Toledo'*, ed. José Gomez-Menor Fuentes, Clásicos Toledanos, ser. 4., vol. 4, Toledo, 1976.

Descripción de la imperial ciudad de Toledo, y historia de sus antigüedades (Toledo, 1605), reprint ed., Madrid, 1974.

Ponz, Antonio, *Viaje de España*, ed. C. María de Rivero, Madrid, 1947.

Quiroga, Cardinal Gaspar de, *Constitutiones sinodales hechas por el illustrissimo y reverendissimo Señor d. Gaspar de Quiroga*, Madrid, 1583.

Ramón Mélida, José, *Catálogo monumental de la provincia de Cáceres*, 2 vols., Madrid, 1924.

Réau, Louis, *Iconographie de l'art chrétien*, 3 vols., Paris, 1955–1959.

Rekers, B., *Benito Arias Montano*, London, 1972.

Rojas, Hernando de, 'Relación de la vida del Ven. P. Fr. Alonso de Orozco,' ed. T. Cámara, *Revista Agustiniana*, 6 (1891), 87–91.

Rosenbaum, Allen, *Old Master Paintings from the Collection of Baron Thyssen-Bornemisza*, Washington, D.C., 1979.

Rousseau, Theodore, 'El Greco's Vision of St. John,' *Metropolitan Museum Bulletin*, 17 (1959), 241–262.

Salas, Xavier de, *Cuatro obras maestras*, Madrid, 1966.

Salazar y Castro, Luis, *Historia genealógica de la casa de Silva*, 2 vols., Madrid, 1685.

Salazar de Mendoza, Pedro, *Chronico de el Cardenal don Juan Tavera*, Toledo, 1603.

 Cronica de el gran Cardenal de España, Don Pedro Gonçalez de Mendoça, Toledo, 1625.

 El Glorioso Doctor San Ildefonso, Arçobispo de Toledo, Primado de las Españas, Toledo, 1618.

 Monarquía de España, 2 vols., Madrid, 1770.

 Origen de las dignidades seglares de Castilla y Leon, Madrid, 1657.

 Vida y sucesos prósperos y adversos de don fray Bartolomé de Carranza y Miranda, ed. A. Valladares, Madrid, 1788.

Sánchez-Cantón, Francisco J., *Catálogo de los cuadros del Museo del Prado*, Madrid, 1972.

 El Greco, trans., Milan, 1961.

 'Sobre la vida y obras de Juan Pantoja de la Cruz,' *Archivo español de arte*, 19 (1947), 95–120.

Sánchez de Palacios, Mariano, 'La influencia teresiana en la obra del Greco,' *Arbor*, 72 (1972), 107–116.

Sandoval, Bernardino, *Tratado del officio ecclesiastico canonico de Toledo*, Toledo, 1567.

San Román y Fernández, Francisco de Borja, 'De la vida del Greco,' *Archivo español de arte y arqueología*, 3 (1927), 139–195, 275–339.

 'Discurso leído en la solemne sesión extraordinario de las Reales Academias de Historia y de Bellas Artes de San Fernando, celebrado en Toledo, el dia 6 de abril 1914, en conmemoración del tercer centenario del fallecimiento del célebre pintor Dominico Theotocopuli, el Greco,' *Boletín de la Real Academia de Bellas Artes de San Fernando*, epoca 2, vol. 8 (1914), 112–124.

 'Documentos del Greco, referentes a los cuadros de Santo Domingo el Antiguo,' *Archivo español de arte y arqueología*, 10 (1934), 1–13.

 El Greco en Toledo, Madrid, 1910.

Santiago Vela, Gregorio de, 'Colegio de la Encarnación de Madrid, llamado vulgarmente de Doña María de Aragón,' *Archivo histórico hispano-agustiniano y Boletín oficial de la provincia del Smº. Nombre de Jesús de Filipinas*, 1918, vol. 9: 8–21, 81–88, 161–173, 323–337; and vol. 10: 11–12, 401–419.

Santos Diéz, José Luis, *Política conciliar postridentina en España: el Concilio provincial de Toledo, 1565*, Rome, 1969.

Schiller, Gertrud, *Iconography of Christian Art*, trans. Janet Seligman, 2 vols., Greenwich, CT, 1971–1972.

Soehner, Halldor, 'Greco en Spanien,' *Münchner Jahrbuch der bildenden Kunst*, 8 (1957), 123–194; 9–10 (1958–1959), 147–242; 11 (1960), 173–217.

 Una obra maestra del Greco, la Capilla de San José en Toledo, trans., Madrid, 1961.

Sonnenburg, Herbert Falkner von, 'Zur Maltechnik Grecos,' *Münchner Jahrbuch der bildenden Kunst*, 9/10 (1958–1959), 243–255.

Steinberg, Leo, 'The Sexuality of Christ in Renaissance Art and Modern Oblivion,' *October*, 25 (1983), entire issue.

Suárez Fernández, Luis, 'Pedro I el Cruel,' in German Bleiberg, ed., *Diccionario de historia de España*, 3 vols., Madrid, 1969, 3:198–200.

Tellechea Idigoras, José Ignacio, *El Arzobispo Carranza y su tiempo*, 2 vols., Madrid, 1968.
 Bartolomé Carranza. Documentos históricos, 3 vols., Madrid, 1962–1966.
 'El libro y el hombre,' in Carranza (q.v.), 4–96.

Thomas Aquinas, Saint, *Summa Theologica*, Blackfriars Edition, vol. 52, *The Childhood of Christ*, trans. Roland Potter, New York, 1972.

Thomas of Villanueva, Saint, *Sermones de la Virgen y obras castellanas*, ed. Fr. Santos Santamarta, Biblioteca de Autores Cristianos 96, Madrid, 1952.

Trapier, Elizabeth du Gué, *El Greco: Early Years at Toledo, 1576–1586*, New York, 1958.
 'El Greco in the Farnese Palace in Rome,' in *Gazette des Beaux-Arts*, 6th series, vol. 51 (1958), 73–90.
 'The Son of El Greco,' *Notes Hispanic*, 3 (1943), 1–46.

Trens, Manuel, *La Inmaculada en el arte español*, Barcelona, 1952.

Trent, Council of, *The Canons and Decrees of the Sacred and Ecumenical Council of Trent*, ed. and trans. J. Waterworth, London, 1848.

Valdivieso, Joseph de, *Sagrario de Toledo*, Madrid, 1616.

Vázquez, Dionisio, *Sermones*, ed. Félix G. Olmeido, Clásicos Castellanos 123, Madrid, [1956].

Vegue y Goldoni, Angel, 'El Cardenal Quiroga, retratado por el Greco,' *Archivo español de arte y arqueología*, 4 (1928), 135–137.
 'En torno a la figura del Greco,' *Arte español*, 7 (1926), 71–79.

Villar, Emilio H. del, *El Greco en España*, Madrid, 1928.

Villegas, Alonso de, *Flos Sanctorum y historia general de la vida y hechos de Iesu Cristo y todos los santos de que reza y haze fiesta en la Yglesia Catholica*, rev. ed., Madrid, 1588.
 Flos Sanctorum, secunda parte, Toledo, 1584.
 Flos Sanctorum, quarta y ultima parte, Madrid, 1589.
 Fructus Sanctorum, Cuenca, 1594.

Viniegra Valdés, Salvador, *Catálogo ilustrado de la exposición de las obras de Domenico Theotocopuli 'El Greco' en el Museo Nacional de la Pintura*, Madrid, 1902.

Waterhouse, Ellis, *El Greco*, with catalogue by E. Barcheschi, New York, 1980.
 'Some Painters and the Counter-Reformation before 1600,' *Transactions of the Royal Historical Society*, ser. 5, vol. 22 (1972), 103–118.

Wethey, Harold, *El Greco and His School*, 2 vols., Princeton, 1962.

Wilkinson, Catherine, *The Hospital of Cardinal Tavera in Toledo*, Ph.D. disseration, Yale University, 1968 (published in the series, Outstanding Dissertations in the Fine Arts, New York, 1977).

Wittkower, Rudolf, 'El Greco's Language of Gestures,' *Art News*, vol. 56, no. 1 (March 1957), 45ff.

Yepes, Fray Antonio de, *Cronica general de la Orden de San Benito, patriarca de los religiosos*, 7 vols., Real de Yrache and Valladolid, 1609–1621.

Zamora Lucas, Florentino, 'El Colegio de doña María de Aragón y un retablo del "Greco" en Madrid,' *Anales del Instituto de Estudios Madrileños*, 2 (1967), 215–239.

Zurita y Castro, Geronimo, *Emiendas y advertencias a los cronicas de los reyes de Castilla, D. Pedro, D. Enrique el Segundo, D. Juan Primero, y D. Enrique el Tercero*, ed. Diego Josef Dormer, Zaragoza, 1685.

INDEX

Paintings by El Greco are listed without attribution. Works by El Greco are included under the location of the present owner as well as alphabetically by title under 'Greco, El'. Saints are grouped alphabetically under the entry 'saints'.